PHOTOGRAPHERS
AT WORK

PHOTOGRAPHERS AT WORK

A Sociology of Photographic Styles

by Barbara Rosenblum

HOLMES & MEIER PUBLISHERS, INC.
NEW YORK LONDON

First published in the United States of America 1978 by
Holmes & Meier Publishers, Inc.
30 Irving Place
New York, N.Y. 10003

Published in Great Britain by
Holmes & Meier Publishers, Ltd.
Hillview House
1, Hallswelle Parade, Finchley Road
London NW11 ODL

Library of Congress Cataloging in Publication Data

Rosenblum, Barbara.
 Photographers at work.

 Bibliography: p.
 Includes index.
 1. Photography—Social aspects. 2. Photography,
Journalistic. 3. Photography, Advertising. 4. Photography,
Artistic. I. Title.
TR183.R67 770'.1 78-8986
ISBN 0-8419-0402-2

Manufactured in the United States of America

Cover photo courtesy John R. Hamilton/Globe Photos

contents

1. Introduction 1

2. Photographic Styles 13

3. Socialization 19

4. Newspaper Photography 41

5. Advertising Photography 63

6. Fine Arts Photography 87

7. Towards a Sociology of Style 111

Notes 131

Bibliography 135

Index 141

grateful acknowledgments

The hardest part about deciding whom to thank is to figure out when the book actually began. Thanks go to many people, each of whom helped me in her or his own special way. Howard S. Becker, John I. Kitsuse and Allan Schnaiberg, my original thesis committee, made it possible for me to have a rare educational experience and gave me the intellectual freedom to pursue impertinent questions. So did Janet Abu-Lughod and John Walton. I am grateful to the Woodrow Wilson Foundation for a Dissertation Year Fellowship. Peter Kroll, an old friend, gave me great support during those years.

Rachel Kahn-Hut, Paul Hirsch, John Meyer and Barbara Sobieszek read the manuscript in dissertation form and gave me helpful feedback. Special thanks go to Francesca Cancian and Arlene Kaplan Daniels who always believed in it as a book.

Bernice Fisher, Clarice Stasz and Sheryl Ruzek read different parts of the manuscript while I was revising. They gave me speedy feedback with good cheer. Jane Usami typed the manuscript in record time. Thanks also go to Bill Martin and Joyce Seltzer, who made my first book publication a very smooth experience.

Thanks to Philip Perkis, who gave me the courage to point my camera inwards. I also want to thank Stan Deneroff and Alice Henry. At various times, they were live-in editors, hug-givers, music makers, joyful pals and silent partners.

Finally, I want to thank David Watanabe. In addition to all of the above, David gave me a quiet and safe harbor. Thanks for the loving and the laughter.

For my parents,
David and Regina Rosenblum,
with great thanks
for the warmth, the music, Yiddishkayt,
and for the gentle brand
of Brooklynese socialism.

chapter 1
introduction

"Why do things look the way they do?" Ordinarily, sociologists do not ask this sort of question. In fact, analyses of material culture are usually done by anthropologists and archeologists who are concerned with such things as characteristics of tools, designs in baskets and functions of masks. Art historians, too, analyze material culture in the sense that they interpret, classify and define art objects. Neglect of material culture by sociologists seems a bit myopic, for we live in a dense world of objects and things, things which bombard our senses daily. From toothpaste tubes to cars to canned goods, at every moment we use and interact with objects which help with a task, obtain information for us or which we simply appreciate. If we want to know more about why things look the way they do, it seems reasonable to suggest that the discipline of sociology can be used to focus our attention on the social conditions that determine the production and distribution of things. Sociology can help us understand how social processes contribute to the distinctive characteristics of a given class of objects. In fact, one art historian, Meyer Schapiro (1962:302), practically invites sociological analysis of art styles:

> In many problems the importance of economic, political and ideological conditions for the creation of a group style (or world view that influences a style) is generally admitted. . . . Yet . . . the general principles applied in explanation and connection of types of art with types of social structure have not been investigated in any systematic way.

This study is an attempt to connect types of social structure with photographic styles. Specifically, it will explore the differences among three styles of photography—news, advertising and fine arts—and define the distinctive characteristics that enable observers to group together a variety of images under one category. I argue that work organization affects style. Certain distinctive social processes dominate in each setting where pictures are made and they affect what photographers can and cannot do, what kinds of images

1

they can and cannot make, what kinds of visual data they can include in the pictures or leave out. By comparing how photographers make pictures in each of three differently organized settings, the relationships between photographic styles and social structure settings can be seen.

In order to clarify the issues involved here, let us examine some approaches to the study of styles and then show how sociology can contribute to our understanding of material culture.

What Is Style?

Stylistic analysis is a relatively modern intellectual enterprise that is done by a small number of scholars in varied fields such as art history (Ackerman, 1962; Allsopp, 1956; Finch, 1974; Gombrich, 1960; Panofsky, 1965; Peckham, 1967; Rothschild, 1960; Schapiro, 1962), anthropology (Kroeber, 1957), linguistics and literature (Fowler, 1975; Hough, 1969; Lanham, 1975; Matejka and Titunik, 1976; Miles, 1967; Turner, 1973) and psychoanalysis (Schapiro, 1965). Yet, no matter what the specific concern, the enterprise always begins with the same task: the identification of common denominators and shared characteristics that are distributed among some group of objects, people or situations. Having accomplished step one, the second step is to see what accounts for the distribution of the identified characteristics.

For the many readers who are unfamiliar with these issues, let us begin this discussion with a useful quotation from Finch (1974:1):

> There are fundamentally two types of style: these are an individual's personal style and the style common to a group of artists. In other words, the distinctive traits in a work of art enable the observer to link art with other works by the same artist or with other works by different artists.

Finch points out the need for the analyst of styles to select a unit or level of analysis and, secondly, to be aware of the linkages among the various levels or units of analysis. Although one might wish, let us say, to analyze the stylistic changes in Picasso's work and thus do an intra-individual analysis, it would be an intellectual error to neglect the social and historical importance of Cubism (Golding, 1968). Bethers (1957:15) makes the same point succinctly: "Individual styles become part of general styles, all reflecting a particular period" (see Kroeber, 1957, for the anthropological version). A major issue facing the analyst of style concerns defining the boundaries of units of analysis (persons, groups, time periods) and the recognition that the act of drawing boundaries creates the possibility that the analysis might be an artifact of boundary definitions.

Once the unit of analysis has been established, understanding style depends on identifying "certain common denominators of visual choices and aesthetic emphasis" (Zucker, 1963:3). Traditionally, in order to identify common denominators, the analyst of style began with three categories—

form, subject matter and meaning—which were regarded as the basic components of style. Finch (1974:4) discusses these categories:

> Style is any factor pertaining to form, subject, or meaning which is sufficiently constant in a group of works to establish a relationship among the works. Subject matter and meaning sometimes contain traits that are distinctive enough to be reliable indicators of style. By themselves, however, subject matter and meaning are usually inadequate gauges. By far the most significant factors in identifying the artist of a work or in locating a work as to date and place involve *how* the subject is handled and *how* the meaning is conveyed. *Form* is the most reliable clue to the artist's or the group's identity. Form usually betrays identifying characteristics—style—no matter what the subject or meaning may be. Because of the connection between form and style, the assumption that the two are virtually synonymous is common.

There are problems, however, with these distinctions. Usually, they are imprecise and overlap a great deal. One meaningful critique was offered by Sontag (1961) who notes that an unintended consequence of getting caught up in making distinctions (and sometimes oppositions) between style and content prevents us from asking the really important questions and thus perpetuates a type of analysis whose fruits are dubious.

Modern analysts of style treat works of art as *totalities* and attempt to avoid making distinctions between form, content and subject matter. Hough (1969:4) comments on the issue: "The whole distinction between matter and manner has been decisively rejected. . . . The work of literary art is seen as an organic unity, in which manner and matter, thought and expression, are indissolubly one." Art historians such as Panofsky, Gombrich and Schapiro bring the *total* approach to art criticism and analysis by placing the art work in its sociohistorical context and focusing on the *total meaning* of the work. These scholars show the interrelationships between "morphology (the study of forms), iconography (the tracing down of symbols and narrative allusions), iconology (the analysis of meaning) and areas of period specializations (such as Medieval art, Renaissance art)" (Finch, 1974:46).

I, too, share the assumption that style is not reducible to form and content but is, in itself, *sui generis*. While an understanding of the components may be helpful for analysis—and, in fact, might be the first necessary step in any systematic analysis—it is necessary to apprehend the art object in its totality. Even though we might use such terms as "form" and "content," we must guard against fragmenting the art object (and the analysis of it) by reifying those terms.

Approaching style from a sociological viewpoint, we can attempt to redefine the enterprise in a way that permits fresh insight, with the additional benefit of helping to eliminate the problems generated by adhering to the distinctions between form and content. Before presenting this perspective, however, other points of view should be mentioned briefly. Sometimes, style is viewed in terms of individual genius. Here innovation is seen as the function of

one individual's power to influence the development of a medium. For others, the historical era is central to an analysis of style. The *Zeitgeist* of a period is treated as a major explanatory variable; it is assumed that the spirit of an age pervades all cultural products of a given time period. For others, technology is an important variable. For still others, ethnicity may be required to bear the explanatory burden. Rothschild illustrates the difficulties associated with the geographical origin theory of style:

> At one time, theories of style in art gave inordinate importance to the place of origin, reflecting the pattern whereby each town or province had its own kind of cheese, soup or special shape of bread loaf. Some museums still label old masters simply as "Dutch school," "English school," "Italian school," as though there were any such thing.

While each of these approaches, taken singly or in concert with one another, helps us understand some factors that affect style, another useful but little used approach is to study what people actually do while working in their medium.

A Social-Behavioral View of Style

A social-behavioral view of style begins with the assumption that style is the outcome of doing something. Morse Peckham notes that "style is the deposit or evidence of a particular kind of patterned behavior" (1967:19). Because seeing patterns in human behavior is the basis of all sociological inquiry, it stands to reason that sociology can contribute to the analysis of styles. In the first place, it enables us to study the ways in which human behavior is patterned; this is the window through which social structure becomes visible. The discipline of sociology is well suited to address and to answer such questions as: What do people actually do while making art objects? What procedures are employed for what purposes? How does the practitioner foresee the outcomes of various processes? What kinds of constraints affect behavior?

Looking at art styles in terms of behavior or "doing" was first suggested by the anthropologist Alfred Kroeber, whose focus on the execution of a work of art led him to evaluate it as the chief act in a series of creative acts. For him, style is the outcome of a commitment to one way of doing something. Similarly, the recent work of Howard S. Becker (1974) and Elizabeth Burns (1972) which relies on the concept of convention also emphasizes the *doing* of the art. Although neither of them specifically address the issue of style, it is clear that the concept of "convention," which is a shorthand term for patterned ways of doing things, has implications for the study of style. After noting that behavior is patterned, it is our task to discover the underlying general social processes that create the conventions which shape and condition human behavior. One area that clearly shapes behavior is the organization of work, which is a subset of larger socioeconomic concerns that are, in principle, of general importance to the analysis of styles.

Socioeconomic arrangements have long been regarded as one of the basic forms of organization that is constitutive of social practices and, by extension, cultural products. In art history, the analysis of socioeconomic arrangements and their impact on art styles is a common approach. Arnold Hauser's well-known work, *The Social History of Art*, is a classic example. In general, European Marxist social philosophers have examined the socioeconomic basis of art products and have attempted to link qualities of the product with social processes. Georg Lukács (1969), Theodore Adorno (1941), Walter Benjamin (1969), Ernst Fisher (1963), Lucien Goldmann (1964, 1967), Adolpho Sanchez Vasquez (1973) and others approach the art object in terms of the degree to which it can be seen to encapsulate and embody the social and economic circumstances of the period in which it was produced. Although there is a good deal of variation among their theories, there is an underlying unity based on their common perception of the importance of socioeconomic determinants of art.

In contrast, hardly any American sociologists have studied the social and economic foundations of art styles. Recently, a study was done by Peterson and Berger (1975) which advanced the explanation that the homogeneity of popular music styles is a function of market concentration. Their measures of homogeneity, however, did not take into account the actual features of musical styles, such as flatted thirds or perfect fourths, respectively features common to American blues and Eastern European folk songs. Rather, they look at such indirect indicators as the chart position of a recording or whether the performer was an established artist or a newcomer. Thus, while their argument may be correct, their data are insufficient and incomplete, making the plausibility of their assertions difficult to assess. This is a serious shortcoming which undermines a basically sound theory and correct emphasis on the role of the market. In short, there is really no satisfactory American sociological study of art styles which has, as an integral component, the analysis of features of works of art. Although such a task is not easy, it is clear that we must pay attention to the content and structure of art products if we are to understand how social and cultural processes shape material culture.

This study takes into account the lessons of previous work by attempting to avoid certain problems and perhaps raising new ones. To this end, I have incorporated an analysis of photographic styles based on direct, observable characteristics of the photographs and have explained their existence and patterning by applying general sociological principles and analysis.

Exploring the impact of the work setting can help explain why each photo-graphic style looks the way it does. It is possible to discover the ways in which patterns of work, particularly the constraints of work roles, shape and limit the types of aesthetic choices that can be made. The organization of work thus generates its own vocabulary of stylistic conventions. I selected one type of activity—making photographs—and studied it in three work settings. My major analytic categories as defined by the focus are the division of labor, decision-making, task allocation, technology, client-photographer relation-ships, occupational autonomy, alienation and the work role.

Institutional understandings or conventions also constitute a major form of influence, which must be taken into account in a social analysis of style. Therefore, institutional features of journalism, advertising and fine arts will also be included in the analysis.

Another factor which influences style is what people think, as well as what they do. Photographers think in and about pictures; they think about the meaning of pictures; they think about visual imagery and have many ideas about what photography and creativity mean to them. Therefore, it is not only the social and economic arrangements that shape style, but also how these are subjectively interpreted by the participants. Participants' ideas about photography are taken into account in this study because they comprise a perceptual screen through which visual imagery is interpreted, organized and created. This selective screening steers photographers to "see" some things and not others, to consider some things worthy of photographic attention and not others, to regard some types of photographers as creative and to evaluate some photographs as "great." As a result of my concern about the photographers perceptions, a section on socialization into news, advertising and fine arts photography is included in chapter 3. In that section, there is a discussion of how social factors help to build an internalized perceptual screen in the form of attitudes which are learned through the systems of induction into each particular enterprise. This is pursued further in a section on participants' conceptions of creativity to show how these ideas seem to arise in response to the constraints of the work role and can be seen as an integral part of the overall perceptual screen.

To sum up, in order to analyze photographic styles from a sociological standpoint, I have selected a three-pronged approach: one, the analysis of the organization of work; two, the impact of institutional features and shared understandings; three, the effect of participants' conceptions on what they do.

There are several important advantages to formulating style as a function of work organization. By focusing on work, art can be seen as a form of practical human activity, a form of doing something in the real world. Methodologically, this means that the work behavior of artists is accessible to empirical observation. Sociologists can observe musicians, painters, writers or sculptors. As this study demonstrates, access to such people is relatively unproblematic. On a theoretical level, looking at styles in terms of work organization represents an important shift in the analysis of artists and art products, for making art can no longer be conceived of as the externalization of the contents of an individual mind nor can the products be explained solely in characterological terms. Thus, in addition to whatever the personal motivations and individual genius of the artists of the Renaissance may have been (see Freud's discussion of Leonardo da Vinci's homosexuality, for instance), the burst of aesthetic exploration during the period might be attributed to the breakdown of the guild system and the development of the "school" system (Berenson, 1957). This simple example illustrates the importance of keeping in mind the practical factors of daily work life when trying to understand aspects of art.

Another advantage of seeing style as a product of work organization and

the work role is that it allows us to apply an established body of concepts and concerns drawn from the larger area, the sociology of work and occupations. By applying some time-tested concepts to new populations, particularly to artist populations who are surrounded by a good deal of mystique, we can approach the subject with fresh insight. Also, when applying "old" concepts to new populations, we can see how useful and general the concepts really are; that is, we test their utility each time anew. But perhaps the most important thing is that, when we apply old concepts to new populations, we not only bring the wisdom of the past but, in a sense, discover hidden meanings of the concept and uses that have not yet been revealed. For instance, "control over work" is a major concept in the sociology of work, and it is important because it is theoretically related to other concepts such as alienation and job satisfaction. It has been studied in a variety of settings, ranging from physicians (Freidson, 1970, 1971) to factory workers (Blauner, 1964).

If we think about how artists have control over work, it becomes immediately apparent that we are studying how artists make aesthetic decisions. One way to look at how artists do this is in terms of the degree of aesthetic choice and in terms of the range of aesthetic opportunities open to them. How aesthetic choices are structured by the organization of work, that is, the settings in which the activities are performed, is the core of this study. Therefore, the division of labor, level of technology, decision-making processes and the influence of clients or critics are vital to our understanding of how work settings set boundaries on the range of aesthetic choices.

Alienation, too, becomes a relevant concept and, when applied to artists, takes on specific meanings. From a Marxist point of view, alienation is the result of the fragmentation of the labor process. It occurs when the worker is deprived of working on a project from its inception to its completion. It is clear that alienation and control are companion concepts; in fact, they are defined in terms of one another. For artists, alienation can be seen in terms of the range of aesthetic opportunities and the capacity to freely select from among them. Following this, we can provisionally define an artist's alienation as the loss of control over aesthetic choices while making the art object. This definition of alienation treats it as a function of control over the production process.

Applying these notions to photographers, we would predict that newspaper photographers have the least amount of control over their work and are the most alienated and that fine arts photographers, who have the most control over their work, are the least alienated. While this assessment of their alienation is correct from a Marxist point of view, because it is based on their objective social relations, photographers' self-assessments of their own happiness and satisfaction were the complete reverse of the patterns of "objective" alienation. Newspaper photographers who might be expected to complain about their work and to report how mechanization deprived them of control over film processing did not. The greatest number of complaints, in fact, came from fine arts photographers who, on the whole, seemed the most unhappy of all three groups. This contradiction between subjective self-assessment and the Marxist definition of "objective" alienation is theoretically puzzling, but it led me to probe further and to discover that, for artists,

alienation cannot be defined solely in terms of loss of control over the production process, as we provisionally defined earlier. Rather, for artists, control over the distribution process is just as important.

It is true that most fine artists have complete control over the production process. However, the market structure cancels out the artist's control over the distribution of the art product. This affects the artist's subjective sense of control and feelings of satisfaction. On a theoretical level, it suggests that the concept of alienation needs modification so that it makes sense when applied to artist populations. We cannot look at alienation solely as arising from and relating to the processes of production, as a simplistic Marxist version would hold. For Marx, production was always seen as a servant of the market and his analysis of production was based on capitalist exchange relationships. Exchange relationships and distribution systems are tremendously important to the extent that they may set the boundaries on the artist's aesthetic choices, in the form of audience demand. This means that distribution affects how the artist chooses from among aesthetic alternatives and that the range of choice is not purely determined by the organization of production. All of this further suggests that we must explore the relationships between production and distribution to see the effects each has on the other and, furthermore, to see these effects in terms of the consequences for our conceptualization of alienation. I am suggesting that we look at the supply and demand curves simultaneously to understand the larger meaning of alienation.

Finally, another important area to consider is creativity. We need to explore creativity in *social* terms, not only psychological ones. For instance, we want to know answers to such questions as: What conditions facilitate creativity? Does maximizing control over work through increasing the range of aesthetic choices and opportunities always mean that artists will feel more creative? And, if they feel more creative, does this mean that their products will actually be more interesting and innovative? By whose standards? Who defines creativity and how? Will increased control over the distribution of art products lead artists to feel more creative and to regard themselves with greater self-esteem? How are autonomy and creativity related?

These are important questions to consider and questions which sociology can and should address. This area of inquiry is uncharted; it invites empirical investigation and theoretical musings. The study of the social foundations of creativity is a rich, untapped and vitally important area. The more we can learn about the conditions which generate creativity, the better we will understand its expression.

One final note: the analysis of styles here rests on the association or correlation between two types of data. On one hand, there are descriptions of three categories of photography. On the other hand, we have descriptions of the social worlds in which these pictures are made. I am making a connection between the two sets of data. It might be useful to call this type of analysis the "association of two configurations" (see Kaplan, 1964, for an explication of configurational analysis and a discussion of its utility). Furthermore, because this study is comparative, the association between styles of photography and

types of socioeconomic arrangements is strengthened and is more convincing than if a single case study had been done.

This analysis does not intend to assert that one specific thing in the work setting, let us say, technology, "causes" one particular aesthetic feature in the photograph. Such an analysis is naive because it is impossible to demonstrate a one-to-one correspondence between a social fact and an aesthetic outcome. Rather, I treat one particular style of photography as a totality and treat a socioeconomic system as a totality of patterns. In short, the analysis rests on the association between totalities.

I have outlined one way of looking at style to show that sociology can shed light on intellectual domains that are traditionally untouched by sociologists. Sociological insight applied to the analysis of styles in photography—and the arts in general—is an exciting enterprise that can substantially contribute to our understanding of the social construction of material culture, that is, why things look the way they do.

A Note on Methods

The bulk of the data was collected between 1971 and 1972 in New York City and between 1972 and 1973 in San Francisco. Prior to that time, pilot interviews were conducted in Chicago; additional field work was done in New York and San Francisco to update findings.

The type of research done is known as participant observation, which consists essentially of immersing oneself in the social world of the people one is studying. Ethnographic research of this type has been used by anthropologists and sociologists and is a common means of obtaining first-hand, richly detailed data about a particular social reality.

Because the work is comparative, it required three ethnographies: one on the world of news, one on the world of fine arts and one on the world of advertising. Little has been written about comparative ethnographic research; not many researchers do it, presumably because of the tremendous number of difficulties facing the researcher. There are really no guidelines to help formulate strategies. I began with the idea that I would study newspaper photographers for a year, then study advertising photographers the next year and finally spend the last year studying fine arts photographers. This seemed a useful research strategy because, by keeping each group separate and isolated (at least in my mind), my perceptions of one group would not be unduly influenced by perceptions created through interaction with another group of photographers. Of course, the fallacy is obvious: by attempting to control simultaneous influences, I insured that I would be influenced sequentially over time. The larger fallacy, however, was my assumption that being influenced by one group of photographers, while studying another group, was a bad thing. In fact, it turned out that the wish for "purity" was philosophically and empirically naive and, the pragmatic utility of studying several types of photographers simultaneously was of enormous benefit; my understanding grew exponentially.

I immersed myself in all three worlds of photography simultaneously for approximately four years, on and off. A sample of key persons was generated who were generous enough with their time and lives to allow me to observe them at work and during their leisure time. The sample consists of the following: sixteen newspaper photographers, seventeen advertising photographers, seventeen fine arts photographers, and eleven uncodable photographers. The category of uncodable photographers consists of people who work in specialties and who, for one reason or another, did not fit into my narrow classification scheme, but who shed light on my findings.

The sample sizes do not adequately reflect the nature of the research. In fact, the evaluation of ethnographic research in terms of sample size is an error and to do so violates the nature of the research. Each person was not seen only once but rather over an extended period in which relationships developed. I spent time in their studios, helping, watching and listening. I went to meetings of photographers forming cooperative photo galleries. I ran into them on the Broadway bus or along Riverside Drive or in the Cafe Trieste or at the Art Institute or at a fire on Canal Street. And every time we met, we talked about work, jobs, life and pictures.

It is my judgment that the samples of newspaper and advertising photographers are representative of the larger populations. I interviewed young photographers who were just breaking into each field, as well as experienced photographers, well-known and highly esteemed photographers as well as some who had been around for many years but had never attained fame.

I have some doubts, however, about the representativeness of the sample of fine arts photographers. The statistical reason for this is that the criteria for defining that population are much more uncertain than for the other categories of photographers. On the one hand, it was possible to include anyone who called himself a fine arts photographer. Yet, it was necessary to find some objective criteria other than self-definition. Therefore, included in this category are photographers who had shows in galleries and museums, those who currently derived a portion of their income from photography, either through sales of pictures or through teaching, and whom others regarded on a reputational basis as fine arts photographers. The sample of fine arts photographers includes internationally famous photographers as well as unknowns. Included are young people, older people, poor people, independently wealthy people and other combinations considered to be important in the systematic selection of a sample. Yet, it is impossible to assess whether this sample is representative. It is probably biased in the sense that I talked with photographers who, by comparison to other photographers I subsequently met after the data-collection phase of my research, seemed to be extremely articulate. Many of them were passionate about philosophical, photographic and artistic issues. Others were obsessed by intellectual concerns. A few were intense about psychoanalysis and their internal lives and saw photography as a means for externalizing internal visions. These photographers used the interviews as a vehicle for expressing many of their concerns and feelings, often in ways that touched me deeply. Other fine arts photographers seemed unable to

articulate even the simplest ideas, and I often grew impatient with their preciousness and "arty" presentation of self. If the sample is biased, it is in favor of those photographers who thought a lot and talked a lot about life, art, politics, reality and photography.

A great deal of time was spent talking with people who, while not photographers themselves, work intimately with photographers and are part of the photographer's world. In news, interviews included editors, reporters, darkroom personnel and typographers. In advertising, I spoke with models, art directors, copywriters, designers, stylists, secretaries, photographers' representatives and advertisers. In the world of fine arts, museum curators, gallery directors, art school teachers and art school students were interviewed. I visited photographers' cooperatives and photo stock houses. These additional interviews proved invaluable, for they provided details about work organization and role relationships that photographers often neglected and which I had been unaware of.

A variety of other types of data was used. These may be conceived of as the natural excrescences of daily work life: lists of news assignments, newspaper log books, advertising photographers' calendars and appointment books, gallery announcements for openings of shows. A great deal of secondary data was used as well but, even though I read books and articles about photography, reviews of shows, biographies about photographers and other assorted materials, these were of little use in terms of what I was trying to do. Although a good deal of factual information came from these sources, I am still not sure how those facts helped me put my own conceptual scheme together.

Finally, because I needed to ask photographers technical and aesthetic questions about why they shot something one way and not another way, I took photography courses at Pratt Institute and at the San Francisco Art Institute. By the end of the research, I was often taken for a photographer rather than a sociologist, which always surprised me because I never knew how either was "supposed" to look, and I always looked the same to myself.

chapter 2
photographic styles

Any study, sociological or otherwise, which attempts to explain style must begin with an analysis of the stylistic features of cultural products. It is thus necessary to create a provisional classification of some styles in photography and to analyze their characteristic features. This has not been done by historians of photography.[1]

Styles in Photography

The fact of styles in photography is empirically unproblematic. Most people, when asked to distinguish types of photographs from one another, can do so. In an experiment I conducted in one of my classes, I asked students to sort twenty photographs with respect to various categories. Agreement was 97 percent. Most people can recognize a "news" picture and distinguish it from "a picture in an ad" and, furthermore, distinguish each of these from "a picture that hangs in a museum." Although there is borrowing and exchange among these categories, which I shall discuss in the conclusion, I assume the distinctiveness and independence of these three styles of photography.

Each of these three styles may be analyzed with respect to its total appearance, the organization of the parts and the identification of the specific common denominators that enable observers to group them together. Even for one untrained in stylistic analysis, it is nonetheless possible to accomplish this task by using our powers of observation and thinking about what we see. This chapter is a formalistic analysis, that is, I look primarily at the subject matter and its rendition. An analysis of meanings, in the tradition of Gombrich or Panofsky, is beyond the scope of this inquiry and would lead to other questions. Descriptive terms from the areas of stylistic analysis, art criticism and art history will be used here.

News Photography

News photographs are generally recognizable by their specific range of content depicting newsworthy events such as baseball games, press conferences, urban violence and disasters. Subject matter consists typically of a

person or a group of people doing something in a specific situation at a specific moment in time. Because it is situation-specific and time-specific and because it is placed in a newspaper context, we read such pictures as data, visuals containing information.

The composition of a news picture is perhaps its special signature. Usually the center of interest *is* the center of the composition. Asymmetrical composition is rare in news photography. Probably because the informational content of a news photograph constitutes its primary impact, people and objects must be arranged so that the composition enhances the information. Flat, frontal positioning is therefore one of the key signatures of news pictures. Since people are so often the center of interest, news pictures are compositionally characterized by dominant verticals. Where the image has a horizontal line, it seems that the horizontals are strong, not soft. News pictures are characterized by realistic proportions and natural scale. The construction of space is linear and planar, that is, the lines are parallel to the picture plane, giving news pictures a quality that Read (1965:64) has called *place sensibility* and the absence of *space sensibility*. In other words, news pictures are flat.

The overall effect of news photography composition is an image on a flat surface where light is used to create line. Since lines do not exist in the real world—only edges do—line has to be created in a visual image. In news pictures, line is achieved through the juxtaposition of light and dark areas. Where this cannot be done, parts of the image become muddy and unreadable. Lights and darks, then, are used for line, not for the creation of volume or bulk or deep space. Intermediate tones are usually present but do not serve the function of shading, modeling or creating space.

Zucker points out that some types of light are used to create "mood" and atmosphere, whereas other types of light are used to emphasize the morphology and form of the object. In the case of news photography, light is used to create line.

News pictures typically lack atmospheric light, nuance, subtlety, shading and "mood." Focus is medium sharp, which means that it is not crisp and precise, but, on the other hand, it is not as fuzzy as the soft focus used to create other moods. Since it is neither crisp nor soft, the focus, when combined with other constituent elements of the photograph, creates what we have come to think of as a "news" mood.

Surface pattern consists of several properties found simultaneously in news pictures. Its first component is the visible dots which become an integral part of reproduced news images. These dots, of course, are not found on the original print itself, although there is some surface grain. Secondly, surface pattern includes the large blocks of lights and darks. The third aspect is the surface pattern of the object being photographed, such as the checkered pattern on a suit or the design on a shirt. Surface pattern is unvaried with respect to the first and third dimensions. Since the areas of lights and darks are generally used to establish definition through line, they are probably read as having little to do with surface pattern.

Another dimension is surface texture, that is, the representation of the

characteristic tactile sensations associated with objects. In news pictures, there is little sense of whether an object is coarse, smooth or silky. The net effect is that the surface life of a news picture is dull and unanimated; in a word, dead.

In sum, a news picture is actually a highly abstract visual image which contains very little *visual* information, which contradicts commonsense notions that evidentiary photographs contain a great amount of real visual information. In fact, news pictures consist mainly of areas of lights and darks. I suspect that viewers do not read news pictures as impoverished or insufficient sources of information but rather see the image as evidence and data. One reason for this is that a photograph often accompanies a story. A second reason is that the viewer reads the image as a categorical one, that is, a brief episode of other similar type images.

Advertising Photography

Advertising photography is characterized by an entirely different set of constituent elements than news pictures. With respect to subject matter, the product or model is the center of interest in the photograph. Advertising photography often depicts extraordinary people or objects in extraordinary situations presented in visually extraordinary ways. A typical example is a picture of a brand new, highly-polished automobile placed in the middle of a huge, grassy meadow where a model, dressed in a flowing crepe, floor-length evening dress, stands near the automobile, looking up towards the sky and smiling romantically at us. We find in advertising photography many non-ordinary situations, unconventional positions, gestures and visual effects.

While the product or the model is the center of interest in the photograph, it does not automatically mean that the center of interest occupies the center of the composition. The center of interest can be placed virtually anywhere on the two-dimensional picture plane, but it captures our attention through the use of lighting and compositional techniques. Sometimes the composition is asymmetrical. Visual interest and tension are created through the use of unopposed and unbalanced angles, which have the consequence of creating a sense of movement, excitement and instability. On the other hand, opposed angles, right angles, strong lines parallel to the picture plane and other similar devices can have a stabilizing and balancing effect, which means that the model or product can be located anywhere in the composition, but the viewer has a subjective sense that it is located somewhere around the center.

Advertising photography can depict flat or deep space. Usually, a special kind of space accompanies advertising pictures. The space does not recede much behind the objects or person being photographed; the space stops right behind the product. A flat, horizonless background can accomplish this, as in the case of a uniformly colored background or the case of buildings as a background for models. The distance between the camera and the object photographed is not too great, perhaps a few feet. The distance from object to

background is not great either, perhaps a few inches. The space within the picture, however, seems deep, interesting and complex, despite the fact that it does not recede. This construction of space is not characteristic of most photographic imagery, although it can be found in painting and, curiously enough, in non-objective painting. There are several devices which contribute to the illusion of advertising space. In the first place, the tremendous surface life and surface detail create form, volume and bulk *within* the object being photographed. Another device that contributes to the total spatial effect is called transparency, in which one plane can be seen through another. Advertisements with glassware, particularly liquor ads, often have this characteristic. Transparent planes create the illusion of space in two interesting ways. First, it flattens deep space and, therefore, the image does not recede very far back. On the other hand, it expands the middleground by making the viewer aware that the middle is not just one block of space but rather thousands of adjacent planes. Short foreground, complex middleground and a deadstop background is one of the key treatments of space found in advertising photography. Yet, while such a visual situation is, in and of itself, fairly unusual and unnatural, the unnatural handling of space does not stop there. Not only are we often confronted by close-ups, such as beer bottles dripping with moisture, which has the effect of presenting unnatural scale to the audience, but we are additionally bombarded by more subtle alterations of natural *perspective*. For instance, even *within* one shape the perspective can be incorrect and parts of it might be elongated while other parts are compressed. Elongation or compression are effective sources of tension in a composition and, as such, grasp the viewer's attention. A spatial contradiction, of course, is one of the strongest devices to reach out and catch the viewer.

The surface pattern of advertising photography is one of its prominent ingredients. Crisp focus and sharp detail create a dense, rich and busily detailed surface. Light is used in conjunction with focus to create a hyper-tactile effect. Things look real; in fact, almost too real. Light and shade and surface tactility are used to convey descriptions of products and to convey information about them, such as the viscosity of a cream. Light and shade are not used simply for the creation of line or form but also for sensual information. Lighting is unnatural in advertising photography in the sense that it is used to achieve surface detail and atmosphere. Often, there is backlighting for mood; evanescent surface illumination is another illusion that creates warmth around the image. Deep chiaroscuro may be used for dramatic effects and for the creation of an illusion of the structure of the object. Chiaroscuro can also contribute to the sculptural quality found in the representation of products. Shallow chiaroscuro can also imply contour and volume and evoke mood. In sum, advertising photography contains a great deal of purely visual information. The surface is rich, textured, patterned, colored, shadowed. One might say that the surface is overaccented in advertising photography. But such a surface keeps the viewer's interest up front, in the foreground or middleground, and therefore there is a functional and beautiful fit between surface life and the characteristic division of space.

Fine Arts Photography

Fine arts photography is perhaps the most elusive of all types to categorize. The range of imagery that comes under the heading "fine arts photography" is much greater than for news and advertising photography. The diversity of imagery, therefore, is one obstacle to doing a stylistic analysis because, after all, there is more than one style. In fact, the boundaries of fine arts photography are elastic, although the field is internally differentiated with respect to "school" or "tradition." In a sense, fine arts photography may be treated as a large residual category which subsumes a good many types of "unclassifiable" photographs. But fine arts photography is more than a residual category because, while the elements in fine arts pictures may include some or all those mentioned in news and advertising pictures, it does not admit any and all combinations. Rather, a selective process is at work.

Another factor to consider is that, while there is general agreement in classifying news and advertising photographs, fine arts photography is characterized by conventions that seem contingent. Therefore, the images usually carry some element of surprise or unpredictability. What does characterize a good deal of fine arts photography is the *self-conscious representation of space, meaning and light. In other words, the representation of space, meaning or light becomes the content of the image, no matter what the subject matter*. Three-dimensional space may be represented as flat or planar, deeply recessional, or it may project from the picture plane towards the viewer. Space may be realistic or surreal. The entire gamut is possible in fine arts photography.

With respect to the surface life of the photograph, the representation of two-dimensional space may also vary enormously. Forms may be crisply delineated, using contrasts and sharp focus to achieve definition and to convey morphological features. Or, at the other end, a painterly feeling can be achieved in photography through the control of focus. For instance, in David Watanabe's portrait of father and son, the outlines dissolve softly, so that the entire surface has a liquid character. There is little sense of volume that would convey heaviness or stability. Rather, the very soft focus evokes a strong feeling of motion during a seemingly quiet moment.

Light may be represented as realistic and natural, as indicated by the shadows and the quality of light on the surface. On the other hand, light can be unnatural in the sense that the particular kind of light depicted does not appear in nature. Light can be obtrusive, as if forcing the viewer to take it into account, or it can be subtle. Light can be used to describe forms analytically, in terms of drawing lines around forms, and it can be used sensationalistically to highlight and tone surfaces and forms. Emotional qualities are associated with light. Combined with a hard-edged line, light may convey an unmerciful look at life. Light combined with a soft line may glow and shimmer and dissolve, usually conveying a warm feeling which can be increased by a wide distribution of tones. Contrast has emotional qualities as well.

The self-conscious representation of meaning is a relatively modern

phenomenon. In the old days, a photograph was a picture of something; it represented something in the real world. If it was rendered with explicit accuracy, that was even better. During the last hundred years, the revolution in the visual arts has had the consequence of making meaning, along with the artists' intentions and motives, an important dimension of the image. With that in mind, we can mention several types of representations of meaning and isolate one that is peculiar to the medium of photography. In the first place, emotional and psychological states and relationships can be represented in photographs. The character of persons can be suggested through posture, gesture, positioning and shadow. In these ways, photography is not different from painting or drawing. Photography *is* different from every other medium in the sense that it has the "problem" of the meaning of verisimilitude. The property of the photographic process that is the basis for its meaning problematicity is its capacity to capture "reality" in sharp detail, often much sharper than the naked eye can see. This peculiar property makes photography both an instrument for establishing reality and for evidencing it, as photographers have long been aware (see Lyons, 1966). In the medium of photography, one can establish reality without relying on the camera's capacity for realism, in the same sense that a Magritte fable can tell the "truth" about reality without depicting the real. Thus, the single most important dimension of meaning in photography concerns the degree to which the visual image represents "reality" or, as Peckham (1967:95) puts it, its inconicity, for the general case, defined as the degree of resemblance. This, however, is more problematic in photography than in general. Sontag (1977) points out, that, in photography, the meanings of the "original" and "copy" are at issue and that our conventional distinctions between the two are made problematic by the technology of the photographic process. Without pursuing this in greater detail, we can see that meaning and reality are important ingredients in fine arts photography and are constructed by—yet independently interact with—light, form, and the division of both two- and three-dimensional space.

Discussion

We have identified several common denominators in news, advertising and fine arts photography. If we conceive of aesthetic conventions as a huge matrix of myriad possibilities, we can see that the range of possibilities for news, advertising and fine arts is quite different. The vocabulary for news is quite narrow, a little greater for advertising although in different directions, and largest for fine arts.

Now that we have identified common characteristics among the three groups of photographs, we can proceed to analyze social factors accounting for their distribution.

chapter 3
socialization

Learning how to take pictures means learning the properties and limitations of the medium, its instruments and materials. But the acquisition of basic technical skills does not make a person a photographer. Indeed, the widespread popularity of amateur photography indicates that the technical skills are easy to acquire. Unlike medicine, where the acquisition of specialized knowledge and skills implies professional status, the acquisition of technical skill does not imply professional status for photographers.

A person becomes a professional photographer when, in addition to sustaining himself with an income derived, whole or in part, from photography, he takes on the role of photographer. This requires the acquisition of a complex set of attitudes and behaviors, linguistic and gestural vocabularies and the internalization of a set of attitudes about photography. At the same time, the photographer "learns to see" (Castaneda, 1968). While acquiring a complex set of attitudes and behaviors, he also learns to selectively attend to those visual "things" that are relevant to his activities (Shibutani, 1961: 64–79). "Seeing," then, is socially constructed and acquired through the newcomer's interaction with significant people and is shaped by various structural factors, such as institutional and organizational definitions, constraints and practices.

When the neophyte enters one of the "worlds" of photography, he generally knows how to take pictures but he has not yet learned to "see." By examining the systems of induction—apprenticeship (news), assistantship (advertising), art school and the sponsorship system—we can see how visual perspectives and orientations are formed through socialization.

News

When a new photographer is hired by the photoeditor, he does not immediately "go out on the street." At one newspaper, the neophyte photographer spends six months to a year at the picture desk, assisting the photoeditors in the picture selection process. At another paper, the neophyte photographer

spends about six months, rotating between the picture desk, the darkroom and several other key places. At a third, darkroom experience is required before the neophyte can "go out on the street."

During the neophyte's apprenticeship period, he is socialized into the organization's normative structure. If he is assigned to the picture desk during his apprenticeship period, the neophyte learns what kind of news is featured in the newspaper. He learns about the picture selection process, space allocations, editing, cropping and scaling. As he learns about the picture selection process, he is, at the same time, internalizing the implicit criteria governing the picture selection process for that newspaper. If he works in the darkroom, he learns the technical and mechanical processes that constitute "newspaper reproduction." He learns what kinds of images reproduce best. No matter what his assignments may be, the apprentice photographer learns the rules of the organization at the same time he is learning about the world of news. He is socialized into a work rhythm, organized by edition deadlines. He learns how the photo department articulates in the total news organization. He internalizes the news and picture orientations of the editors. In short, during the apprenticeship period, the photographer builds allegiance and loyalty to that particular organization.

After his apprenticeship period ends,[1] the neophyte "goes out on the street" but he does not go out alone on his first few assignments. Instead, he goes with a more experienced staff photographer who "teaches" him the norms of the street. "Going out on the street" is the second and much shorter phase of socialization. In a sense, the neophyte photographer is rewarded for having internalized the organizational norms when he is defined as ready to go on the streets and learn working press culture.

First, the experienced photographer introduces the neophyte to staff photographers from other newspapers and news-gathering organizations. Waiting for a prescheduled event to begin, the neophyte observes who interacts with whom. He overhears gossip about people he might know or should know. He learns that photographers and reporters rarely share information about a story and that there is traditional antagonism between the two. He learns that a press conference will be postponed until all the network TV crews have arrived.[2] The neophyte learns that the presence of the TV crews means that he has to take into account the fact that lighting will be altered because of the lighting apparatus the TV crews bring with them. He overhears other still photographers mutter under their breath when they see TV crews arrive on the scene. Thus, the neophyte begins to sense conflicts between still photographers and TV news film or videotape crews, since the presence of one medium makes work difficult for the other.

The neophyte observes how other photographers work. He notes that most photographers shoot 35 mm. single lens reflex cameras but, once in a while, he will see a photographer working with a 2¼" square camera. He notes that no one uses the old forty-pound plate cameras and that about 90 percent of the photographers do not use artificial lighting, although they may bring electronic strobes with them.

Once on the street, the neophyte photographer learns aspects of the role of news photographer that he could not have acquired during the apprenticeship period at his own newspaper. The photographer's perspective shifts from a local orientation to a cosmopolitan orientation and his primary identification is with other news photographers, his own membership group. The photographer learns the culture of the "working press." No longer is his socialization confined to a specific news organization but rather to the larger culture of press photographers. Part of his initiation requires that the experienced staff photographer introduce the neophyte to certain people with whom the neophyte will engage in "favor" relationships. Specifically, these include policemen, firemen and Secret Service men:

> The President has Secret Service men, right? You get friendly with them and they're pretty nice fellas. The Secret Service men get to know you by sight. When the Secret Service men tell somebody "He's with us," that helps me a great deal. You'd be surprised. Or if the President is in New York . . . you call his press secretary and you find out the President is sleeping. But when you ask the Secret Service man in the hotel lobby, he tells you the President just went for a stroll along 67th Street.

The neophyte learns that, in exchange for confidential information from key informants, he is expected to keep silent. His judicious and discretionary use of this information is not enough; one of the key norms of working press culture is that photographers do not share their information with reporters. The photographer's interaction with reporters is minimal and, in fact, most photographers report antipathetic feelings towards reporters. This tension is inherent in the structure of work itself: a photographer must be present at the event in order to get the picture while the reporter can reconstruct a story after the event has taken place. Reporters can tap various sources for facts and, in fact, their presence at the event is not essential. Photographers, on the other hand, either "get the picture" or they don't. This norm of not sharing is clarified in the following lengthy excerpt from an interview. Although this respondent was the most vehement, he was also the most articulate and he clearly expresses what all the press photographers reported:

> A reporter is bad news. And the reporters here aren't the best in town. They don't have the sense not to use the information a cop might give them, just for a break, because they want the big story. So what happens? The story breaks, it prejudices the case, it's thrown out of court and the cop who gave the tip in the first place is hurting. That's what happened in the Alice Crimmins case. . . . There's no reason to talk to a reporter. My job is not to report, especially some information I might get from a cop. Some information is for my ears only. If I tell the reporter, then he's going to ask me about my sources and then somebody will get in trouble, right? . . . Very few reporters have integrity. There are very few reporters you can trust. They lie, steal, cheat and make up stories. I once got a call that there were two cops dead. Shot to death. They send me out to cover the story. I get there and nobody knows what it's about. Two teenagers got into a fight and they had to go to the hospital for minor injuries. I came back to the

office and I was asked for the pictures. I said there are no picutres because it never happened. Meanwhile, they're working on this big story of two murdered cops, holding the copy for pictures and names. . . . With a picture, it's either there or not there. No bullshit. No reporter making up a story.

The neophyte's introduction to the norms of working press culture is just the beginning—there are two other aspects of socialization which warrant additional attention. When the neophyte goes out on the street with a more experienced photographer, he learns two fundamental aspects of the role of "press photographer." I will call one the "choreography of the unobtrusive." The second thing the neophyte must learn is "anticipation of sequences."

The Choreography of the Unobtrusive

The 1940's stereotype of the press photographer, propagated in various media, has a strong basis in fact. Press photographers themselves make a sharp distinction between the "old breed" and the "new breed." The stereotype of the old breed suggests a slovenly, tough-talking photographer, a press pass tucked in his hat, a cigarette dangling out of his mouth, lugging around a forty-pound press camera.

With the kind of equipment he had available, the old breed photographer had only six or eight chances to "get the picture." As a result, he was more dependent upon his "favor relationships" to insure that he would get the picture than is a contemporary press photographer today. Often, the old breed photographer would intervene and disturb the natural flow of an event and ask the participants to smile, move around, or get closer together so that he could take the picture.

> I was assigned to cover the opening day at the New York World's Fair. One of the key human interest aspects of events like that is getting a picture of the first lost child when he and his mother are reunited. Every photographer had the same idea. It's to be expected. Anyhow, the first kid came in, all crying and upset and most of the photographers took a few pictures and now we were waiting for the mother to show up. That was going to be the big picture. The mother comes in and this one photographer, who is a good example of what you call the old breed, stands in front of all the photographers and shouts, 'Could you and your son hug each other?' And he started giving orders. He bullied his way in, destroyed the naturalness of the event, destroyed the feeling and got a lot of photographers angry. He staged the shot, plain and simple. You don't do things like that any more.

With modern equipment and lenses, fast film and a naturalistic tradition of photojournalism developed by magazines such as *Life* and *Look* over the last thirty years, the new breed of photographer approaches his work with a philosophy that is the antithesis of the old. A newspaper photographer today believes that he should not disturb the natural unfolding of an event. He believes that he should not disturb "reality" but that his task is to record it

photographically.[3] This ideology is verbally expressed by photographers and, furthermore, it can be observed in their motor movements.

Gestures and body movements are culturally patterned learned behaviors (Shibutani, 1961: 486–94; Mead, 1934: 42–51; Birdwhistell, 1970; Hall, 1969). Similarly, an examination of socialization into this occupational subculture reveals that there are patterned body movements the neophyte must learn to be a news photographer. Learning gestural and movement vocabulary, all of which function to minimize the intrusion of his presence, is a major part of "on the street" socialization. In other words, he learns the choreography of the unobtrusive.

No matter what the individual variations, newspaper photographers learn to walk very slowly, almost in slow motion. When they have to move fast, they walk very quietly. Their shoulders hunch over; they crouch as they walk. Arms are bent although held stiffly at their sides and do not swing freely. Their body movements, from one shooting position to another, seem to be the essence of silence. Once positioned, however, the photographer becomes obtrusive owing to the sounds of the camera, but this varies with the nature of the event. Aware of his intrusive role, a press photographer minimizes his presentation-of-self by dressing conservatively, by making sure there is nothing flamboyant about his appearance and by engaging in the choreography of the unobtrusive.

Working unobtrusively is so much a part of the newspaper photographer's consciousness and ideology that it came up unsolicited in *every* interview. Although a pervasive ideology, it does not guide a newspaper photographer's behavior in all situations. Experienced photographers know when it is necessary to intervene, and they know how to shape and control their intervention so that its disturbing effects on the natural flow of an event can be kept at a minimum. For instance, on one occasion, a person being photographed was extremely nervous in front of the camera, despite the fact that he had been photographed hundreds of times. The photographer, who was adept at working unobtrusively, intervened by beginning to talk. The photographer was as charming and as relaxed as anyone I have ever seen in action. Almost instantly, he put the subject at ease with his witty and charming stories of other famous people who got nervous in front of the camera.

Here is another example of how a newspaper photographer might intervene in the natural flow of an event. Assigned to cover a fashion show, one photographer wondered how he could get some interesting shots, instead of the "typical, routine, boring shots that appear in every paper." He knew that models are accustomed to being photographed and that models are generally wise to photographers' antics. The photographer borrowed a ladder and perched himself on it. In the middle of the fashion show, he shouted to the neophyte photographer who accompanied him on this assignment, "Boy, am I glad they were one man short today. This is much better than sweeping floors in the darkroom and mixing chemicals." Hearing that remark, the models registered great surprise and the photographer, well known for his rapid picture taking, got the out-of-the-ordinary shots he wanted.

Thus, while working unobtrusively is standard behavior, learning when it is safe and appropriate to intervene is also part of socialization. Most of the time, he does not interfere or disturb "reality" but rather witnesses and captures an event with his camera. If a situation calls for possible intervention, the photographer must use himself as the instrument of intervention in order to create the effects he wants. Sensitivity and subtlety help but also his knowledge of the typical unfolding of an event helps him foresee what kinds of photographs are probable. An integral part of learning the choreography of the unobtrusive is learning the kinds of routines that typically occur in news.

Anticipation of Sequences

The neophyte staff photographer learns that there are typical patterns and sequences of action for prescheduled news events. Thus, when he gets his assignment, he can think about which recurrent patterns he might want to photograph. As one photographer explained:

> Take a baseball game. It's the end of the ninth inning, there is one out, the photographer knows that there are two pictures in the bag. What is the guy at bat going to do? He's going to bunt. So he might go in for that shot. You change the lens and you go in for that one. At the same time, you know the runner on first is going to try to slide into second. You may decide to go for that shot. It's the same for other kinds of events, too. You learn to anticipate what comes next.

All photographers agreed that "the trick in news is to anticipate action" or, as one photographer phrased it, "You gotta know what's coming up." News photographers, then, anticipate general situations and typical sequences of social action inherent in those situations. The more a photographer knows about the prescheduled event he is assigned to—press releases, for instance, are useful in this respect because they outline the *dramatis personae* and the sequences of action—the more the photographer can consider possible photographic renditions of that event. In other words, the photographer anticipates sequences of social action and therefore can plan certain shots in advance. Knowing how he will cover an event, that is, what kinds of shots he wants to take, enables the photographer to put into practice the ideology of the unobtrusive, for he can plan his positioning and his choice of lenses in advance. Anticipating sequences of action is most applicable to prescheduled events. Spontaneous, unrehearsed spot news demands that the photographer react instantaneously and that he photograph the event. The challenge in that situation is to get a picture, nothing more and nothing less.

Summary

The neophyte's socialization begins with his induction into the organization, during which time he learns the ideological orientation and normative structure of the newspaper he is working for. After approximately a year, the

neophyte begins the second phase of socialization, when he is permitted to go out on the street with a more experienced photographer. On the street, the neophyte is socialized into "working press culture" and he learns how to anticipate sequences of events, as well as how to conduct himself unobtrusively. When his apprenticeship period is over, he is promoted to the American Newspaper Guild's category, "photographer, first year of experience" from his previous classification of "office boy." His salary increases from $154.06 to $233.57. He is now ready to do a photographer's job.

Advertising

The essential set of skills required for advertising photography may be acquired either in or out of school. Art school training may be helpful, but it is not necessary. All the photographers I spoke with agreed that the technical skills required to make photographs are easily acquired. In fact, twelve of the seventeen advertising photographers I interviewed acquired the photographic skills on their own, primarily from books.

The inference can be made, then, that formal training is not necessary for a career in advertising photography, although art and design schools do provide specific courses in advertising photography and photographic layouts for ads. In advertising photography, one learns by doing. But, in order to "learn by doing," the neophyte advertising photographer must enter the socializing system for advertising photographers, what I am calling the assistantship system. Like the apprenticeship system for newspaper photographers, the assistantship system for advertising photographers is the institutionally organized system through which the culture of advertising is transmitted to the neophyte.

Of the seventeen advertising photographers I interviewed, fourteen began as assistants to an established advertising photographer. Of the remaining three, two began as technicians in photo labs and the third, previously an art director for a fashion magazine, was encouraged by an established photographer to "become a photographer." Typically, the photographers in my sample began as assistants to established advertising photographers who had their own studios.

To obtain his first job as an assistant, the neophyte prepares a portfolio of his photographs to present to established advertising photographers. There is no rule-of-thumb to guide the neophyte in selection which photographs to include in his portfolio. In fact, the employer's reasons for hiring the neophyte may have nothing to do with his photographs (this was reported in four out of the seventeen cases). As one photographer observed:

> The first job is the hardest. You have nobody and nothing to recommend you. Only your portfolio. You have to show you can print well. That you have eyes. You've got to talk fast. Tell them that you are going to be courteous to clients. You have to make the guy like you. From then on, once you get the job, getting the second is easier. It adds up because you've worked before.

Once the neophyte has obtained his first job, often after a long search, he begins a long period of socialization into the culture of advertising and the aesthetics of advertising photography.

As an assistant, the neophyte is required to do a variety of tasks. Some are related to photography, such as printing, mixing chemicals, and setting up lighting banks, but many of his tasks are not related to photography at all, like sweeping and washing floors, cleaning up the darkroom and the studio, building sets, getting coffee, and so on. Many of his tasks are regarded by the established photographers as dirty work (Hughes, 1958: 49–52). The character of the assistant's dirty work tasks is determined by the number of assistants on the photographer's staff.

> I was the third assistant. But that meant I was really the floor assistant. A floor assistant lifts and pushes. That's basically his job. He loads cameras, takes light readings and shifts lights around. On location, he is the person who lugs around all the equipment and hails cabs with his third spare hand.

In addition, the personal eccentricities of his employer also determine the character of the assistant's dirty work tasks:

> Like T., no matter what time we knocked off, he always wanted me to wash the floor in the darkroom. Sometimes I'd work until really late . . . one, two at night and I could have come in in the morning and washed the floor, because he'd come in later in the morning than I did. But he wanted the floor washed every night, so that's what I did. Or this other guy I worked for, he had a thing about the way you have to hold a print. And you'd have to hold it his way or else he'd go crazy.

It is the hierarchical arrangement of statuses in the assistantship system that has led more than one photographer to compare this system to "going to school."

> It's very structured, in its own way. You take 101 first and then 201. Like in college. You are somebody's third assistant and then maybe his second assistant and then you go to someone else and you're his first assistant. Then you go out on your own.

The assistant is paid a salary between $85.00 to $125.00 a week. Although every assistant complains about the pay scale and "lousy working conditions,"[4] no assistant or photographer seemed to question the legitimacy of the system, that is, the legitimacy of the employer's right to expect his photographically skilled assistants to perform janitorial duties. As such, it is clear that the assistantship system is a taken-for-granted institution. Further, since every institution is also a system of social control (Berger and Luckman, 1966:55), it is also clear that the neophyte must learn "predefined patterns of conduct" appropriate to his status. Occasional stories of assistants who have gone beyond the bounds of their status, with the result that they were fired,

serve to remind restless and uppity assistants of what sanctions might be brought to bear if they are defined as deviant. In short, the assistantship system is not only a quota funnel for limiting the number and kinds of opportunities in advertising photography, it is also a mechanism that established photographers can use for weeding out deviants and for carefully choosing types of people who will be allowed to go on to successful careers. Thus, established photographers can hand-pick their successors and, by their manipulation of promotion mechanisms, can curtail opportunities for some assistants as well.

Above all, the assistantship system socializes the neophyte into the world of advertising photography. Through it, he gains technical competence he could not obtain elsewhere. Over time, he witnesses his boss handle a variety of technical problems that are entailed in each shot. He learns how to manipulate and control sophisticated lighting equipment in order to achieve a specific desired effect. He learns how to make a glass of beer look cool and foamy even though the temperature of the liquid is ninety degrees. He learns that translating each hand-drawn layout into a photograph generates its own specific set of problems. Furthermore, he learns that there are conventional technical solutions to these problems.

While the apprentice newspaper photographer must learn how to minimize his presence in the shooting situation, the assistant advertising photographer must learn the opposite. He learns that, in order to translate the art director's layout into a photograph, nothing must be left to chance. He learns that there is little room for accidental discovery in advertising photography, as there is for fine arts photography students.[5] Every aspect of creating a photograph must be under his direct or indirect control. In order to achieve the effect he wants, the assistant must learn how to stage a shot, how to set it up. He must know where to obtain the satin that the perfume will be placed on and how much it will cost. He must learn how to make creases in the material so that the creases add to the total effect of the shot, rather than distracting the eye. Setting up a shot requires thorough knowledge of the craft of photography. Thus, the neophyte must learn how to exert maximum control of the shooting situation and how to organize all the elements and resources so that he can obtain exactly what he wants. This applies not only to technical aspects of photography, but to people as well. The neophyte learns that he is not unlike a director who instructs and commands actors to behave in specific ways. When a shooting involves models, the assistant watches how his boss interacts with the models and observes how and what his boss says to the models in order to create a specific mood or expression. Finally, the assistant is a silent witness to the constant, ongoing interactions between his boss, his boss' representative, art directors and clients. In short, the assistant learns the business end of advertising photography.

From an attitudinal standpoint, the neophyte internalizes a problem-solving, technical orientation towards work. Assistants know they must learn technical skills and report that they keep their janitorial work complaints to themselves because, very simply, they want to learn.

The reason you do it is because you get a lot out of it. You learn. You learn why he used this technique and not another . . . it's an osmosis process. You don't even have to ask questions. It's a way of working that rubs off on you. Oh, I couldn't begin to tell you all the things I learned as an assistant. All the technical things, all the things about dealing with people. But I guess the most important thing I learned was how to run a studio . . . and don't ask me to explain that because it would take days. But I'll try to do it in a nutshell. If someone wants to do a shot with two polar bear rugs, I could have it ready in twenty minutes. I could shoot an elephant on top of the Pan Am building in half a day's notice. I learned how to go about getting permission to do things. I learned what is city property and who to contact and whom to charge and how to bill.

One photographer was especially insightful, for he recognized that while the assistant learns new things, his attitudes towards photography are being changed at the same time. Here's how he puts it:

Being an assistant is the way to learn. If your ambition is to do what your boss is doing, that's the way to learn. And you're learning the business end. Most guys who come into advertising have bad ideas about what it is. They see it as artistic and glamorous and then they have their heads turned around. See, your boss explains what the business is like. He teaches his assistant a lot of things, many technical things about photography, but he's also teaching him the business. What he's really doing, I think, is turning around the assistant's misconceptions about the business, these ideas about creativity and being an artist. A good boss is a person who gives his assistant the illusion that this was the way he did it. And that's the way it's always been. Noble suffering, as [my previous boss] would say. Some idea that doing all that junk work gives you creativity.

From the previous quotation, it is evident that during his assistantship, the neophyte learns many social and technical skills he will later use. But, more importantly, the neophyte's attitudes towards work and towards photography are reshaped. The major feature of the transformation of his attitudes is that he shifts from an individualistic to collectivistic orientation towards photography In other words, the neophyte comes to understand that advertising photography is a collective enterprise and that it consists of many types of complex social relations, all of which he must learn to manage. Another attitude that changes as a consequence of socialization is that the neophyte begins to understand that, although he must now please his employer in his role as assistant, he must please art directors and advertisers when he is an established photographer. As the neophyte increasingly sees himself in the role of "established advertising photographer," his reference group (Merton, 1949: Chapter 8; Shibutani, 1961: 139–213; Turner 1956) shifts from other photographers to art directors.

While there is no set time period for socialization, the neophyte usually spends between three to seven years as an assistant. At some point, he will decide to go into business for himself. Not every assistant will go on to a career as an advertising photographer with his own studio. Some assistants will

remain assistants for a variety of reasons. One reason is of particular interest: after working for several years, the assistant no longer aspires to become an advertising photographer because he does not want the responsibility of forming and maintaining his own studio business. But for those who choose to give it a try, going into business is the next step.

Going into Business

It takes time for a photographer to mobilize the human and material resources for going into business for himself. Because studios can be rented or can be shared with other photographers, a photographer can build accounts and contact potential clients without laying out the capital for his own large studio. When the photographer has enough accounts, he may set up a studio from scratch or may take over a studio that is available. If the new photographer can acquire the capital for the purchase of a complete studio, he can find himself in business overnight.

> I was working for X and he knew that one day I would open my own business. Something happened. . . . Oh yeah, Y's studio became available because Y decided to quit the business and go to Europe. Y couldn't take it any more. So X, my boss, decided to buy Y's studio and he offered me his own studio. X said to me, "This is the end . . . it's time for you to go off on your own. Buy my studio . . . it's the smartest thing you can do." I didn't know what to do. I had no clients, no money, no equipment. A lousy portfolio. But I knew I was a competent photographer. X made a deal with me. He said he'd sell me the studio for $4,000. I could pay it out on time, in one year. I borrowed $2,000 from friends immediately. I had a Nikon and a Hasselblad at the time but I needed more equipment. I was scared about the whole thing, about not raising the money and paying off bills. The rent here is $315 a month, which isn't bad. The decision took time and I had a long, serious conversation with myself. I asked myself, "So what if you fail . . . it's just money and $4,000 is a bargain." I figured I'd give it an honorable try. December 1969 was the worst time in the economy and it was the worst time to start a business in advertising photography. But I did it.

Material resources can be divided into capital goods and perishable goods. A photographer's capital goods include darkroom equipment, special lighting fixtures and cameras. Film, paper, chemicals and other items are perishable goods which must be replenished constantly. In addition to these photographic expenses, he has many other business expenses.

> He pays an assistant. His electricity bills are staggering, just to run the lights and the equipment. His phone bills are staggering. He buys darkroom stuff, chemicals, paper, film, insurance, lab bills. Fixing up and maintaining the studio. Now that's close to $1,000 a month, easy. And that's a very low budget. (photographer's agent)

Thus, "going into business" may be viewed as a period during which the photographer mobilizes material resources. It requires an initial capital outlay, the amount of which varies according to the size of the studio and the kind of equipment in it. The other aspect of going into business is finding clients.

When a photographer sets up his own studio, he often announces to his former boss' clients that he is on his own. He assures the clients that he "does not wish to take them away from his former boss but he'd appreciate it if they would throw a little business his way." In fact, the former boss often recommends the new photographer for jobs that he does not have time or does not wish to do. But if the new photographer relied on his former boss' spillover business to sustain him, he would starve quickly, so he must acquire his own clients.

A photographer's clients are advertising agencies. In order to get their business, he must approach art directors at advertising agencies and, through the presentation of his portfolio, convince the art director that he can fulfill job assignments. This, however, takes a great deal of time, for the photographer must make the rounds of agencies, talk with art directors and present his portfolio to each. He might be asked to leave his portfolio at an agency for some time, a situation which is clearly dysfunctional for the photographer. Although some photographers represent themselves, most find it necessary to hire a representative, because they cannot spare the time to find new clients.[6]

The photographer's representative (rep) is the photographer's agent and acts on his behalf. The rep is hired on a contractual basis and receives a commission that ranges from approximately 15 percent of the photographer's net income to as much as 25 percent of his gross income. Because the rep's commission is a fixed proportion of the photographer's fee, the rep tries to obtain work at the highest possible fee. Photographers who feel they cannot negotiate fees easily or who do not wish to be bothered by financial details appreciate their rep's financial acumen and emotional stamina.

At the same time the rep tries to generate business, the rep must also protect the photographer by not obtaining too many jobs, because the photographer might be overworked to the point of exhaustion. Economically, there is a point of diminishing returns.

It is precisely because the relationship between a photographer and the rep is much more than a business relationship that the photographer's selection of a rep is an extremely important decision, for the rep, in effect, is the business half of the team. The following two quotations illustrate the criteria photographers consider when looking for a rep.

> The advantage of repping yourself is that you know which art directors you can get along with. But since I can't be bothered repping myself, I have to make sure that my rep is my kind of person, because art directors generalize from the rep to the photographer, especially in the case of a new photographer. See, the personality of the rep says something about the personality of the photographer.

This following bit of conversation from an interview with a highly successful fashion photographer also contains explicit criteria.

Q: What do you want in a rep?

A: (Laughs) [That] they think I'm God. And that they have an appreciation of what I do and what I want to do. My rep has to build my ego. The rejection rate is enormous. I get one out of the twenty jobs my rep tries to get. Your rep must have faith in you, despite your being turned down. You must have rapport.

Although selecting a rep is a difficult decision for any photographer, the limited number of reps and their individual reputations help the photographer make choices. Some reps are known as slow and easy developers. Others are reputed to have a stable of art directors on hand and, when they work with a new photographer, they can assure him of an instant income because the photographer will be plugged into an existing social network. The relationship between the photographer and the rep is complex, displaying characteristics of both primary and secondary relationships. A prominent aspect of that relationship is the kind and degree of reciprocal trust and rapport that both parties share. This is especially interesting when one considers that personal trust and rapport need not exist in contractual or professional relationships. Nonetheless, personal attributes are a big factor in a photographer's decision to hire one rep over another.

To summarize, the neophyte advertising photographer begins socialization into the culture of advertising when he is hired as an assistant to an established advertising photographer. For the duration of his role as an assistant, he is required to perform "dirty work." He learns how to organize people and objects in order to achieve specific ends. He learns how to direct, control, manipulate and set up shots. The assistantship system is the socializing mechanism through which the knowledge, skills, values and norms of advertising culture are transmitted to the next generation of advertising photographers. After an unspecified period of time, the assistant goes into business for himself, usually when a fortuitous opportunity presents itself.

Fine Arts

Because there is no such job, strictly speaking, as fine arts photographer, this discussion cannot be organized like that for news and advertising; the occupational orientation and emphasis will be absent from the following discussion. Rather, because there are more and more photography majors in an increasing number of photography programs in art schools throughout the country, this discussion of socialization focuses on the academy, since it is the chief means of socializing fine arts photographers today. This has not always been the case; interviews with established, middle-aged photographers indicate that, prior to the photography explosion of the 1960's, fine arts photographers, as a rule, did not attend art school. Instead, they picked up cameras,

learned how to use them and discovered they enjoyed the craft. Moreover, they did not set out to become fine arts photographers, for there was no such thing. Their careers began with approbation from friends, as well as encouragement and the proverbial "push" from other photographers, who made certain contacts possible. But this was possible in 1938 when the Museum of Modern Art inaugurated its photography department, and the two decades that followed, for the embryonic world of "fine arts photography" consisted of a handful of practitioners.

With the increasing recognition of photography as a fine art, in addition to the growth of an American photographic tradition, art schools began to offer photography courses in the 1950's and early 1960's. At first, there were only a few courses and sometimes they were offered in conjunction with other departments, such as "Photography for Fashion Layouts." Full photography programs, while previously offered at only a few institutions, were offered in many schools around the country by 1973. Since this report purports to describe and analyze contemporary patterns, the academic socialization of fine arts photographers is what concerns us here. However, biographical and historical evidence suggests that art school training is not necessary or sufficient to create photographs which are defined by others as "fine art;" see the biographies of European and American pioneers in photography for this point (Gernsheim, 1955; Taft, 1938; Pollack, 1958; Newhall, 1961). Attending art school has other consequences, the paramount one being the placement of the student within a network that has strong links with the institutional apparatus for conferring recognition, namely the "art world" of galleries and museums. The school's second important function is that it confers credentials, now a mandatory requisite for teaching in publicly supported schools and a good thing to have for teaching in private art schools. Keeping these points in mind, then, let us examine the socialization of photography students in art schools.

Learning to See Photographically

Art school training steeps the student in the problems of the visual arts. These problems have been deliberated by numerous students of the subject, but one of the most succinct statements is found in Langer (1957:28):

> A picture is made by deploying pigments on a piece of canvas, but the picture is not a pigment-and-canvas structure. The picture that emerges from the process is a structure of space, and the space itself is an emergent whole of shapes, visible colored volumes. Neither the space nor the things in it were in the room before. . . . The apparently solid volumes in it do not meet our common-sense criteria for the existence of objects; they exist for vision alone. The whole picture is a piece of purely visual space. It is nothing but a vision. . . . But the virtual space of a painting is *created* (italics hers). The canvas existed before, the pigments existed before; they have only been moved about, arranged to compose a new physical object, that the painter calls "my big canvas" or "that little new

canvas." But the picture, the spatial illusion, is new in the sense that it never existed before, anywhere, nor did any of its parts. The illusion of space is created.

Although Langer uses painting as the specific example, we can readily see that the same general principle applies to photography. Where the painter uses brush strokes to create texture or tactility, the photographer can use focus, close-up lenses, and various kinds of paper surfaces. Where the painter can create spatial illusion through the interaction of color, the photographer uses the range of all the tonalities in the gray scale, from black to white. But despite the differences in materials and techniques, the overriding concern in the visual arts remains the same: how to fill a two-dimensional, rectangular or square surface so that meaningful spatial image is created.

The photography student learns how shapes, forms and tonalities work together to create an image, how the organization of elements within the boundaries of the frame interact to create space. In a general sense, this can be called "learning to see visually." "Learning to see photographically" is more specific than a general visual orientation. "Seeing photographically" requires the student to become sensitive to the play of light on real forms, to paraphrase Le Corbusier's definition of architecture. Learning to see light, then, is a major step towards learning to see photographically. Light becomes a fetish. "Photography is drawing with light." Photography students games (Mukerji, 1977) revolve around light; one hears one student say to another, "Did you see the light yesterday, around four o'clock?"

Learning how to print well is emphasized, not only to create an acceptable or good looking final photograph, but also because there is a reciprocal relationship between printing and seeing light:

> Let's say you take a picture of an apple. And it's got three grays. If you print lousy, you won't even see the three grays. You think the apple is just one color. But the better you print, the more you'll see. And then the next time you shoot an apple, you'll look at it differently and you'll see that it's not just three grays, but it's more.

On another occasion, the photographer quoted above suggested that the students look around the room to find the whitest white and the blackest black. In this class exercise, students became aware that dead black and absolute white occur rarely in "objective reality" and that everything that we saw could be translated into shades of gray. Then he added, "If there's hardly any black or white in this room, how come your prints have so many blacks and whites and about four shades of gray in between?"

Seeing light is only one part of seeing photographically. The subject matter itself—the people and objects being photographed—is the raw material of the photograph. Some subject matter, however, is defined as more meaningful than other subject matter, a view rooted in an aesthetic functionalism, a traditional ideological position which holds that the purpose of art is the

elevation of man's soul to lofty and sublime spiritual planes. Although these functionalist theories have changed over time since their first expression in the work of Aristotle, the notion of intrinsically appropriate subject matter for the fine arts is a widespread normative ideology that is perpetuated in art schools.

But subject matter is only the beginning. The "image" is not only what is photographed but *how* it is photographed, for "how" it is photographed injects meaning into the image. Thus, the photographer's point of view and his attitudes toward the persons and objects in the photographs warrant extensive discussion. The "class crit" (critique), an organized social ritual during which students hang their current work on the walls and, along with the teacher, comment on each other's work, helps students become consciously aware of their attitudes. There are a number of ways to approach this kind of awareness. One teacher, for instance, is psychoanalytic in his approach. He responds to photographs by telling the student how he thinks the student felt while taking the picture. He suggests that the student experienced love or hate or sexual attraction to the person or things being photographed. This approach, with its emphasis on the affective relationship between the photographer and whom/what he is photographing, makes the student aware of his feelings in the shooting situation itself.

Another way to talk about photographs is to evaluate their evocativeness and their potential to stimulate fantasy. When hearing how his instructor and other students respond to his photographs, the student begins to understand how his images affect other people. He might learn, for instance, that his personal symbolic vocabulary of images does not link up with a universal iconography or with universal archetypes.[7] Or, similarly, instead of eliciting the positive responses he anticipated, the photographs are defined by other students as uninteresting; the students cannot create a fantasy or "make up a story" about the photograph. Perhaps there is too little information in his photographs or perhaps there is too much.

A third way to talk about pictures is in terms of the formal properties of the image. This includes the shapes, the lines, the perspective and the space created by the interaction of these elements. Talking this way, one might typically hear the following statement:

> I don't like the shape of this line here it's a very strong line it tends to dominate and I don't think it goes with these other shapes here.

Even though each teacher in art school has his or her own unique way of talking about pictures and structures the class crit along lines of personal taste, the student always gets feedback about his pictures, his vision and, most important, himself. It is assumed that one's photographs are a controlled visual expression of how one sees the world. If there is a prevailing "vision" in the photographs, perhaps unknown to the photographer, that theme is made explicit during the crit. For instance, a student at the San Francisco Art Institute photographed a variety of subjects, but his photographs of women

aroused the class' anger and suspicion. He used a variety of techniques to make his female friends or models appear distorted. From his photographs, other students inferred that he, himself, had problems relating to women. At another school, a student who consistently made extremely dark photographs was told that he had some personal problems, since he portrayed the world as a dark, ominous place. I, too, received feedback on my pictures, at various times, that concerned my personal life. On one occasion, I was told that the photograph I hung for the class crit represented a real psychological break-through for me, in terms of seeing. I was told that the photograph "was a new and important way of seeing." One student said, "Up until now, you were afraid of showing tenderness or sadness in your pictures." From these examples, it is evident that the crit is a way to discuss students' photographs, specific emphasis given to the meaning of the image, what it elicits in others and what the photographer's emotional attitudes are towards his subject matter.

Another major aspect of art school socialization is the communication of conceptions and definitions regarding what constitutes fine arts photography. I have already implied that there is some fetishism of individuality in art schools, through the cultivation of the self and through the awareness of individual creativity. Also, Mukerji (1977) describes how film students glorify originality. With all this rampant individuality and originality, how does the student learn that most of his photographs are not "fine arts photo-graphs," even though they may be original and individual? How do students learn what a fine arts photograph is and what social mechanisms facilitate this learning?

One common device instructors employ is the use of slide presentations to communicate what fine arts photography is. The instructor may organize the slide presentation in a variety of ways, such as thematically, historically or by individual photographers. The principle of organization that guided one of my instructor's slide presentations was an especially interesting one, for he would first show a photograph and then a painting or sculpture. He then asked the class to think about what the two had in common. By comparing photographs to other media, he implicitly emphasized general aesthetic principles which apply to the visual arts. He never, for instance, compared a photograph he considered "art" with one he considered "not-art." The key to his approach was the "oneness" of photography and art. Slide presentations help students understand the same traditions of fine arts photography. But how do they know when their own photographs come close to those traditions?

The mechanism that facilitates the internalization of a vocabulary of conventions associated with fine arts photography is one which is found everywhere in collective life: the social control of deviance. In the classroom, teachers often point out the deficiencies of photographs and thereby show how the picture is *not* a fine arts photograph. Pointing out its shortcomings is apparently much easier for teachers than committing themselves to a position that one particular picture is, in fact, a fine arts photograph. The value-laden words used to point out flaws and problems in the photographs may sound

cutting and hurtful to outsiders but they are common terms found in art school and used as part of everyday conversation. For instance, a teacher might say to a student that his work is "slick," meaning that the technique of the photograph is more developed, better and more important than the content. Another term that carries great opprobrium is the term "derivative." "Contrived," "designy," "flat," "cerebral," and "lifeless" are other terms that are commonly used. It should be evident that the class crit resembles, for many students, a public shaming or degradation ceremony.

In sum, the class crit is an organized social ritual during which students learn how to see and learn new definitions of fine arts photography. One way to think about learning to see visually is in terms of behavioristic psychology: negative reinforcements extinguish shooting patterns and visual orientations. Positive rewards create new orientations towards photography. However, learning patterns are not reducible to simple rewards and punishments, as is indicated by some additional complexities in the data. Rather, learning to see photographically is part and parcel of the process of internalizing the role of the fine arts photographer.

Becoming a Fine Arts Photographer

The process of redefining one's self as a fine arts photographer, rather than the "photography student," is a process of locating the self in a particular social space that is, in some ways, a very specialized social world. The role of the fine arts photographer is more specialized than "photographer" and it is located in the world of art. Thus, redefinition of the self as a fine arts photographer necessarily incorporates redefinition of the self as an artist. Various structural and interpersonal processes facilitate (or sometimes inhibit) the redefinitional process. For one thing, studying photography in an art school means that students will encounter other students from other media and there will be a healthy cross-fertilization of interests and exchange of ideas. For another, just hanging around an art school and hearing people talk about creativity and imagination means entering a specific universe of discourse. Becoming a fine arts photographer means internalizing this specialized universe of discourse. Thus, association with an art school subculture is the beginning of redefining oneself. However, in order to understand the creation of the fine arts photographer identity, two other things have to happen. The first is that the student learns what I shall call the cultivation of the self and accidental discovery. And the second thing that happens is that the student internalizes an autonomous orientation.

Cultivation of the self is the pervasive ideology and attitudes towards the self I discovered in these observations. From the previous descriptions of the class critiques, one can see how important the self is regarded and how the self becomes a primary locus of analysis, for the photographs are seen as an extension of one's self. The quality of one's work, then, is dependent on who one is. Let me use a personal example to illustrate how the self is cultivated.

One day in January, 1972, I had a few extra hours on my hands. After typing field notes all day long and before a dinner date, I decided to shoot a roll of film. I gave myself a technical assignment I hadn't done before and one which I wasn't sure I could execute: to photograph clouds at sunset. I walked into a deserted park along the Hudson River and saw no one, except for an occasional person walking a dog. The deserted park, a cold, gray day and the dull winter sunset made me feel lonely and quietly sad. But I quickly repressed my feelings and tried to photograph this difficult lighting situation.

When I brought my photographs to class, I was proud and happy that I had, in fact, executed the assignment competently. However, when my teacher looked at the two prints I had made, as well as the contact sheet, he was visibly moved. He said, "Ha . . . you went out to do a technical thing and you came back with two great pictures. That mood really comes through." The teacher redefined the entire photographic enterprise by his feedback. He said nothing about technique, did not inquire about what settings I employed. He did, however, positively reward me for capturing "mood" and "atmosphere" and made me realize that the loneliness I had tried to repress nonetheless invaded my imagery. He helped me understand that, rather than running from my emotions and seeing my feelings as something that interferes with photography, my feelings were central to the development of my personal photographic syntax and vocabulary.

A major component of art school experience is the cultivation of the self and bringing aspects of the self into the public arena so that these aspects can be articulated more fully. Thus, the deeper meaning of the class critique is that irrelevant identities are successively discounted and that the fine arts identity is reinforced time and time again. Thus, the class critique is not simply a situation of rewards and punishments and automatic learning but rather one in which there is a destruction of some visual imagery *and the identities implied in that imagery.*

A second important social psychological consequence of art school socialization is that the student acquires an inner directed or autonomous orientation, an attitude which has important consequences for the post art school career. Put another way, the system helps students learn to trust themselves and their perceptions of their work and their self-worth. I mentioned earlier that teachers "punish" and "reward" students. Since the student will have many instructors in his art school career and, additionally, since there is little consensus as to what constitutes fine arts photography, there is the tremendous probability that one teacher might dislike that which another teacher rewarded. In a larger sense, this can be seen as an intrinsic dilemma in the socialization of *all* art students, independent of medium, for unlike the sciences, there are few consensually defined criteria nor are there specific empirical referents for the terms and concepts employed. Nonetheless, one latent consequence of this structural arrangement is that students learn that you can't please everybody. The student comes increasingly to rely on his own judgments and becomes his own critic. The student increasingly withdraws the legitimacy he has attributed to the evaluation by his teachers. The

net effect of art school training is the creation of an inner-directed autonomous photographer who can sustain self-esteem and continue to work despite the lack of positive feedback from others. This is a learned attitude that can sustain the fine arts photographer later on, during long periods when he is developing ideas but has not yet produced satisfactory photographs. Since this kind of autonomy can be "taught" and reinforced in a variety of social circumstances, such as within the family, art school is not the only place where a student learns how to account to himself, that is, to be his own critic. Although this logic smacks a bit of psychological reductionism, it does explain why older, accomplished fine arts photographers did not have to attend art school; they learned how to follow their own personal vision in the same way that art school helps students withstand assaults to their esteem later on in life by preparing them with an autonomous orientation.

This also helps to explain why some students go on to careers as fine arts photographers, that is, achieving social recognition in the art world of galleries and museums. The nature of the work itself requires the photographer to withstand disappointment and periods of discouragement. Of the many talented students who enter fine arts photography, few seem to survive periods of massive discouragement (two of the seventeen fine arts photographers I interviewed were hospitalized for suicide attempts during these periods of discouragement). Being able to work during these periods, as simplistic as it sounds, turns out to be a very important variable and may be one reason why many talented students who can potentially achieve social recognition do, in fact, drop out.

Social Recognition as an Artist

Of all the students who take photography courses in art school, only a handful are defined by their teachers as "special." Most students are not regarded as artists because they have not come into their own before graduating from school, that is, they failed to create their individual signature. Here's how one teacher puts it:

> A photographer tends to imitate the person he studied with or a person he admires. But I think the person you study with is the biggest influence. And that is the problem with every portfolio. You know, when you study with someone, you put that person on a pedestal and everything that person does is great. It's a real thing. And that's how you can tell a young photographer: too scared of his own individual vision and still copying the teacher. Every year I see hundreds of would-be Westons or Callahans. I can't stand fruit any more or people standing next to windows with light pouring on their hair. If I get more windows, I'm going to scream.

Teachers report that they try to help good, competent students find teaching positions. Established teaching photographers can help to launch a student's career by activating the network of which he is a part. There are

linkages between important university and college photography departments and institutional gatekeepers in the fine arts photography marketplace. Since the sponsorship system obtains in art school, students who are defined as special have the benefit of the "connections" their mentors can make for them. When an established photographer-teacher decides to support a student, he throws all his weight behind the student and makes special opportunities available to that student. For instance, the student might be referred for a prime teaching job. Or the student might be advised to apply for grants and special funding prior to actual graduation from either a BFA or MFA program. The teacher may introduce the student to museum curators, book publishers, gallery directors and even his own agent or representative. Sponsorship of a student is perhaps the major mechanism by which students are defined as "artist" at this stage in the career cycle.

As one might suspect, such an occurrence is rare. In the first place, the fine arts photography world is small and its capacity to absorb new recruits is very limited. Thus, a tremendously selective process of elimination is at work. One famous fine arts teaching photographer reported that while he generally helps students get jobs and tries to be supportive and so on, he actually threw his *full* weight behind a student only *once* in twenty years of teaching. The results were significant: the student was referred to an excellent teaching job, obtained funding for a project and, within several short years after graduation, obtained a two-man show at a prominent New York museum which ran concurrently with his one-man show at a prominent gallery.

For most students, the end of art school education means entering the commercial marketplace and, as Griff (1960: 255) has pointed out, they have the special set of problems of reconciling their "purist" art school ideology with the practical exigencies of financial survival. But the handful of students who elect careers in fine arts photography must choose, from a limited number of options, how they will support themselves while making photographs. Teaching photography is one option and doing odd jobs here and there is yet another option. In short, they have the same problems and occupational contingencies that face all artists, independent of medium. And, at the end of art school, they have come to see themselves as artists with a camera and, if they are one of the chosen, they have convinced others that, indeed, they are.

Summary

Nearly every social group, whether a large unit like "society" or whether a small unit like a "family," has need to insure its continuity. The process of preparing the young to assume the adult roles and responsibilities is socialization. By examining how photographers are socialized in each of these three settings, we have seen that the systems for transmitting culture—apprenticeship, assistantship, and sponsorship—are quite different and, then, for each of the worlds of photography, different dimensions of "being a photographer" are stressed. For news, learning how to be unobtrusive and how to anticipate

sequences of social actions are the keys to learning how to be a news photographer. In advertising, acquiring a problem-solving, technical orientation is the key, in addition to learning how to direct and to control. For fine arts, learning to follow inner signals is essential, as well as acquiring an inner-directed orientation.

By the time the neophyte has passed through one of these systems of socialization, he is on his way to becoming a type of photographer. As Bennett has pointed out, one does not become a musician in general but rather a type of musician. The recruit has incorporated various appropriate and relevant attitudes and has learned how to produce pictures that are acceptable within the rhetoric of conventions associated with his specialized field. At the end of the socialization period, the young photographer now assumes the role fully and enters the social role he has been preparing for. He is now ready to work.

chapter 4
newspaper photography

In this chapter I focus on those aspects of the organization of a newspaper that affect news photographers. In the first part of this chapter, a general picture of a newspaper and the photographer's role within the organization are sketched. What photographers actually do on the job is then described in a greater detail. This chapter continues with a discussion of the degree of control over certain aspects of the photographic process and finally concludes with a discussion of structural forces that shape definitions of creativity.

The Background

A newspaper is a product that miraculously emerges from a bureaucratically organized system which coordinates the activities of thousands of people every day. Although a newspaper contains all types of materials, including classified ads and advertising pages, its main product is news and whenever possible, the editors want a picture to accompany a story. Since the definition of news varies from paper to paper, it is important to know how news is constructed and evaluated so that the logic of the allocation of manpower assigned to cover stories is intelligible. To see how each newspaper's definition of what constitutes "news" determines what assignments staff photographers will carry out, let me furnish a lengthy example which illustrates not only the social construction of news (see Tuchman, 1973; and Molotch and Lester, 1973) but also illustrates the editorial and ideological differences among some New York newspapers.

On December 8, 1971, a story broke in the afternoon. A man in New Jersey had allegedly murdered his wife and children. The murder was brutal, and the bodies were not discovered for a month. The wire services' photographs came to the picture desk but, at this newspaper, there was a great deal of equivocation about the story.

4:00 P.M.: Photo-editor #7: The guy was middle class, a middle-class suburban dweller. He lived in a hundred year old house, had two cars, the whole bit. He lost his job, which

gave him twenty-five grand a year, about a year ago and he's been increasingly despondent over his salary cut to around nine grand a year. Do you know what this means for middle-class people, people like us, people who read our paper?

For the next hour and a half, although the picture desk handled photographs for other stories (Senator Muskie, the United Nations meetings on the Bangladesh crisis, the questionable suicide of an opera singer, several other stories), the murder remained the central topic of talk and interest. Editors, both news and photo-editors, did not know how to manage the story and the accompanying photographs.

4:30 P.M.: Photo-editor #7: We don't want to use the pictures of the house or the kids. We've got high school type pictures of the kids. No one likes pictures of dead kids. Maybe we'll run a picture of the guy. That's a public service. The guy's missing and it helps the police. But to show pictures of the guy's dead kids, that's old journalism. But I'll bet you Newspaper B will have a photographer out in New Jersey right now. But we don't want to do that.

4:45 P.M.: Photo-editor #7: I don't know what to do about the murder pictures.

5:05 P.M.: Photo-editor #7: Gee, that murder is still on my mind. What are we going to do about it?

Photo-editor #6: I'm thinking about it too. I don't know.

5:15 P.M.: Photo-editor #6: How do you feel about it? We've been thinking about it all afternoon and we don't know what to do. We've got pictures of the house, the kids, the guy.

Photo-editor #5: I don't want the kids in. Let's just consider using the house.

At this newspaper, a meeting takes place in the afternoon. At this meeting the managing editor, the top news editors and the chief picture editor review the items on the morning's news summary list to see how the events shaped up during the day. They also review the major spot news events of the day. Then they decide which news items will be incorporated into the paper and how much space will be allocated for each item on the feature pages.[1] Most important is that during this meeting, the top editors can reject any news story and/or decide what kind of treatment they want to give it. This includes rejecting the photo-editor's choices of the day.

5:55 P.M.: The "bullpen" meeting is over. The chief picture editor returns to the picture desk. He shouts to the other picture editors, "Two columns on the house." The editor turns to me and says, "You might

wonder why we've had a change of heart on the
story. The kids part is gruesome. The picture of
the man is ok because it's a public service. But the
house, well, I suppose it shows something about
the man." I say, "I think it shows the way he
lived." He says, "I think it shows that he's us. It's
a middle-class crime."

As is evidenced by this example, the firmest determinant of the appearance
of photographs in a newspaper is whether the news item appears. But, beyond
this, the selection of news is based on a general editorial attitude of what news
is appropriate for that newspaper, what news fits the image of the paper, and
what kind of treatment of news items the editors think the readers expect of
that paper.

In the newspaper cited in the above excerpt, the item was placed on page
one but was not given sensationalistic treatment. In another newspaper, the
murder story was given page-one headline treatment, with many accom-
panying photographs, taken by their own staff photographers, on their feature
picture pages. Understanding the differences between newspapers, with re-
gard to their definitions of the "news," is the first step in understanding the
picture assignment process and the picture selection process.

When the "news" has been determined for the day during the morning
meeting, the summary list is mimeographed and circulated throughout the
editorial department which includes all personnel at the picture desk. The
photo-assignment editor reviews the list and then allocates specific assign-
ments to specific photographers. This information is communicated to the
photographer when he begins his day, either by coming into the office or by
phoning in for his assignments.

When the photographer returns to the office with the exposed film, he
immediately passes the film to the darkroom staff for processing. The three
major New York newspapers have automated film processing equipment. It
furnishes a fully developed, dry strip of negatives within four to six minutes
from the time the film is placed into the machine. The machine develops,
rinses, fixes, washes and dries the roll of film. These same procedures, when
performed manually, take approximately an hour.

While automated film processing provides good quality negatives,[2] it does
not draw out the full potentialities of the film. Hand processing, in contrast, is
a discontinuous process and allows the photographer to make fine adjust-
ments, often to compensate for poor lighting and other problems. By varying
the temperatures of pet chemical formulae, by varying the number of minutes
allocated for each chemical process and by varying the vigor of manual
agitation, the photographer *qua* developer can produce a superior negative. In
automated film processing, however, only a few adjustments can be made.
Automated film processing, then, eliminates idiosyncratic, human variables
and, therefore, the negatives which result from this continuous flow process
are standardized. This standardized negative is "grainier" than a hand-
processed negative. This difference does not matter in news, because the grain

of the photograph will match the grain produced by the half-tone screen, which consists of 65 dotted lines to the inch.[3]

The dry strip of negatives is cut into strips of six frames each. Each strip is placed onto a sheet of photographic printing paper and the entire sheet is placed under the lens of an enlarger. Light is passed through the lens, the negatives are held aside, and the paper is chemically developed. When the paper has been developed, each film strip appears in the exact same size as in the actual strip of film. This process is called contacting and the sheet of paper is called a contact sheet. It is sometimes referred to as a proof sheet.

No matter what specific organizational variations there are at this stage, one essential feature is common to all newspapers: someone other than the photographer chooses which frames, from the contact sheets, will be enlarged and printed. Theoretically, photographers can participate, in varying degrees, in the initial editing from the contact sheets. One photo-editor said:

> After bringing in his film, the photographer is responsible for captioning it. We have a system that is unique, as far as I know, among newspapers in that we contact print almost everything. The photographer is encouraged to make his own tight first selection in the normal cases. We have contact sheets at the picture desk, also, so we can see if he's missed something, or if something's come up in a story or if we have a layout problem that requires a vertical cut rather than horizontal. So it's a question of both photographer and editor making choices, with the editor having the final say.

Although the three major newspapers differ with respect to their professed ideologies insofar as the photographer's degree of participation in the initial selection process, *not once* did I observe a photographer make initial selections nor talk with the photo-editor about the selections. In addition, only one of the sixteen newspaper photographers reported that he actually participated in the initial selection process, a fact which he attributed to his shift, the late night shift, when there is a skeleton staff. Typically, however, photo-editors make the initial selections. As one photo-editor states: "Most of the time, the lab sends us contact sheets and we make the selections."

Once the selections have been made, the marked contact sheet is returned to the lab staff and given to a printer, who makes 8" by 10" enlargements of the frames which have been selected. Like film processing, the printing process is automated, but to a lesser degree.

The darkrooms at all the major newspapers are equipped with a dry processing printer. When a print is made from a negative by ordinary methods, the negative is placed in an enlarger and, by allowing a given amount of light to pass through the enlarging lens, the negative is projected onto a photo-chemically sensitive paper. The paper then passes through a series of chemical baths which bring out the latent image and make it permanent. This process takes about ten or fifteen minutes. With partial automation, the printer still projects light through the enlarger containing the negative but, instead of running the paper through the series of chemical baths, the special paper is

placed into the dry processing machine which makes a print in twenty-five seconds to a minute.[4]

The printing process itself, whether automated or not, is not solely a technical process. Printing is an *interpretive* process which requires the printer to make decisions about the negative and to implement these decisions by his manual manipulation of several variables. For example, a printer can selectively block out the amount of light passing through the enlarging lens, by placing his hand or a piece of cardboard over an area which, he knows, will be too dark if the same amount of light, necessary for the other parts of the negative, passes through this area. This technique is called dodging, and it is one of several techniques which can be used while printing. Using these techniques, a printer can compensate for over- and under-exposed negatives, as well as other problems, by selectively treating different areas of the print with more or less light.

Thus, printing consists of a series of technical decisions, the consequences of each known to the printer, which results in the production of a deliberate image. But since photography is a medium in which technical decisions have aesthetic consequences, we must inquire further into the interpretive process. According to what criteria is the negative printed? How does the newspaper printer (or rarely, the newspaper photographer *qua* printer) interpret the negative?

He does not, as will be discussed in the chapter on fine arts photographers, interpret the negative from an artistic standpoint. He does not choose from among the many kinds of available photographic papers,[5] nor does he choose to lighten or darken specific areas to achieve compositional balance or dramatic effect.

He does not, as will be discussed in the section on advertising photographers, interpret the negative as to indicate that he anticipates extensive retouching on the selected areas of the print, particularly those areas where the fine details of a garment or product are essential.

The sole criterion for the interpretation of the negative is technical: the printer's objective is to interpret the negative for reproduction in a newspaper. Printing for newspaper reproduction means producing a print which, after passing through seven to nine stages in the photo-engraving department, and, after losing between 30 and 60 percent of the detail from the original print, is still "readable" in the newspaper.[6] Loss of detail means that the dark areas become black and muddy and take on an inky quality. For instance, if a political figure wears a medium-gray herringbone suit at a press conference, the suit may appear black, without detail in the pockets or buttons by the time the newspaper reaches the stands. Thus, because blacks and dark areas are problematic for news reproduction, prints which are lighter than one would ordinarily expect for other purposes, a snapshot, for instance, are required for news reproduction. Even before I knew about the technical processes of news reproduction and the need for light prints, I noticed that the prints were extremely light.[7]

Not only are the tonal range and the contrast range of these prints visibly different from prints made for other purposes but, additionally, the photographically educated eye can discern many white spots on the print itself. These white spots come from dust on the negative while it was enlarged; since light does not pass through a fleck of dust, a tiny dot is visible on the print. While even the tiniest dots on the print are anathema to fine arts photographers, museum and gallery people, advertising photographers, and advertising people, it does not matter for news reproduction because the white dots will become part of the dot pattern produced by the half-tone screen.

The print is now passed onto the photo-editor's desk (he is commonly called the picture editor). It is not exactly a desk, but rather a large social/physical area, consisting of several desks, drafting tables or layout tables with wall space to hang pictures. All incoming pictures from all sources are placed in the "incoming" baskets in this area. Staff photographers' pictures, pictures from the wire services' special photographic transmitting machines and unsolicited free-lance pictures come here. Foreign, national and metropolitan news pictures all come to the photo-editor's desk.

Approximately four hundred pictures a day come to the photo-editor's desk at one New York daily. Of these, only 85 are used. At another New York daily, approximately the same number of pictures come across the desk, but only about 60 pictures a day are used.[8] To understand how these photographs are selected, we must consider the picture selection process in detail. Because I want to communicate to the reader the ambience of the picture selection process, particularly the frantic rush before deadlines, I include extensive and detailed excerpts from my field notes.

At all newspapers, there is a great deal of activity, noise and interaction for about two hours before the major edition deadline. For the picture editors, this is the hardest part of the day. They are in constant interaction with news editors to ascertain which stories might run. Although the news summary list is now used as a practical check-off list, verbal communication now replaces the need to look at the summary list. Picture editors literally shout over to the city desk to find out about the news. Editors and reporters stream by the picture desk to find out which photographs have been selected to illustrate the stories.

The firmest determinant of whether a photograph will appear in the paper is whether or not the news story will run. If the story is dropped, the photograph is almost always dropped. Occasionally, however, a "floater" will appear, generally with a "rope." Translated, this means that a photograph which is outstanding, in terms of its impact, appeal, human interest, or visual quality, will appear with a long caption which tells the story. This is very rare, however.

The photo-editor's job, typically, is to collate news with the photographs he selects from among the many photographs submitted that illustrate the same event. One photo-editor described how he selects photographs:

> It's the stories that determine which pictures go in. If we have a story and
> pictures ready to go and a big news item breaks, we put the breaking story in and

take out the other one. The photographs are chosen on the basis of how well they illustrate the story.

All editors and all photographers I interviewed agreed that a "good news picture" tells the story.[9] Everyone agreed that "a good news picture tells you immediately what's happening, without the need for captions" (PE#7). Thus, it is the photo-editor's job to select good news pictures. For foreign and national news, he reviews wire service photographs and selects the best from among them. The "best news picture" is often not the "best photograph," in terms of composition, richness of tonality, and other criteria employed by critics of the medium, as illustrated in the following example:

> *3:10 P.M.:* The picture editor has 16 pictures on the India/ Pakistan war. He marks seven of them with a check mark, using a red grease pencil. I ask him why and he tells me he is picking his favorites so far. He tells me he will go over them later and refine his choices. One photograph is an aerial shot, showing tanks and soldiers and is very out of focus. It is really blurry and hardly readable. Yet this was one of the photographs he checked off. I asked why. He tells me, "We've got lots of pictures of the war in East Pak, but we don't have any of West Pak. This picture shows what's going on in Karachi. We've got enough of East Pak, but no one has run anything so far on West Pak."
>
> *3:35 P.M.:* He comes over to the board (on which all the first selection photographs have been tacked) and stares at them for a long time. An assistant picture editor comes over and the picture editor says slowly, "At least we've got the Karachi picture, at last."

Here we see that the shift in news emphasis demanded the picture editor's selection of a photograph which, by his own professed criteria of clarity, directness and readability, is regarded as less than the best. However, for the story, it was the "best news picture."

For metropolitan news, the picture editor's decisions are more difficult, for he must compare his own staff photographers' pictures with those submitted by the wire services and the many photographs of the same event submitted by free-lance photographers who hope to break into news photography. Since the best photograph is sometimes one which is not taken by a staff photographer, the photo-editor is in conflict about which to choose. While seven out of eight photo-editors reported that they select photographs impartially, photographers, on the other hand, unanimously reported that, in such a case, staff photographs are used. During my observations, I found that staff photographs were consistently selected over others, the only exception being a photograph of an event which was not covered by a staff photographer. In that case, they run a photograph supplied by the wire services.

The selection of photograph for page one, as well as the feature picture pages, does not mean that the photo-editor's job is finished. He next decides which non-essential elements in the photograph, such as the background or a crowd, can be eliminated through cropping.

After eliminating the inessentials, a photograph is scaled, a manual procedure which, by using specially calibrated triangles, transforms the length and width of the photograph into column units. Because scaling is not only a technical problem but is also an editorial evaluation of the relative importance of news items, the numerical terms in scaling language carry implicit value judgments. Not only do photo-editors become known for the kinds of pictures they select, but also for their stylistic preferences in presenting those pictures: PE #5 (talking about PE #6): "Do you know what we call him? We call him the mug *maven* (expert) or the king of the one columns."

After the spatial allocations have been determined through scaling, the photograph is sometimes retouched for reproduction by a retoucher who airbrushes paint directly onto the print surface. Then, the photograph is sent to the photoengraving department, where additional fine contrast adjustments can be made by differentially applying acid to different areas of the plates. The photographic plate is placed into a page and column format, with type already in place. From there, the plate passes through several mechanical steps until the page-plate is placed on the presses. The photograph now appears in the newspaper.

If the news does not change too much from the first major edition, subsequent editions might carry the same photographs. More likely, however, up-to-the-minute photographs replace the hours'-old photographs. For instance, a photograph depicting a weigh-in for a boxing match is old news for the late evening edition, especially when the winner has already been declared on the late evening television news. A photograph of the winner will replace the weigh-in photograph in the second edition of the paper. Thus, the life-cycle of a photograph is short. It may last only until the second edition. As one photo-editor told me, "A picture will probably make it to the third edition, if it's a really good picture."

The Job

The daily life of a newspaper photographer is characterized by a good deal of regularity. The time a photographer comes to work, as well as the type of experiences he will have, depends on the shift he requests. The day shift begins roughly between 9:00 and 10:00 a.m. and lasts until about 4:30 or 5:00. Since most prescheduled news events take place during business hours, most photographers work on the day shift. The night shift works from approximately 5:00 or 6:00 p.m. to anywhere from 12:00 (midnight) to 2:00 or 3:00 a.m., depending upon the events of the night. The "lobster shift," begins work around midnight and works until roughly 8:00 a.m. If a newsworthy event occurs in his residential area, the photographer will be called, day or night, to

photograph it. During crises or unusual events, photographers are required to work overtime and to work on their days off or, possibly, cover an entire event for its duration. Overtime is paid for this work, of course. Some examples include the New York City blackout, the Chicago Democratic convention in 1968, election coverage and the Woodstock Festival.

When a photographer chooses to work on a particular shift,[10] he makes decisions, at the same time, about the nature of his assignments, as well as the cast of people with whom he interacts. Photographers on the day shift generally are assigned to cover prescheduled events: a press conference, a fashion show, a baseball game. Photographers on the night shift photograph different subject matter:

> News photographer #3: I went to the theatre [to photograph] Jackie Onassis. . . . Then I went to a demonstration. And then to the Four Seasons. Another night, I went to the ballet, covered Agnew at the Waldorf and then I went to the morgue. Most of the time, I cover two or three things in a night, which is the same as the day guys. When there's a murdered cop, that's a full night's work. Sometimes the mayor will make a statement at four in the morning and that's a big thing. See, on the night shift, you are in touch with a different side of the world. News is made during the day but at night you need a good human interest story. You don't really need violence or action, just good human interest material. You pay attention to the birth of a baby, you see murder, fires, death. You see life from birth to death, especially late at night.

From the above, we can see how job content varies with which hours of the day the photographer works. Within their daily schedules, photographers can manipulate work rhythm by employing various strategies to shorten actual working time and, therefore, maximize free time in between assignments. Shortening transportation time to and from the event is one way photographers can manipulate daily work rhythms. Taking a taxi, the cost of which is charged to an expense account, instead of using public transportation, is one strategy.

The day begins when he comes into the office (or calls in) to get his assignments for the day. The photographer is assigned to cover two or three events in a seven and a half-hour day. Depending upon the events, that is, whether it is a three-hour press conference or a ten-minute shooting session with a new vice president of a bank whose picture will appear in the financial pages, the photographer's daily routine is, to a degree, determined by his assignments for the day.

Out of seven and a half-hour day, a newspaper photographer spends approximately a half-hour or forty-five minutes actually taking pictures. What, then, do the photographers do for the rest of their working time?

A newspaper photographer spends most of his time waiting. He waits for events to begin during which time he engages in friendly interaction with other photographers from other newspapers or news-gathering organizations. One might hear a photographer say to another, "I saw your shot of the ship the other day . . . it was a good picture." While he waits for the event to begin, he

also tries to ascertain, from other photographers, who is expected to be present at the event. For instance, on one occasion, I heard a photographer inquire, "Who's here today?" meaning "Which newsworthy notables are expected?" or "Have there been any rumors that a notable might make a surprise appearance?" Press releases might list the order of speakers or might mention a key person participating in the event. Therefore, a photographer need not remain present for the duration of an event, especially if he has already obtained satisfactory shots of key persons. Again, not all news situations lend themselves to this kind of manipulation. For instance, a basketball game or a potentially violent political demonstration requires the photographer's presence throughout the event, but routine events can be curtailed.

Depending upon the kind of event he must cover, especially if there is potential for violence, the photographer is required to evaluate how long he will stay. Photographers report that they are more likely to remain for the duration of an event, despite the fact that they have a sufficient number of pictures, because nowadays, they anticipate possible outcomes that they did not consider ten years ago. Assassination attempts, for instance, are now within the range of possible outcomes at certain kinds of events. Photographers who, in the past, would "get the picture and get out" now find themselves on "mental standby" for the duration of an event.

Newspaper photographers spend a good deal of their time getting caption information for each shot or series of shots. Obtaining caption information, commonly called "the left to rights," is the photographer's second most important task. He is required to identify all persons he has photographed and write their names and official titles on a sheet of paper, which he submits along with the exposed roll of film. Since reporters depend on photographers for correct caption information, especially if a reporter was not present at the event, caption information must be accurate. Thus, the photographer may write on a sheet of paper, "Roll 1, frames 1–7, Lindsay and Murphey, frames 7–10, Murphey and Jones, . . . Jones is head of the steering committee of X union."

When the event is over, the photographer returns to the office with the exposed rolls of film. If the film is required immediately, particularly towards the edition deadline time, a messenger might meet the photographer at the event and take the rolls of film back to the office.

In general, this is an accurate picture insofar as it applies to normal days and nights. The discussion has excluded "spot" news or spontaneous news. It is possible that, on the way to an assignment, a photographer passes a spontaneous event that, in his judgment, might warrant photographic coverage. This judgment, of course, requires his familiarity with the picture selection process. A bank robbery or a fire are classic examples of spot news. The photographer generally shoots as much film as quickly as possible, arranges for the film to be picked up by a messenger, and remains until the situation is resolved. Thus, a crisis, special assignments, or unanticipated events, are types of occasions that photographers are required to cover, in addition to prescheduled news and also shape the photographer's job.

Controls and Constraints

The constraints on news photographers are of two types. The first are structural constraints, which are characteristic of all news photographers, since they arise in the job situation itself and are part of the social structure of news organizations. These are technology and the division of labor. The second set of constraints are situational constraints. As a sociologist, I am interested in identifying and analyzing the patterned constraints that shape photographers' work and the following analysis will reflect this interest.

Technology

In news photography, the entire photographic process is dominated by automation and mechanization. One major feature of automation is that it demands standardized equipment. Photographers routinely use single lens reflex cameras. In fact, these are issued as "company equipment." Typically, photographers are issued two SLR camera bodies and three lenses: one 135 mm. telephoto lens, one "normal" lens (either a 35 mm. or 50 mm. lens) and one wide-angle lens (usually a 24 mm.). All photographers reported that the equipment issued to them is adequate for "normal" work, that is, suitable for most situations to which they are assigned. Some photographers have their own equipment and special lenses in addition to the standard equipment.

For most photographers, the quality of negatives is irrelevant. The printing press does not distinguish between a technically good picture and a technically poor one. Consequently, most photographers reason that a technically adequate negative is sufficient for newspaper reproduction and do, in fact, always pass the film on for automated processing. Younger photographers reported that they will hand process film if time permits, although it rarely does. During a conversation between two of these photographers and myself, the following comments were made about automated processing:

News photographer #6: There are certain processes which are irreversible and certain which are reversible. For example, once you've made the negative, you can print it in many ways. You can suggest dodging or burning in to the printer . . . or sometimes you can indicate the way you want it printed. But the irreversible processes are far more serious. Developing, for example. You see that machine there? I don't use it. It's unreliable.

News photographer #7: There isn't one photographer who's put an important roll of film in that machine.

News photographer #6: I'm not so sure about that. I've seen many people do that.

Me: What are some of the problems with that machine?

News photographer #6: It's very limited in its ability to cope with different exposures and lighting situations. I prefer to do my

own developing when I can. Or the machine some-
times chews up the film and that's irreversible. One
roll of film chewed up is enough to stop me from ever
using that machine again. I think [News photographer
#7] is right now . . . you put things in that machine you
don't care about.

A photographer can decline to use the automated equipment. He may insist
that hand development is required for his negatives and, if time permits, a
darkroom staff person will develop the film by hand, according to the
photographer's specific instructions. Or, if his own schedule permits, he can
develop his own film by hand himself. But, since the darkroom staff resents the
request for hand development, and since new darkroom designs and layouts,
plus new purchases or automatic equipment, all point to greater automation,
most photographers accede to the social pressure to use the equipment. I never
saw hand-processing of film, either by a photographer or by a darkroom staff
person, at any newspaper.

After the negatives have been developed and selections have been made
from the contact sheet, a print is made by one of the staff printers. As
described earlier, a print for newspaper reproduction is visibly different—in
terms of its characteristic range of tonalities—from a print that hangs in a
gallery. All the photographers I spoke with recognize this difference and,
furthermore, claim that their own printing of that same negative, if it were not
reproduced, would yield a high quality print.

News photographer #5: I don't think a newspaper picture can be too subtle in
terms of all that darkroom work that can go into a
print. Like my own pictures, I think, are subtle not
only in content but in technique. But if you work for a
newspaper, what does it matter if the technique is
subtle?

Me: I'm not sure I understand exactly what you mean.
Take this picture here (I point to a print that has just
been printed by a staff printer and is ready to be passed
onto the editor for cropping) . . . what would you do if
you printed this yourself?

News photographer #5: It would probably be that dark, but a bit more con-
trasty. But if you're printing for the paper, you have to
be careful of the darks, because they come out too
dark. When it gets down to the presses, you can't even
see the detail in it. So you have to try to print to a
certain extent flat.

Me: Flat means not contrasty?

News photographer #5: You don't see blacks or shadows.

Me: You keep it in the middle grays?

News photographer #5: Lighter. See, but the print you hand into the paper
doesn't stand up as a print by itself.

Although photographers claimed that they instruct the printers occasionally and make printing suggestions to the printing staff, I never observed this. When photographers were in the office, they talked among themselves, and prepared for their next assignment or rested from the previous one. It appeared to me that they had very little interest in the printing process itself.

Similarly, photographers had no interest in retouching decisions. Whereas photographers can theoretically exert partial control over printing but do not, photographers do not have this option at the retouching stage. These decisions are made by art directors or photo-editors and are executed by one of the retouchers.

In sum, I found that newspaper photographers can intervene and control various aspects of the technical process but, in general, do not exercise these options. With regard to technique and high-quality negatives and prints, the general attitude photographers expressed was "Why bother?" Photographers did not seem to care about how the photograph reproduces; as one photographer phrased it, "We aren't making salon photographs." Photographers *do* care about whether their pictures will be included in the next edition. In short, newspaper photographers are not concerned with *how* the photograph shows up but rather with the fact that it does appear in print.

The Division of Labor

In addition to technology, the division of labor at a newspaper is an important social determinant which ultimately affects what news photographs typically look like. When we examine the division of labor which precedes the photographer's receipt of an assignment, we are also interested in looking at how much photographers can express their assignment preferences to the photo-assignment editor. We also want to look at the extent to which photographers' wishes and preferences are taken into account when the assignments are made.

The responses to my question, "Do you have any gripes about the assignments you get?" show that my sample was evenly split. Further analysis showed that most of the unsatisfied group worked at one particular newspaper. One photographer expressed satisfaction with his assignments as follows:

> Where else can I get paid to enjoy myself, fool around, have a hobby, go places, meet people? They pay you to go to a ball game. I wouldn't change this job for anything in the world. Where else can I get paid for doing what I really enjoy doing?

The dissatisfied photographers complained vehemently about their assignments. They felt that their skills and interests were not taken into account when the assignments were made. The complaints voiced in the following excerpt, all from one interview, are typical of those that came up elsewhere. When I asked him about assignments, this photographer began a tirade against

his photo-assignment editor. He said that most of the photographers don't like him. I asked him to be more specific.

> He has absolutely no concept of photography. He uses manpower inefficiently. I do good magazine-type feature stories, so I asked him to assign me to them once in a while. I do this well, somebody else does sports well. Whatever, he says no. He doesn't know how to use his staff. He once made a faux pas that tells you a lot about him. He sent one of the photographers to cover some game at a stadium, baseball, I think. He tells the photographer to take along some long lenses so that the photographer will bring back some shots of the crowd. [Then we both burst into laughter.]

A reanalysis of the data indicated that, of the eight photographers who reported extreme dissatisfaction, six were employed by one newspaper. Further analysis indicated that there was a structural explanation that seemed to account for this.

At only one of the three major newspapers in New York City, do photographers specialize in subject matter: one photographer covers city hall, another photographer covers fashion shows and society balls, another two cover sports, and so on. At this paper, there were fewer complaints than at the other two newspapers, both of which have an assignment rotation policy. Specialization, then, is related to satisfaction on the job.

Systems for allocating assignments to photographers vary at each newspaper. The allocation of assignments based on specialization, which takes into account the photographer's preferences and his strengths and weaknesses, generates more satisfaction than one which, in effect, randomly matches the assignment with the photographer. In a rotational random assignment system, photographers are interchangeable; their skills are homogenized, their personal preferences are discounted and it is not surprising that such a system generates dissatisfaction.

Each step in the newspaper picture-making process, which was traditionally the photographer's sole province and area of expertise, is allocated to a variety of persons, each of whom is an "expert" in a small area of knowledge. Thus, in news, the picture-making process from beginning to end is a highly complex, coordinated series of activities and communications that spreads out decision making over a considerable number of people. The way the picture finally looks, then, is the result of a kind of assembly-line production in which individual persons make discrete decisions about pictures. These decisions are typically made by each person alone; they do not usually consult one another. Nor does it resemble the form of social organization where orders are passed from one person to the next.

We know that the division of labor, especially in an assembly-line organization, depends on bureaucratic organization and management, one major feature of which is reliance on rules and regulations. We also know that bureaucratic organizations generate their own classification systems, one consequence of which is that shorthand categories come to stand for ways of

doing things. On the organizational level alone, a bureaucratically organized newspaper's reliance on their own category system tends to homogenize photographic imagery simply through the mechanism of rejection of images which do not fit the existing category system. But each newspaper's system of categories is shaped by the journalistic categories. In fact, the organization of the division of labor within each newspaper is partly shaped by the institution of journalism.

Journalism is characterized by a national system of categories that is institutionally pervasive. Examples of such categories are disasters, elections, celebrities, heroic stories, horror stories, medical breakthroughs and so on. Thus, while the *dramatis personae* may change over time as public officials, baseball players and murderers come and go, the basic news scenarios remain the same. The institutionally pervasive system of journalistic classification may be seen as a highly elaborated code (Bernstein, 1971) that permits the differentiation of all human activity into subunits. On the intra-organizational level, there is a correspondence between functionally specific departments and roles and many of the journalistic categories. I do not mean to imply that there is total isomorphism between journalistic categories and the social division of labor, but there is a strong relationship which, of course, varies with the size and circulation of each newspaper.

Each newspaper, then, is dependent upon the institutional system of journalistic categories and must intermesh its own local and idiosyncratic categories with those that are institutionally prevalent. The combined effect of an institutionally pervasive codification of the world, in addition to the bureaucratic strain towards calculability and predictability, yields a picture of a news organization that relies heavily on shared agreements, especially shared agreements that concern the matching of real-life events with news categories (see Merton, 1957; Schutz, 1964; and Berger and Luckmann, 1966, for explications of classification systems as reality-maintaining frameworks and decision-making frameworks). Thus, the social organization of institutional journalism generates its own tendency towards standardization through the elimination of many uncodeable or insignificantly evaluated real-life events.

Situational Constraints

Situational constraints are those features of "normal" social situations which are taken into account by all participants, photographers included. While many types of events are social productions created for no other reason than for media coverage, most news events, in fact, are "real life" social occasions that occur whether the press covers them or not. Such events are regulated by situational norms that have come to be associated with that particular social occasion. For instance, spectator behavior at a baseball game is vastly different from spectator behavior in the courtroom. While norms of ballpark behavior permit the expression of hostility, enthusiasm, and taking sides,

courtroom norms demand silence and, minimally, the air of impartiality. The norms of the social situation itself dictate the appropriate behavior for photographers as participants in the occasion and thus partly determine what the photographer can and cannot do. There are situational norms that govern the behavior of special categories of participants.

For example, I went on an assignment with a photographer to cover the funeral of a famous person. It was a solemn occasion; the press was confined to the balcony of the church in which the funeral service was held. In addition, artificial lighting was prohibited. These two rules, plus the behavior required for the occasion, immediately reduced the kinds of photographic possibilities to a handful of shots. Frontal shots are impossible; all shots from the balcony are angled downward towards the altar. In a case such as this, a photographer has essentially two choices. The photographer may decide that the prominent persons eulogizing the deceased are newsworthy in and of themselves. Using a telephoto lens, the photographer gets a close-up shot of a speaker. Included within the frame is the speaker's face and torso, in sharp focus, against a blurry background.[11] Some photographers, roughly about one-third, choose this approach. However, because artificial lighting was not allowed, photographers were constrained to shoot from an angle that produced another problem: certain parts of speakers' faces were in deep shadow, giving the visual impression that the speaker might have a moustache or deeply set eyes or a dirty neck. This, of course, can be corrected by manipulating the exposure of film or, after a print is made, selective retouching of these areas.

The photographer I was on assignment with, as well as roughly two-thirds of approximately twenty-five photographers present, used a wide-angle lens. Included within the frame were the entire altar, the casket and the speaker at the podium. Everything was in sharp focus because the wide-angle lens, unlike the telephoto lens, is capable of furnishing great depth-of-field. This means that many planes are in sharp focus at the same time. The photographer I was observing later described some reasons behind his artistic decision.

> The light was so bad in there that I couldn't be sure that Rockefeller was in focus if I used a 135 or a 200. It was lousy light, so I opted for the big forms. I figured that Rocky and Lindsay would be the pallbearers so I could get a close-up in daylight, as they brought out the casket and placed it in the hearse. Well, I figured right . . . you saw I got Rocky . . . but Lindsay snuck out.

The photographer's familiarity with the routines of a funeral enabled him to anticipate possible sequences in the unfolding of this event and enabled him to plan shots accordingly. Figuring into his anticipation of possible sequences was his knowledge of the technical limitations of indoor shooting and his reliance on outdoor (natural) lighting for certain kinds of shots.

Situational norms and technical characteristics and problems inherent in the situation itself interact to determine, in large measure, what shots are possible. The photographer's artistic decisions consist of judgments made within these parameters. Of course, photographers can choose to "violate" the

normative expectations that govern and guide their behavior in specific situations, as for example the photographer who obtruded during the fashion show. But a fashion show is a less solemn occasion and not the culturally meaningful ritual that a funeral is. If a photographer flagrantly and consistently violated the norms of seriousness required for "funeral behavior" and other "serious occasions," it is likely that his inappropriate behavior would result in admonition by his superiors, if not by other photographers.

Conceptions of Creativity

The particular configuration of constraints I have just described may be seen as parameters within which conceptions of creativity develop. Here I focus on how photographers and editors view creativity by examining how they define "good photographers" and "good pictures."

When I asked, "What makes a 'good' news picture?" all photographers and editors agreed that a good news picture tells the story without words; "it tells you immediately what's happening," as one photographer put it. All agreed that this quintessential feature was used to differentiate between a "good" news picture from an ordinary one. In actual practice, judgments about what constitutes a good news picture vary with the social location and job needs of the person making the evaluation. For instance, editors, who have their own particular set of organizational demands to meet, define "good pictures" and "good photographers" in ways that make sense to them, that is, in terms of helping them accomplish their tasks. In contrast, photographers define creativity in ways that are meaningful to them. After reviewing each, we will see how there is conflict and tension between these two sets of definitions.

From an editor's point of view, a creative photographer is one who not only gets the picture but gets a picture that is visually interesting. "Getting the picture," however, is a phrase that has several meanings to both photographers and editors. It does not only mean being present at the event to photograph it. It also means having the good judgment to make sure one is present at a newsworthy event. The editors, then, expect photographers to know what the "news" is and to have internalized not only visual or photographic criteria but also journalistic good sense as well. Two photographers talk about this aspect of their work:

News photographer #1: If there was a fire on 42nd Street and a photographer who was coming back to the office didn't get the shots and if I was the boss, I'd say, "Check your camera" and fire the guy. We have to get the news and that's what it's about. But a fire on 42nd Street is different from a fire in the Bronx.

News photographer #6: If I'm out and I see U Thant shopping, I'd stop and take a picture immediately, no matter where else I'm supposed to be going to. He's big with management and they like to run pictures of him. . . . You've got two

stories on your hands and you must decide quickly which is more important. It's relevancy. You might say, "Fuck the baseball game." Oh, I can tell you a story. A few weeks ago, I was coming back with some film and there was some excitement at a bar on the Upper West Side. A few police cars. So I stopped . . . asked what happened.

Me: (Interjecting) Oh, was that the Rap Brown shoot-out?

News photographer #6: You bet it was! And the police said it was nothing important. And I think it was the weekend and we know that on Friday and Saturday nights there's more violence and homicide . . . they're bad for your personal safety. But it was Rap Brown. And I missed it. Yep, did I miss it. And did I catch it for that!

Thus, from an editor's standpoint, a photographer's "creativity" is seen and evaluated in terms of the total role of photo-journalist. The editor doesn't use the narrow conception of "photographer" as the basis for his evaluation of "creativity."

The second criterion editors use in assessing creativity among their stable of photographers is based on the extent to which a photographer will go to obtain interesting pictures. In other words, editors use the criteria of personal initiative and ambition. Often this has little to do with the "artistic" quality of the pictures that the photographer brings back. Simply knowing that the photographer made the effort is often sufficient evidence upon which editors base their judgments of "good photographer." The following statement was made by a photographer who is considered by both photographers and editors as the best and most creative on the staff at his newspaper. The quotation captures the attitude that editors regard as a necessary trait that "creative photographers" should have:

This is the biggest city in the world. There are at least one million pictures every day. We only get a few of those pictures. But you do get a chance to go out and create a picture. One Sunday, a few summers ago—and Sunday is the worst day, nothing happens—I was working and I was told to go out and see what I could find. I went over to the park. Thank goodness I was out of the office . . . and I began to notice that there are lots of baby carriages and no mothers. Only fathers. I begin shooting. Guys with a robe and slippers and the Sunday papers. Some guys dressed in their Sunday best. Other guys like slobs. It was right there. A story before my eyes. There are pictures everywhere.

The most interesting criterion for assessing "good pictures" and "creative photographers" was one which photo-editors did not articulate and of which they did not seem to be aware. Yet, in actual practice, during the photo-selection process, "flexibility" turned out to be one criterion that was used more frequently than any other. In order to understand this, we need to backtrack a little. Earlier I mentioned that the editorial staff gets together at the same time everyday, usually in the morning, to map out key stories for that

day. Much later in the day, when the reporters and photographers have come back and have submitted their work to their respective editors, there is another meeting during which the editors decide what will actually go into the paper. At this time, editors decide on the placement of stories and space or column allocations. This is especially crucial for key stories and their accompanying photographs. The time difference from morning to evening is an organizational feature that effects how editors make selections, especially in the case of "developing news." Not all stories are occasions which have clear beginnings and endings, like baseball games. Some events begin but their development is gradual and takes time, since the participants create the event. Thus, the ending is unknown to participants and to observers. Labor negotiations, hijacks, shoot-outs where hostages are involved, campus demonstrations, huge explosions and fires are all examples of developing news. Because no one knows exactly how the story will finally turn out, editors need at their immediate disposal a vast array of stories. The ambiguity and uncertainty in developing news requires flexibility to illustrate different aspects of the same story, depending on how the story evolves.

Photographers have developed routine ways of coping with these editorial demands. The main strategy photographers use is to "cover themselves" by providing the editor with a wide range of photographs that, in effect, can tell many stories. Thus, as the copy changes or as marginal facts or marginal people become increasingly relevant, the photo-editor knows he can illustrate any new development and select the appropriate visual images because the photographer has anticipated the editor's needs for flexibility.

Interestingly, editors do not seem to be aware of how social structural factors, such as time lags and deadlines, create the conditions that require photographers to overshoot and to shoot in particularly regularized ways, so that they, the editors, can depend on the photographers for the images they need. Surprisingly, some editors complain when photographers come back from the assignment with too many pictures, without realizing that the photographer actually responded to the organizational demand for a variety of pictures and, by that criterion, did his job well. In the following quotation, the editor virtually accuses photographers of the tendency to "overshoot" while not realizing that the photographer is giving him exactly what he wants and needs.

> Photographers tend to overshoot. They cover the same picture from fifteen angles. In the old days, they had a few chances to make the picture. They took their time. They composed better. They sniffed their way around the situation first, before they shot the picture. We get a lot of angles today and a lot of wasted film.

In fact, the news business itself structurally induces "overshooting." We can now see "overshooting" and "providing the standard picture" as forms of strategic adaptations photographers utilize to cope with editorial demands.

There is one more important feature of the relationship between the editor and photographer that requires some elaboration because it determines, in

part, how newspaper photographers shoot pictures and, therefore, contributes to our understanding of why newspaper pictures look the way they do. Photographers tend to produce "standard" pictures because they believe that editors think in ideal types. The system of classification of news events is an especially important aspect of a news-gathering organization, and the major purpose of a news photograph is to *illustrate* aspects of the content of a story. But, because of the classification system, every story is treated as a concrete instance of a larger abstract category. The abstract category is an ideal type of all similar stories, and its properties are typified as well. Because the abstract category remains the same, even though the content of the real-life stories vary somewhat, photographs that illustrate properties of the ideal type are repeatedly selected for illustration. This is an organizational and institutional dynamic that contributes towards the homogeneity of imagery we find in newspapers. The institutional classification system generates what Cawelti (1970) has called "formula" asthetic, that is, "a highly conventionalized system for structuring cultural products." The analysis of the photo-selection process invites us to ask the key question, the answer to which helps us understand newspaper photographers' work and patterns of shooting: just because editors consistently pick certain kinds of "standard" pictures, does it mean that photographers actually shoot these kinds of pictures? Or, on the other hand, does homogenization occur at the photo-editor's desk and photographers shoot with great freedom of variation?

The answer to this question is "both." Editors do, in fact, select pictures along lines of personal preference and, in this sense, they homogenize the look of the newspaper's picture pages. But not all the homogeneity can be attributed to the editors. Photographers also shoot "standard" pictures. One major reason for this is photographers' expectations regarding their editors' photo-selection. In the statement below, the photographer is aware of his editor's biases and preferences:

> You have two choices. First, you can take the standard picture and forget about it. Or on the other hand, you can work very hard for the great picture. You crawl under manholes and over buildings and you get a great shot. I'd say we've got a great deal of freedom in assessing what the news is and how to shoot the picture. But if they are not inclined to run my great shot, then I say, 'Why bother?' I'll get the standard picture and forget about it.

Another factor which influences how photographers shoot pictures is their conceptions of what other photographs the editor sees while he, the photographer, is out on assignment. One photographer put it this way:

> By the time I get back, the AP [Associated Press] pictures are over the wire and the picture editors have already been conditioned to a certain kind of picture. Or even if a picture didn't come across the wires, they still have been conditioned to a certain kind of picture. It's trite, cliche, stale, but it illustrates the story.

Yet, this same photographer went on to say that he, himself, provides his editor with the kinds of pictures the editor wants, which generally partake of institutional conventions. For instance, when there is a newcomer to the public eye, photographers will shoot clear, sharp, frontal portraits of the person to the extent that it is possible. On the other hand, if the person is generally in the public eye, photographers can be more inventive and playful in their renditions of the person and provide the editor with unusual shots of the celebrity. Thus, even the types of subject matter in which the photographer can experiment with focus and form are, in some senses, predetermined by institutional and editorial conventions.

Even if a photographer wanted to depart from conventionalized ways of shooting the "standard" picture, the presence of the other photographers is a factor with which he must contend. In the working situation, the presence of his peers seems to keep photographers in line. I cannot remember when I was more aware of group conformity—almost as if I were observing the proverbial herd—than when I observed news photographers at work. After one photographer provides the downbeat, the others begin to click in concert for the next measure. Latecomers join the rising crescendo of clicks until the cadence is reached. They rest for a few bars until the next photographer begins.

If the photographer chooses to depart from the pattern and shoots his assignments in personal ways rather than standardized ways, he might not be directly sanctioned for his "deviance" but he will discover that his photograph has been made to conform to the standard version by editorial cropping.

> [We are looking at the photograph.] Now, here's a picture of a rehearsal at the New York State Theatre. There's just two dancers. There's just a lonely stage. Empty. There's no set or anything. Two little figures in the center of the stage and there's all this space around them. If I could, I'd increase the space around them. Anyhow, by the time it got in print, it was a photograph of the two dancers, head to foot, nothing else. That wasn't the picture I shot.

Note that this is not defined as "creativity" by the editors, but rather as a problematic picture.

Newspaper photographers do not see themselves as artists with a camera, and they do not seem to treat themselves or each other with the "precociousness" or "temperament" stereotypically associated with "artists." They regard themselves as hard-nosed photo-reporters, and they know how hard it is to simply be there to "get the picture." Among one another, they reward each other for having successfully gotten a "good" picture. Since they do not look at one another's contact or proof sheets, they think about another's pictures in terms of the single image. In contrast, as we saw earlier, the editor thinks in terms of sequences of images. Photographers reported that creativity, for them, is the freedom to create a story and the freedom to determine how it looks in print. In short, they want to determine their own assignments. The "creative" photographer is seen by his peers as one who sees something special and extraordinary within the repertoire of the standard imagery, who injects something

special into the photograph so that it transcends the boundaries of being "just another typical news picture." For photographers, a good news picture and a creative photographer do something special within the limitations of the role. They do not regard "something special" as the result of initiative or ambition, as the editor does, but rather as something unique, something that not all photographers, no matter how hard they tried, would eventually achieve. In short, photographers evaluate one another's work on the bases of photographic criteria, whereas editors often use extra-photographic criteria from which they draw inferences and then make the attribution that the photographer is, in fact, creative.

Photographers' conceptions of creativity have their social bases in the specific areas of occupational discretion, artistic control and autonomy that are by-products of the social division of labor. Since social arrangements shape participants' ideas about what they do, conceptions of creativity can be expected to vary with the contexts in which photographers work.

chapter 5
advertising photography

There is more specialization and diversity among advertising photographers than newspaper photographers. It is difficult, therefore, to describe a "typical" work setting for the "typical" advertising photographer. Despite this variability, one basic social configuration is shared by all advertising photographers: the relationship with the advertising agency and the client. In this chapter, the character of that relationship and its impact on the photographers and their work is described and analyzed. A discussion of definitions of creativity ends this chapter. However, before these relations are analyzed, it is necessary to describe the larger social background of advertising. To do this, I will trace the history of a print ad so that social relations can be seen in their natural setting.

The Background

When a client comes to an advertising agency, a sequence of activities begins which includes a number of people, from within and from without the agency, who interact from the inception of the ad to its completion.[1] If the proposed advertisement requires a photograph, a photographer is one of these people.

The sequence begins when the client meets with one of the agency's account executives. The client presents his problem to the account executive and provides an estimated advertising budget:

> Account executive #3: The account executive's job is to find out what the client's problem is. He looks over the client's sales figures. He investigates the product.
> Me: What would an example of a problem be?
> Account executive #3: Oh, there are different kinds of problems. FTC regulations may have clamped down on that product. Let's say there was an untruth, something false or detrimental to the client in a previous campaign. This happens all the time with drugs and cars. Then the job is

to reestablish the image. AT & T has this problem continuously. Everybody hates Ma Bell. IT & T has the same problem. It's image advertising, not the product.

Once the account executive has determined the general problem, he calls a strategy meeting. Members of the three major departments, media, creative and accounting, are informed of the client's problem and they begin to work together to solve it. By reviewing the client's previous campaigns, the group attempts to discover if there are any additional, latent problems, of which the client is unaware. They discuss potential problem areas and propose various hypothetical advertising solutions. However, actual planning for a specific campaign does not begin here. First, a determination of the most suitable medium (or media) for the client's product must be made.

The media department knows the buying public. They have encyclopaedic knowledge of the buying public, ranging from literary magazine audiences to daytime television viewers, and they determine which audiences are more likely to respond to the client's product. They also know which media these audiences respond to and how much it costs to advertise there. As an account executive said:

> That means newspapers, magazines, TV, radio, even T-shirts. Let's say you want to get the youth market, you find out which TV programs they watch. Media has books of statistics. They know how much an ad costs, in whatever medium. They research the problem, so that we don't waste time or money. They may decide that for one client, ten short TV commercials might be better than 100 little ads in local newspapers around the country.

The determination of the medium is the initial step. If the media department decides that a sixty-second TV commercial is the best way a client can reach his potential buying audience, then the agency mobilizes itself around that goal. Generally, a commercial film studio is contacted to execute the film. If media decides that a print ad[2] is best for the client, an advertising photographer will eventually be contacted to execute the photograph. This discussion refers only to print ads.

A second meeting is called during which media presents its decisions to the creative department and to the account executives. At this point, media's role has ended. The creative department now takes over. In the creative department, writers and artists, whose roles are arranged in an elaborate hierarchical structure with such titles as assistant art director, art director, art supervisor and chief art supervisor, are selected to work on the ad. A working team is formed, usually consisting of an art director, a copywriter and a few account executives. Their job is to develop ideas for ads; the team members conceive how visual images and words might coalesce into a unified ad.[3] When they feel that one of their fantasies has some potential, a rough layout of the ad is created. This includes the copy, the headline, and a sketch of the visual part of the ad. When several rough layouts are made up, the art director and the copywriter meet with the account executive to discuss the proposed ad.

Art director #4: We see if the account executive disagrees. Then the account executive, who is really a salesman, takes the ad to the client. He wants client approval on it. The client may want to change it or modify it. Then, after he's got client approval, it's produced.

Me: Does that mean that every ad gets sketched out and written out when it comes time for client approval?

Art director #4: Most of the time we get client approval on layouts. Again, it's individual. Sometimes it's a sketch. Sometimes we verbally describe what we're going to do. If the client is a tough nut to crack or has difficulty imagining what we're trying to do, I'll even hire a photographer to do a shot just for the layout. But I guess you could say that clients approve the layout before we produce anything.

The visual part of an ad may be a drawing, a cartoon, a diagram or a photograph. If the proposed ad calls for a photograph, the art director must select a photographer to do the job. The relationship between advertising photographers and art directors is an interesting one. Since advertising agencies do not have their own staff photographers, the art director must contact a free-lance photographer who has his own fully equipped studio. But the marketplace is glutted and the art director has his choice of many photographers, most of whom would welcome the job.

Art directors tend to hire photographers they have hired in the past. The art director trusts the photographer, regards him as dependable and has a good idea about the range of the photographer's technical competence. But, when choosing a new photographer with whom he has never worked before, the art director relies on the reputation the photographer has achieved for specialized renditions. For instance, in one case I observed, a photographer was chosen on the basis of his reputation to create "old-timey" pictures. His selection of models, the attention to costume and to make-up, his use of soft focus and the way he sepia-toned his prints all added up to a "period" photograph. When an art director believes that his client's product can benefit from this type of rendition, he will choose this photographer. Thus, although there are theoretically over 1,000 photographers an art director in New York City can choose from (Madison Avenue Handbook, 1974), this number is immediately reduced to a handful when the art director considers which photographers can best render the kind of product the ad contains.

In fashion, for instance, if the proposed ad requires a simple shot of a model against a plain horizonless background, the art director will contact a studio photographer who has the lighting equipment and materials to execute the shot. If, on the other hand, the proposed ad calls for a location shot where the model is photographed in a street scene, another photographer will be called. The art director calls the photographer who has a reputation of expertise at taking a particular kind of shot. In the second instance, the photographer must not only know about the garment, he must also know about architecture, how

buildings will look in the photograph and, most important, how to place a figure against an architectural background.

The art director's selection of a photographer should be understood against the background of the economic structure of advertising. The cooperative ad, paid jointly by two or more manufacturers in order to minimize their advertising costs, might be arranged between an airline, a clothing manufacturer and a luggage manufacturer. In the eyes of the art director, not all photographers are able to furnish a photograph containing the three products. Some photographers can do this type of shot better than others, and these are the ones who are contacted for this type of cooperative ad. For another kind of cooperative ad which features, let us say, bathing products and towels, a different photographer will be chosen.

Once the photographer is chosen, oral contractual arrangements are made and the photographer does the job, the details of which will be described shortly. The photographer then furnishes the art director with the contact sheets or, if they have a good working relationship, a small number of prints or chromes which he, himself, has selected. The art director then selects which picture will actually be used in the advertisement. Although the client is sometimes consulted at this stage, it is usually an expression of courtesy, since the art director believes that the client cannot tell the differences between the pictures.

When the final selection has been made, the photographer or his assistant makes the best possible prints. He generally provides two or three prints, each one a little lighter than the other. This print is actually much larger than is required for the page size, but it will be photo-mechanically reduced after it has been retouched. For a color shot, the original chrome is never retouched directly. Rather, an enlarged duplicate (a dye transfer transparency), usually 16″ by 20″, is made. Retouching is done directly on the dye transfer.

> Advertising photographer #2: The art director makes arrangements with a dye transfer house. Then it comes back to the art director and he sends it to a retoucher. Now, at the same time, he's getting type for the ad from the typesetting house. All the materials end up in the art department, and it's actually a mechanical cut-and-paste job from this point on.

The mechanical paste-up is then sent to the engraver, who reduces the size of the paste-up to the magazine page size and makes a plate. Sample engraving proofs are sent back to the art director who must approve or correct the technical quality of reproduction.

> Advertising photographer #9: When the proofs come in, they go to the art director for his ok. He'll check the color of the inks and make changes, if it's necessary. Most of the time, corrections have to be made on color. Something's off. The proofs will go to the client as a sample of the ad, but if the color

needs correcting, the art director hesitates and he'll wait until a better proof comes in before sending it to the client.

Client approval is pro forma at this point. The art director approves the corrected proof. On the deadline day, the magazine presses begin, and the ad will eventually reach its consumer audience.

✓ The Job

The photographer's work begins when he is shown the layout from which he prepares the job. Since most advertising photographers have several types of cameras, their own darkrooms and, often, their own workshops, the kinds of preparations they need to do require the acquisition and/or mobilization of personnel and resources. These requirements vary with the photographer's specialty. For instance, if his work requires it, a photographer might have a special dressing room containing various types of clothing, costumes and accessories. Other photographers, especially those who specialize in highly controlled studio set ups, might have large workshops where platforms, tables and other props might be constructed especially for the job.

In advertising photography, human resources are as important as material ones. In order to get a job done, photographers need to know and to utilize the specialized skills of many other people. Connections and contacts are essential to an advertising photographer; his telephone book might include the names of furniture houses from which he can rent or borrow items as well as the name of the liquor store down the block, which can lend him a bottle of liquor in exchange for a credit line in print. If the ad requires a public location as a background, the photographer needs to arrange for permission and access to the site. Photographers also depend on fashion stylists, interior decorators, food stylists, home economists, model and mannequin dressers, beauty and cosmetic consultants, hair stylists and other experts. Although a photographer might have one of these experts as a full-time staff member, if his volume of business justifies it, these experts are usually free-lancers and are hired on that basis.

For each job, a photographer brings together people who may have worked with each other before, in other studios and for different photographers. The analogy to the surgical team has already been made and is useful here, too. Although each member of the team may be an expert in his or her own field, a common universe of discourse is required to get the job done. But medical language is far more precise than the language used by the photographic work team. Therefore, photographers often hire, on a regular basis, those free-lancers with whom they "connect well." One photographer was especially cognizant of the personality variables that affect these types of interactions:

Advertising Then there is the stylist. She's another important person.
photographer #8: She knows you well. She knows what you want. She

takes care of the small things in the picture. Let's say you want a pretty candy box in the picture, she gets it for you. If you say it's ugly, she must understand you well enough to know why you think it's ugly. You must work with people who are like you, because there is so much confusion in language.

Many shots, especially in fashion, require models. Generally, the photographer and the art director together review models' composites. The final selection of models theoretically rests with the client, who generally does not exercise this option.

For some photographers, the actual shooting is anticlimactic and is the last part of the sequence of events that make up the job. One highly successful still-life photographer attributes his own success to his relentless preoccupation with preliminary planning:

You wanna know why I'm a successful photographer? I'll tell ya. I run my studio like a business. It's well run and I always make a profit. Most photographers don't make a good profit but I do. Many people think that to be an artist you have to be irresponsible. That's baloney. Every writer, every artist I've ever known is absolutely professional all the way. Professionalism is running a business. It's scheduling, impeccable scheduling. It's planning. Every picture is like a movie and I'm the director. I don't know every little detail about what my people do, but I know mostly everything at any given time. There's nothing I detest more than irresponsibility. And the way to be responsible in this business is to plan. So we do tests before every shot. We use styrofoam cutouts shaped like the dishes will be. Then we test for color and the quality of color. Everything is done in the preparation, never in the shot. I don't waste time. I work five days a week, 9:30 to 5:30 every day and I run a very tight studio. I've been accused of being the most methodical man people have ever met.

Advertising photographers may be divided into three conventional categories: fashion, still life and ad illustration. The differences between their work, in terms of job content, is plainly a function of their different specialties.

Fashion

A fashion shooting involves the display and presentation of clothing. Most of the time, live models wear the clothing but occasionally mannequins are used. Models are selected because the photographer wants "a specific look, an attitude, a gesture." The art director must approve the photographer's model choices and, if he is not satisfied, he can veto the photographer's choices and make his own recommendations. In order to avoid this situation, model selections are often made collectively, when the photographer and the art director review models' composites or the catalogue of models provided by various modeling agencies.

If the ad requires a model who can provide a certain "look"—the rugged

he-man, the young bachelor, or the father figure—some models are automatically discounted because they don't have the "look." From among the models who do have the "look," the photographer selects those who are available, since many of them will be tied up for months at a time with advance bookings. Once the models are selected, they are booked for a particular day. They are instructed to bring certain apparel and accessories from their own extensive wardrobes. At the same time, the client is instructed to deliver to the photographer's studio the clothing that will appear in the ad.

A fashion ad may be shot in the photographer's studio or on location. In either case, the photographer gives the model specific instructions regarding position, gesture and posture. But, more important, the photographer "works with" the model. This means that the photographer, like a director in the theatre, attempts to create a reality from which a particular mood and a particular expression might emerge. Like the director, the photographer uses every communicative device to help the model understand and deliver the expression or the gesture he wants.

Advertising photographer #3:	The photographer's relationship with a model can be very personal. It is an intimate relationship in a way. That's why photographers use their favorite models over and over again. You establish a language with your model. You have evolved certain words together, certain gestures. You work well together. Unless the job is a straight catalogue shot, where it doesn't matter who the model is because all you do is show the product, working with a model is very important . . . and what you create with a model is fragile and can be destroyed easily by all kinds of people at the shooting. The model starts getting distracted or she'll put on a show for everybody but the photographer. When that happens, I say to everyone, "Go away . . . this is an intimate setting."

A fashion photographer believes that a special kind of excitement or a certain kind of mental state emerges from his interaction with the model. His job is to create that mental state and to record it with a camera. The photographer is the participant-observer *par excellence* in a fashion shooting. His ability to create a mood is maximal when the shooting occurs indoors and, for that reason, many prefer studio work.

The studio area where shots are taken is called, predictably, the set. If props are necessary, constructions are built in another area of the studio, the workshop. Seamless paper is hung behind the set, to create a horizonless background and, since it is available in a variety of colors, the photographer can choose the best color background for the color of the clothing. Before the shooting begins, the photographer or stylist checks the model's makeup and checks the fit of the clothing. Also, before the shooting, the photographer might begin to create a specific mood by putting a certain record on the phonograph. Wine, beer or sometimes marijuana might be offered to the

models. Typically, there is a lot of laughter, exchange of gossip between the model and the photographer before the shooting begins, an interaction which helps both loosen up. When the photographer and model are ready to work, laughter and gossip stop. They are ready to enter a non-ordinary reality or, as Schutz might phrase it, a finite province of meaning with its own cognitive style (1967, vol. 1: 229–40).

As the following excerpt from my field notes indicates, the photographer begins to create a mood by suggesting a situation:

> The photographer tells the models to pretend they are sweet kids out on their first date. He tells his assistant to get some flowers from the vase at the receptionist's desk, cut the stems and "make this bunch of dying daisies look good." The assistant comes back with the flowers, hands them to the female model. Meanwhile, he is checking out the lighting with a meter and checking out the strobes. He tells them again that they are out on their first date, they are at the park. The models start talking some nonsense, how beautiful the flowers are, what a lovely day it is. The photographer begins shooting with a 35 mm. camera, moving around and giving them instructions at the same time. The camera is always at his eye. He says to the male model, "Run your hand over her hair . . . it's soft . . . smile gently . . . make it a soft smile. . . ." He keeps on repeating the phrase "Some soft smiles now" in a very gentle, soft way. I notice there is something very strange in the air, some kind of fantasy or illusion that is highly contagious. The models smile at me, I smile at the models. This has got to be theatre! We all feel happy!

When the photographer and the models go on a location shooting, the photographer cannot control as many variables as he can in his studio. Clouds, rain and cold weather present technical problems which affect the shooting. If clouds appear during the shooting, new light reading must be taken and all the cameras must be reset. Similarly, as the light falls fast towards the end of the day, cameras must be constantly readjusted for the changing light. If rain begins to fall during the shooting, the shooting might be called off. Since models' fees range between $60 and $75 an hour, it is sometimes cheaper for the photographer and the models to fly to the Caribbean for two days to do the shooting in perfect and predictable weather.

When a location shooting takes place in a relatively populated area, the photographer and models must contend with crowds and passers-by who gather around them. Sometimes models become inhibited, sometimes they become exhibitionistic; and a photographer must keep in mind how a model will react to crowds during a location shooting when he selects models.

Since fashion photographers must create and sustain a mood, the photographer attends to his interaction with the model rather than attending to the way the garment looks in each shot. Anticipating that the law of averages will provide him with a few shots where both the model and the garment look good, the photographer shoots a number of rolls of film. In addition, he knows that extensive retouching will be done on any photograph. This frees him to work

with the model on the expressive impact of the picture, rather than to worry about little creases in the garment, since they will be retouched in any case.

Whereas the theatrical metaphor can be applied to advertising photographers who do fashion and, as we shall see, ad illustration, it cannot be applied to photographers who do still life.

Still Life

Still life, as the name implies, means that the photographer takes pictures of inanimate objects. People in advertising refer to these pictures as either "product shots" or "still life." I use the latter term in this discussion.

Again, the art director's layout provides the photographer with information. The photographer's job is to translate the art director's sketch into a photograph. Whereas art directors will draw a loose, free layout for a fashion shot, because they know the shot is a product of the interaction between model and photographer, art directors' layouts for still life shots are extremely detailed. In addition, because of the differences between free-hand drawing and photography, there are inherent difficulties in the translation. This requires negotiation between the photographer and the art director.

Advertising photographer #3:	I tell him it's a marvelous drawing but it's not a photograph.
Advertising photographer #4:	The idea behind the ad was to have a taxi driver lie on a mattress. The way the art director drew the mattress was impossible to shoot, since the perspective was all off. The art directors insisted that the photograph follow the layout, to the inch. So I took the picture and then traced all the angles against the layout and demonstrated to him that all the angles and the whole perspective was fucked up. Then he finally gave in. Most of the time I work pretty closely to the layout, but that dodo wanted it to the inch. Ordinarily, it's not so tight.

Once the layout has been negotiated, materials obtained and the setup created, the still life specialist is ready to shoot. The actual shooting might be characterized as the photographer's search for the "correct" combination of elements. These elements are lighting, composition, focus and angle. Focus determines the degree of general or selective crispness of detail and the degree of texture. Angle determines the selective elongation or the compression of space in addition to the degree of perspective, through the selective manipulation of the vertical and horizontal parallels. The actual work of still life photography requires constant "tiny" manipulation of all these elements, making little changes and adjustments here and there, until all the elements congeal correctly in the photographer's eye. For instance, if the photographer notices that the product casts an obtrusively long shadow that breaks up the composition, he may move the product over an inch or two. In short, the

photographer constantly makes corrections, then goes behind the camera, judges whether the correction is, indeed, an improvement and then either takes the shot or continues to make additional minor refinements and readjustments. The photographer keeps on adjusting the lighting, the angle and the focus until the proper combination is reached. Often, a Polaroid shot is taken to check the lighting. If the Polaroid is satisfactory, the actual shot is made. If not, the lighting is readjusted again.

Advertising photographers believe that lighting is the key to the "art" of advertising photography. In fact, lighting is so importantly regarded that it is a photographer's signature. Some photographers claimed they could recognize the work of other photographers on the basis of lighting alone. Lighting can be used to achieve mood or atmosphere in the photograph. It can be used to isolate a part of a composition or to highlight part of something.

The angle in which the camera is positioned is, in the most general way, determined by the perspective in the hand-drawn layout. The camera angles are often systematically varied, especially if the photographer shoots the product with a 35 mm. camera. When a larger camera is used, less variation with camera angles is done.

The photographer's choice of type of focus is mainly determined by the mood the art director wants to achieve in the photograph. Great clarity and detail is sometimes desired in a picture, especially one which attempts to communicate verisimilitude. When drama is required, the focus is used in conjunction with lighting to create a dramatic picture.

In sum, the still life photographer is one who works meticulously, constantly paying attention to small details and who relies on technique to accomplish his art.

Ad Illustration

Ad illustration is a residual term which refers to a photograph that shows people using a product. A photograph showing a bottle of beer is called still life; showing a person drinking the beer is ad illustration. Ad illustration also applies to "public service" campaigns, which do not involve a product. Public service ads are sponsored by non-profit organizations and are generally educative and geared for public welfare. "Drive Safely," "Save Your Eyes," and "Only You Can Prevent Forest Fires" are examples of public service ads.

Like fashion and still life, ad illustration begins with the art director's layout. Again, the photographer must provide a photographic rendition of the layout. From the previous discussions of fashion and still life, one might expect that photographers who do ad illustration must possess a combination of qualities that, as we have pointed out, fashion and still life photographers need for their work. Yet this is not the case, for ad illustration is its own *genre*, and art directors do not expect models to radiate, as they would in a straight fashion shot, or the product to shimmer, as it would in a straight still-life photograph. Indeed, the vocabulary of expectations for ad illustration is far

more narrow than for either fashion or still life: the art director's overriding expectation is that the photographer produces a credible advertising photograph, in which the relationship between the models and the product is credible. Credibility depends on the compatibility between persons and products. For instance, an ad for a drug for depressed menopausal women would contradict itself if the photographic illustration featured a young, beautiful model. Sometimes a photographer must go to great lengths to find an environment and/or a model that is consistent with the theme or the product in the ad:

Advertising photographer #9: There's an important story attached to this photograph. The company refines oil and they were going to build refineries in Portugal. But instead of bringing in a whole team of planners, they decided to ask the wine growers in the area what they thought were good ideas to consider when building a refinery. The wine growers said that the smoke from the refineries would kill their crops. But the wind blows the smoke out to sea during certain hours and it blows the smoke over the land at other times. The company agreed to let the smoke out only during the hours it would drift out to sea. Now, this company wanted to make a big deal out of this and publicize all their great efforts in the ecology area. So they decided to do a great big ad campaign emphasizing this. I quoted a price, figuring how much it would be to fly over to Portugal, take the pictures of the wine growers, come back and give them a selection of good prints. They were too cheap to send me to Portugal and you wanna know something, it would have been cheaper if they had sent me there. I had to search for this man we used in the picture. I wanted a certain look. The client told the art director to use a Puerto Rican, if I couldn't find the look I wanted. How dumb can you be? I combed Newark, New Jersey because they have the largest Portugese population in the United States . . . and then I went upstate and searched for an authentic wine cellar. And the man in the photograph wasn't even someone I found. I combed the streets of Newark day in and day out, looking for an authentic look. But I couldn't find it. Finally, we hired a model from the agency. And the company paid more than if I had simply gone to Portugal for a few days and shot a real wine grower in his own cellar.

Ad illustration, then, requires the photographer to bring together people and objects. The relationship between the people and object is central to ad illustration and, consequently, the photographer is preoccupied with making that relationship a credible one. Like fashion and still life photographers, he directs, manipulates and organizes the models and the objects to conform to the art director's layout.

An additional category of advertising photography is "editorial work," which refers to working on a feature layout for a magazine with a writer. The article, with the pictures, runs in the editorial pages, rather than the advertising pages, of a magazine. For this kind of work, photographers receive relatively little money: an editorial job might pay as little as $200. This figure, compared with the $150 to $500 that a photographer might earn in *one* day, clearly indicates that editorial work attracts photographers for reasons other than financial compensation.

There are several reasons photographers offer for doing editorial work. However, they can all be subsumed under one generalization: editorial work generates new business and, as such, is a mechanism for economic survival. First, unlike advertising, the photographer's name appears in print. The credit line enables potential clients to identify him and to request him for jobs, through their own advertising agencies. Second, some photographers feel that editorial work is more prestigious than advertising. Third, it offers the photographer the opportunity to demonstrate his ability to photograph people, situations or things other than what his reputation is based on and other than what he specializes in. One photographer who specializes in still life, photographed a model, full-face, for a cosmetic article to run in a fashion magazine, during the course of my observations at his studio.

> Advertising photographer #1: Fashion is an area I'd like to get into. I'm kinda tired of still life. In fact, I'm getting saturated. I don't think I'm a great fashion photographer, in fact, I know I'm not. I'm more of a designer than a fashion photographer, I think, because of still life. But I want to do more fashion and get into that. I want to do it slowly and my rep thinks that I should go into fashion editorially first. I'm listening to him. But I tell ya I have very mixed feelings about it. You have to dream up fashion techniques all the time. It's got to be new. A magazine finds a photographer, uses him, all the agencies use him, fashion is saturated with his look and then, after six months, they drop him. Nobody touches him. That happened to X, Y, Z and A . . . so that's why I'm going into it slowly, because I'm not sure about it. I'm not ready to do big fashion productions in my studio.

"Editorial work," then, is a mechanism of mobility which enables photographers to try their hand at a new specialty, gain a small reputation in that area and perhaps move into it completely.

Controls and Constraints

In chapter 4 on news photographers, the division of labor, technology and the system of journalistic classification were identified as major structural sources of control that determined, in part, the "look" of news pictures. In this chapter,

we will see that the social forces which shape the "look" of advertising pictures are quite different from those described for newspaper photographers. Here, several constraints are analyzed with respect to their impact on photographer's work and photographic styles. For the sake of convenience, these constraining factors can be divided into two types, economic and social, but it should be remembered that these distinctions are arbitrary and not analytic.

Economic Constraints

Advertising photographers always work within somebody else's budget. The photographer's fee and production budget depend on the client's budget which is, in turn, influenced by the magazine in which the ad will appear:

> Advertising photographer #3: Your price depends on where the ad is going to appear. *Life* magazine has a higher page rate than some other magazines. Your fee is consequently higher. And it also depends on how much the agency has. If it's a tight budget, the agency will tell you to cut corners, like not to run over two hours for model time. Models get $60 or $75 an hour . . . maybe more. And the agency doesn't want to spend the money.

In this case, the photographer quoted above reports that she thinks a great deal beforehand about how she will photograph the model. Before the actual shooting, she has determined what mood to evoke. When the shooting begins, she knows exactly what to say and do to evoke that mood. As a result, she can work quickly, within the budgeted time. Generally, ads which require on-location shootings or big studio productions have larger budgets. No matter what size the budget, all photographers must work within it. Thus, where the ad is to appear determines not only the production budget but also influences the photographer's orientation towards the job:

> Advertising photographer #10: The biggest factor which affects how I'll shoot a job is knowing the ad pages of where the ad is going. Whether it's *Life, Time, Gourmet,* or whatever. And, of course, whether it's black and white or color. *Esquire* wants the quietly hip picture. *Life* wants a more shocking, hard-edge picture, even in their ads.

In addition, the techniques the photographer selects to make this picture are also influenced by where the ad will appear:

> Advertising photographer #9: When you do black and white, the art director and the photographer, too, should know the characteristics of the printing process to determine how to shoot a job. When a photograph is reproduced on a large screen, certain things happen to the tonal scale. If you know an ad will

> run in the Wall Street Journal, like the recent job I told you about, you have to lighten it up so that the blacks don't get lost. If you see it in the *New York Times*, you ball it up [increase the contrast] because, in their reproduction, it flattens out to mush. You shoot for different contrasts when you know it's one kind of a screen and not another. Unfortunately, not so many people in this business know about printing.

As in newspaper photography, the characteristics of the reproduction process are taken into account when decisions are made about the tonality and the contrast of a print. However, because ads run in all sorts of magazines, advertising photographers need to know more technical information about reproduction processes and stocks of paper than newspaper photographers. It is also clear that advertising photographers classify magazines with respect to type of overall graphic orientation.

Social Constraints

The particular nexus of social relationships in advertising forms a social configuration which has some interesting features and which, above all, shape the character of the photographer's work and the photographs that result from that work. In this section, I explore the photographer's relationships with two key people, the art director and the advertiser (known as "the client"), and show how these institutionalized relationships *socially limit* the photographer.

The art director generally has power over the photographer in several ways, and this unequal distribution of power seems to account for photographers' generally negative, ambivalent attitudes towards art directors. For instance, because the photographer depends on the art director to call him again for another job, the photographer is economically constrained to put forward the "merchant" role (see Freidson, 1971) in his relationship with the art director and minimize his "creative" side:

> They give you a job to do. You say that you are going to do a great job on it. You say that you like doing it. During the job, you call him up and you say it's going great and that he'll be pleased when he sees it. You work your ass off and you give it to him before he expects it. And when you show it to him, you say, "Isn't that great?"

Here is another example of how a photographer orients his behavior to the expectations of the art director so that he might be called again to shoot another job:

> And when I'm working with an art director, I'm so busy trying to please him. I don't know if this answers your question, but I'm not too concerned about the final appearance of the ad because I want to work with the art director again. I

want to show him that I'm a good photographer and that I cooperate and don't give him too much flack about other things.

The second way art directors have more power than the photographer is that they have final say about how the photograph should look. From what photographers told me, some art directors take the liberty of extending their mandate to the point at which they interfere with the photographer and his work. One photographer characterized the art director as a person who "bugged" him unreasonably. Most resentment associated with this relationship concerns the transparency of the power differential and the art director's determination of the way the image looks. Because this issue is crucial to the analysis of photographers' work, it will be discussed in greater detail in conjunction with a second set of constraints, those originating from the advertiser.

When the photographer is called by the art director for a job, he inherits his client's client, the advertiser. The photographer has to please both the art director and the advertiser, and we might consider them as dual clients, each with a different set of needs and demands. The photographer wants the advertiser to request that the agency use him again and, consequently, feels that he must distinguish himself from other photographers.

Among advertising photographers, there seems to be a kind of fetishism of "creativity," but it is achieved in ways that seem to bear little relationship to technique or craft of photography. As one photographer put it, "Performance is just as important as the picture." The photographer "performs" by letting the client into his world, the studio. The photographer creates in his studio a "play" environment, supplied with rock music, drinks, pool or tennis tables, dart boards and sometimes beautiful people. Sometimes the noise levels made by executives at play distracts the photographer and thus constitutes a form of interference.

The advertiser's presence at the shooting introduces difficulties for the photographer in ways other than described above. Since advertisers feel that photographers do not "care" about the product, they are present at the shooting to make sure that their product is photographed well. They tend to watch the photographer, police his action, ask a multitude of questions and seem to challenge his judgments repeatedly. They inquire as to whether the tiny creases in a garment will be greatly visible in the final photograph or whether the slight shadow across the brand name will obliterate the brand name entirely in the final picture. In short, they worry that the photographer does not love their product as much as they do and keep reminding him of that. What follows is a detailed description that shows how the client can intervene during the shooting and seriously challenge the photographer's definition of adequacy of presentation.

A men's clothing manufacturer decided to feature their clothing in one full-page ad. Since the number of outfits totaled nearly 120 and since modeling

time is expensive, the art director planned to use mannequins, as well as live models, in the ad. The layout indicated that eight outfits would be shown in each row; two live models would stand between six mannequins. That way, the photographer could shoot eight outfits at one time. The clothing on the models and mannequins would have to be changed fifteen times. Retouching was planned so that the final ad would not show the edges where the shots were pasted together.

When they began to shoot, everything was going along smoothly at the studio. The art director and an account executive were there, helping the photographer and his staff dress the mannequins. The first of the fifteen group shots was completed. Around noon, the client, in this case one man, entered the studio and cheerfully greeted the art director and the account executive. Apparently, they did not expect him because he said, "I dropped by to see how the work was progressing and to fool around a little." The man walked up to the set, examined the models and mannequins, took his shoes off to walk on the seamless paper, and then began talking in a very loud voice:

Client: I have seen all kinds of mannequins in my life, but these are the ugliest mannequins I've every seen. Look at them. They've got bad heads. These are old mannequins and they put long-haired wigs on them. No wonder you only did one shot this morning. You can't dress and undress them . . . the newer ones have arms that move. These don't. And look at these clothes. The pants are too short. (Talks to the account executive) Would you wear these pants? The crease on the slacks doesn't come out right.

Acct. Exec.: (Meekly) But they photograph well.

Client: These guys look like stiffs. The newer ones, they look more real. At least the faces are different. Different expressions. All these stiffs have the same expressions with different wigs. And you can't work with them. They don't bend at the joints. (Deep breath) And I'm also going to teach you people about clothes. I think these pants are too short. Gimme a tape measure. A standard mannequin has a 34-inch inseam.

Asst. Stylist: When I called the mannequin company, they said it was 31 inches. I had the pants shortened to 31 inches.

Client: Look, you've got to stop shooting today. I won't let you do this shot with these mannequins. Let's go and have lunch. We'll talk about it and go to another mannequin place this afternoon. Tomorrow, I'll bring some mannequin dressers up from Philadelphia . . . you need all the professional help you can get for this shot. They can do it faster than you or I can. They know what they are doing. Look, let's go and get rid of these Neanderthal men.

When I spoke with the photographer and the art director later on that day, they confirmed that clients sometimes intervene to the degree that client did in this case. Although it is by no means typical, it is also by no means rare. They also pointed out that conflicting judgments arise from the client's inability to visualize the ad. The photographer put it this way:

> If there are 120 outfits on one page, then each model or mannequin will be about three-quarters of an inch long. You won't even be able to see the crease in the pants. X (the client) thinks like a window dresser. Every detail is important. All you're gonna see in the ad is a red jacket and navy slacks. There can't be any detail.

All the photographers I spoke with complained about the client, whether in terms of interfering with work or in terms of the client's lack of "graphic sense." The client's "bad taste," "lousy products," "lack of understanding," "nervousness," and desire to "goof around in my studio" are frequent complaints photographers reported. In short, photographers identify "the client" as the major source of constraint. One photographer said this:

> The client . . . no good. They are even further away from the craft and have less of an understanding of the medium than art directors. They can't even speak in photographic terms. Look, they come here to see if I'm competent and ok. And they want to know how their product is represented. They worry about it.

Another photographer reported that his clients accuse him of "not caring about the product but trying to win awards." But despite their complaints about the client, photographers permitted clients to attend shootings.

To show how other types of persons might also interfere with the photographer's work and constrain his aesthetic choice, I am including the following excerpt from my notes in which a model discusses how models can also constrain photographers.

Models must be concerned with how they look in photographs, because their livelihood depends on it. They learn what their best angles are and what lighting makes them look best. Models insist that the lighting makes them look good, too, in addition to the garment or product:

> Model: You can feel the lighting on you, what parts of your face are being highlighted. And you can tell a photographer by his lighting. You learn if you look better in tungsten or if Belcars work better for you. Well, photographers use different kinds of lighting. You just remember how you look in certain lights. And, in fact, some models request to see the Polaroid before the photographer starts the real stuff. They'll look it over and make certain lighting suggestions, because they really know the way they photograph.

> Me: Doesn't that bother the photographer?
>
> Model: Yes. But every photographer uses a Polaroid nowadays to check out lighting. But now models want to see those Polaroids before the real shots are taken. And it's simply true that some models know about which lighting is better for them. You spend $800 on a composite, after all, and you always see yourself under different lighting conditions. You've got to know something. I think what bothers the photographer is when models insist upon checking the Polaroid . . . requesting it and being nice about the suggestions is one thing but insisting upon it might bother the photographer.

At another shooting I observed, the art director instructed the photographer to change the lighting on a handbag. The photographer did so, shot a Polaroid and showed it to the art director. The art director was not satisfied and had the photographer make additional lighting changes for one hour and ten minutes. Lighting, then, which is defined as an advertising photographer's major area of expertise can be seen as a negotiated decision.

Much of the character of the relationship between the photographer and his dual clients derives from the fact that this is essentially a bureaucratically organized professional client relationship which conjoins features of bureaucratic roles and professional roles in some peculiar and ambiguous way. Theoretically, the photographer should be treated as a professional who possesses esoteric knowledge and who can assist the client with his problem (Hughes, 1958: 141). The fact that he is an "outside expert," brought in especially for a specific job, should add to his professional status, and consequently we would expect that he would be accorded deference. This picture, however, is true only for top advertising and fashion photographers. For most advertising photographers, the situation is entirely different.

For most advertising photographers, the social organization of advertising has the net effect of chiseling away at the broad range of knowledge and expertise that the photographer brings with him. The photographer's contribution is virtually reduced to technical labor. The photographer is often given direct orders by the art director and is told to photograph the models or objects "the art director's way" and not "his way." When this occurs, the photographer's authority and expertise seem to evaporate entirely and, as his autonomy decreases, there is a concommitant reduction in the dimensions within which he is allowed to be creative on the job. In order to better understand how the photographer's role is narrowed to that of technician, we must explore client demands a little more to see how the institution of advertising impacts and shapes the social organization of photographer's work. By looking at both social organization and institutional understandings the reciprocal relationship between the two can be clarified.

Advertisers come to an advertising agency with preconceptions about what a "good ad" is. Their preconceptions are based on their previous experience with advertising agencies. In addition, many regard themselves as "expert

amateurs" on advertising since they reason that all people who participate in the culture are exposed constantly to advertising and make evaluations about ads. They also come to the advertising agency with conceptions about what consumer's conceptual and perceptual orientations are and these, in part, are based on market research data. There is another factor, too, that shapes advertisers' conceptions of ads. The institution of advertising is similar to journalism in that there are basic stories. Many themes found in advertising— what may be called advertising stories—are institutionalized. A family breakfasting together or the "boys" having a beer after a game are examples of advertising stories. Even a close-up shot of a bottle of beer is a type of standard advertising picture. In short, advertising photography relies heavily on typical situations, typical themes and typical arrangements of people and/or products.

The advertiser expects the agency to provide a picture that partakes of some standard scenario, which is retrieved from the institutional stockpile of advertising stories. But the advertiser also expects the agency to add an original twist so that the final photograph will immediately capture the audience's attention and differentiate the advertiser's product from the many competing products available on the market. In short, the advertiser wants an "original standard picture," but the photograph must be conditionally original in the sense that the visual rendition does not undermine its impact as an advertising picture.

To comply with the advertiser's expectations, the ad agency's art director typically relies on the visual tradition of representationalism or pictorialism for the layout. Art directors seem to believe that advertisers will most readily approve of a straightforward pictorial rendition of their product. While art directors may add some visual elements that are striking, they generally leave it up to the photographer to provide the visual originality the advertiser wants. Thus, by the time the photographer is called for the job, the advertiser and the art director have settled on the type of visual imagery in the proposed ad and they expect the photographer to take their conception and breathe life into it, so to speak. Note that the photographer has not been asked to make suggestions or to comment on the selection of the imagery and its rendition. Instead, the photographer is called upon to supply his skills to turn a graphic design into a photograph. When the photographer makes an unsolicited suggestion, the photographer's comments are typically overruled by the coalition formed by the advertiser and art director. Only occasionally, photographers report, does the art director align himself with the photographer against the advertiser.

Given these constraints to begin with, the photographer's contribution is largely technical. For instance, let us take an example of a "standard pretty girl displaying a product" picture. The photographer may vary the mood by using soft lighting and a soft focus lens and the resulting photograph will have a warm and intimate ambience. Or perhaps the photographer will use high contrast lighting and the result will be a cold and dramatic picture. Typically, photographers work within this functionally specific, narrow technical role that this form of social organization assigns to them. But it is within this

narrow scope of the role of technical translator that advertising photographers define their creativity and try to maximize their control over this limited area. They accomplish this by doing as much technical variation as possible, by manipulating the focus, lighting, distance, scale and distortion. Thus a key stylistic feature of advertising photography is its visual unnaturalness.

On the institutional level, advertising photography is more heterogeneous than news photography, but the directions in which it expands are towards essentially technically innovative photographs and not thematic innovations. Institutional and organizational features determine, in part, both the thematic content and visual rendition of advertising photographs as mediated through the photographer's work.

✓ Conceptions of Creativity

In advertising, as in news, the definition of a "good picture" and a "creative photographer" varies with the social perspective, needs and interests of the person making the evaluation. However, unlike news, there is much less reported agreement as to what constitutes a "good picture." As a result, the assessment of creativity shifts from talking about the pictures to talking about the person who made them, making it difficult for the observer to draw out the social factors from the wealth of characterological attributes that are used as indicators of creativity. In spite of that, I will try to show the social components of definitions of creativity by identifying and discussing two dimensions used for the assessment of creativity. The first dimension concerns the degree to which the photographer is consulted during the initial conception of the layout and this, in turn, often depends on the photographer's prestige and reputation in the industry. Therefore, in the following discussion, I will refer to "typical" and "top" photographers. The second dimension used for the assessment of creativity concerns mastery over technique.

From the art director's standpoint, a typical photographer is one who will provide him with a sufficient number of pictures from which he can choose the "best" photographs to present to the advertiser for final approval. His choice is made from forty to sixty shots of basically the same picture. The reason why they are so similar is because the photographer is pressured to work within the constraints imposed by the layout. Because photographers are required to translate a sketch into a photograph, most advertising photographers have very little control over shaping the initial concept of the ad. All the details of the sketch are, in a sense, indicators of the limits on the photographer. The photographer must create a shadow where the art director has indicated a shadow must fall. Similarly, he must create the highlights where they have been precalculated. Spatial perspectives have already been calculated into the layout. Finally, mood, that elusive combination of elements, has also been determined and calculated into the drawing by the art director. It is indicated by various visual means, such as background climactic conditions or expressions on the models' faces. Since the photographer must conform to the art

director's layout, his pictures contain such subtle differences as to be almost imperceptible to the uneducated eye. What are the differences, then, between the pictures the art director must choose from?

One difference may be that the first ten pictures on roll #1 were shot when the camera was twenty inches off the ground, positioned at a forty-five degree angle towards the product arrangement on the floor. Furthermore, each of the ten shots may have been exposed at a different aperture setting. Giving several different exposures for the same shot is called "bracketing." Advertising photographers cover themselves by bracketing shots, in case any lighting or reproduction problem might come up. The next ten shots on roll #1 may have been made when the camera was twenty-five inches off the ground, positioned at a thirty-eight degree angle towards the product arrangement. Thus, the art director must choose the "best" picture from among forty extremely similar pictures. In the case of live models, an expression or a gesture will determine the "best" picture. But, in the case of a still-life product shot, the size and shape of the shadow will make the difference to the art director. To the typical photographer, these technical variations are seen as an opportunity to be creative, once the layout requirements have been fulfilled. Although they are constrained by the framework of the layout, they are still enthusiastic about their ability to bring variation via technical manipulation.

The situation for "top" photographers is entirely different. Art directors treat top photographers quite differently from the way they treat typical photographers. The top photographer is treated as a visual expert and is called upon for his *conceptual contribution*, not merely his technical competence. He is seen to possess special knowledge regarding design, color, form, shape and space. His technical skills are presumed and completely unproblematic. Top photographers participate in the conception of the ad and liken their work to that of an artist in terms of artistic control, not in terms of craft or technique. In the following quotation, a top photographer talks about how art directors treat her:

> Advertising photographer #3: An art director will call me because of what I do. If the art director wants something else, he'll go to a really commercial studio and show the photographer a literal sketch and say, in effect, to the photographer, "You can fill it in." In that case, he presents an almost exact layout of the ad. If they want that, they go to somebody else, not me. I'm very fortunate to have the flexibility I want.... I'll give you an example. I was given complete freedom to create the concept of the ad for the agency and for the client. I do my thing and then it's up to the agency to sell it to the client.

The situation, however, for most advertising photographers is not like this. Only "top" photographers are regarded as visual experts who are allowed to participate in the conception of an ad.

The second dimension used by photographers and art directors to evaluate "creativity" concerns finding technical solutions to each particular layout's set of problems. Advertising photography is characterized by a body of knowledge that prescribes standard ways of setting up and shooting types of pictures to meet certain standard problems. A photographer mentions several of these:

> All the ice cubes in liquor ads are plastic . . . they're very expensive, $30, $40 each and they're hand carved out of plexiglass. You put glycerine and rosewater in an atomizer to make condensation on a bottle. You put silvered paper behind anything transparent and make light come through it. Light is the big thing. You manipulate light in an unreal way to make the product look more real than real: it shines, it shimmers, it glows. You fill in shadows by popping light into them. You do backlighting for mood. You use clay to prop things up. Or take a car shot; you can't do it in a studio because you can't manipulate light the way you need to. You've got to use light from the sky. But you need an extremely wide open field, because you don't want reflections off buildings, lamp posts, people or other cars. The horizon line has to be low and straight, so it accentuates the lines of the car and doesn't compete with them.

It is precisely because so many photographic problems have standard solutions that photographers and art directors define "creativity" as the solution to a technical problem for which there are no standardized solutions. In fact, this criterion for the assessment of creativity is so important in the world of advertising that photographers swap stories about their search for technical solutions and they talk with great pride about how they devised an innovative solution for a particular problem, as in the following example.

> Advertising photographer #15: I had to do an ad for a large toy store that showed a castle underwater. I built a tank and submerged the castle in water, shot the pictures and they were awful. So I thought about it. Then I set it up and used some gel on a glass screen placed in front of the lens. I smeared vaseline on it so it would look like waves in the water. I placed some vegetation around it. Now that's an example of the natural process of thinking through a problem. And you keep on learning.

It should be noted here, again, that there is great pressure on photographers to devise innovative technical solutions in their attempt to win and secure a "creative" reputation. One consequence of such social pressures is that advertising photography has certain stylistic features which are, in fact, the result of a great deal of technical manipulation.

Advertising photographers, like newspaper photographers, rely heavily on standardized ways to produce standard pictures. Yet, the counter pressures to produce "creative pictures" are so strong that photographers compromise by producing technically innovative standard pictures. Once again, we see that

conceptions of creativity arise in response to the objective social relations and constraints that characterize the advertising world and, furthermore, that conceptions function as a perceptual filter which, in the long run, seems to perpetuate and maintain the "look" of advertising photographs.

chapter 6
fine arts photography

Because "fine arts photographer" is not an occupational category, one might expect that they are totally free from the constraints that are associated with photography *qua* occupation. To a great extent, this view is correct, and the fine arts photographer is not restricted by the organizational features of production associated with news and advertising photography. As a result, the fine arts photographer has a great deal of control over the technical and aesthetic aspects in the production of his photographs. However, though there are no apparent structures that impinge upon the photographer's control over the work process, this does not mean that his choice of imagery is totally free from constraint. In the world of fine arts photography, the constraints are located in the distribution end, rather than the production end, and while they are more difficult to discern than those already identified, they operate forcefully nonetheless.

The Background

A fine arts photographer seeks recognition within that institutional domain known as "the art world," which consists of critics, collectors, connoisseurs, artists, museums and galleries. I will focus on museums and galleries in particular.

Photography is a medium where the notion of "one-of-a-kind" does not apply in the same way as it does for painting and sculpture. Admittedly, there is only "one" negative. But hundreds of photographs may be printed from one negative. This property of the medium has financial repercussions because, as in lithography and other graphic arts, there is a tendency to limit editions in order to sustain, if not elevate, the price each print will command. In fact, there has been an incipient movement afoot, among a few gallery directors, to ask photographers to destroy the negative after a given number of prints are made. When I began my research in 1970, there was much talk about the destruction of negatives. At this writing, the topic has died a natural death, since many photographers refused to cooperate with the gallery people who initiated this idea.

Despite the fact that photography is a modern, multiple-image medium, fine arts photography, unlike photography for the printed page, is governed by the traditional, "one-of-a-kind" criterion: the technical and artistic excellence of each print. Poor technique, no matter how imaginative or profound the image, is rejected, unless its deliberate use is essential to the aesthetic of the image. The proper presentation of photographs, that is, matted and mounted (sometimes framed), is expected in the art world. Thus, the technical excellence of the print and the way it is presented are just as much a part of the photograph as is the image.

Before describing the world of fine arts photography, a distinction must be made between photographers who achieve social recognition and those who do not. In short, the systematic differences in the ways "famous" and "non-famous" photographers are treated require that this distinction be made. In the discussion that follows, I will first describe how photo galleries operate with respect to non-famous photographers and then famous photographers. A short digression, concerning the relations between galleries and museums, follows. Finally, I will describe how museums operate with respect to both famous and non-famous photographers.

Galleries

Young, aspiring fine arts photographers who want to have a gallery show must put together a portfolio of their photographs to present to the director of a gallery. Since gallery directors receive between ten and fifty portfolios a *week*, most gallery directors have established a few formal rules.

> Gallery Director: I look at portfolios every Thursday. I don't want the responsibility of keeping them here. In fact, I don't even want to look at portfolios. I'm over-extended right now.

Another gallery director insists that the photographer's portfolio contains forty prints, all made in the last year.

> Gallery Director: Some photographers submit 20 pictures they made from 1960 to 1969 and then they stopped working for two years and then they turn out 20 recent prints that are totally different from anything they have ever done before. It's hard to see work like that. That's why I want 40 prints from the last year. And that eliminates some people. But I still get about 15 portfolios a week, even with a rule of 40 prints from the last year. We got so many portfolios each day when the gallery first opened, I think about 15 a day, that I couldn't do my job. And when I see work, I like to talk with the photographer about the work. But I couldn't. Now I tell them to leave the portfolios and I look them over when I can.

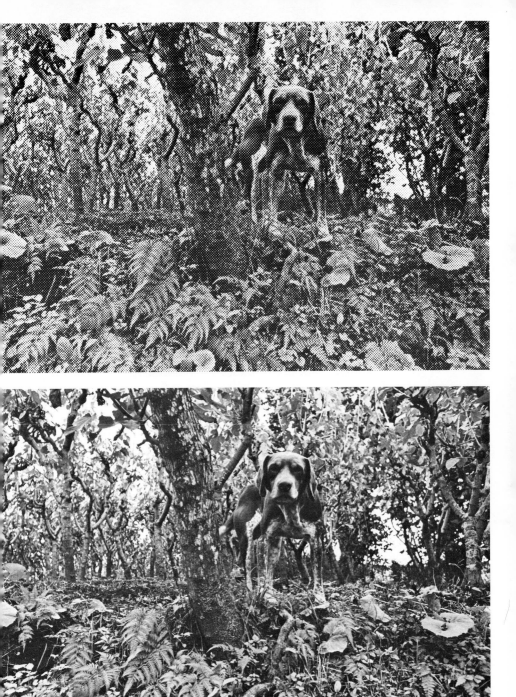

picture, above, printed using a 55-line per square inch screen. Below, the identical image is reproduced using een that has 150 lines to the square inch. Note how the technology of reproduction imparts a characteristic paper look to the image above and a fine arts look to the image below. (Photo by David Watanabe)

News. Example of cropping in newspaper pho
tography. The original photograph above i
quite different from the one below which finall
appeared in print. Cropping means eliminatin
the non-essentials so that the photographer'
primary impact achieves clarity and can b
"read" immediately. (Wide World Photos)

News. Two examples of typical news pictures. Above, familiar faces pose for the press. Right, an "action" shot for the sports pages. (Wide World Photos)

News. A straightforward "head" shot used in the financial section. *(San Francisco Examiner)*

News. A "floater" (a picture without an accompanying story) used as a page one shot. *(San Francisco Chroni*

Advertising. A straightforward model-in-the-center-of-the-composition photo. (Photo courtesy Rona and Betty Yarmon Associates)

Advertising. An innovative composition with unnatural lighting helps create an interesting mood. (Photo courtesy Gucci)

Advertising. The leg cuts the pi
ture diagonally. Ordinarily, th
creates a strong sense of stability
the composition. Yet, the effects
light, shadow and the see-throu
fabric give the leg and the enti
composition a sense of movemen
(Photo by William Mohr. Courte
Edison Brothers Shoe Stores)

Advertising. Using a square fo
mat, the placement of the models
such that the composition fee
solid and stable, although it is n
symmetrical. Look closely and yo
will see the most stable shape i
nature: a right triangle. (Photo b
Gordon Munro. Courtesy Bonwi
Teller)

Advertising. An interesting use of perspective to create "advertising space." (Photo by Sal Corbo. Courtesy Douglas D. Simon Advertising)

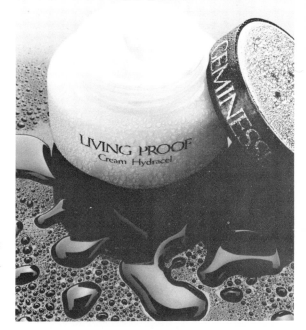

Advertising. An extreme close-up shot provides hypertactility, overaccented surface and surface texture. (Photo by Marc Feldman. Photo courtesy Max Factor)

Advertising. Left, surface pattern is lively and busy. Below, dramatic lighting and close-up give this image a special intensity. (Photo by Bob Richardson, courtesy Kiva Ltd.; photo by Albert Watson, courtesy Kurtz & Tarlow Co.)

ine Arts. Both images have similar themes: people looking out on vistas of space. Yet, each photographer
andles the subject matter very differently. Photo above is an example of flat or planar spatial construction
hile the one below relies on perspective to achieve its effects. (Photos by Frank Nakagawa, David Watanabe)

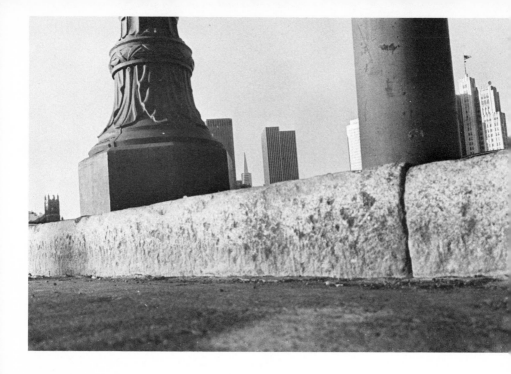

Fine Arts. Above, sharp focus and harsh light give this picture a hard-edge quality. Warm light and soft focus impart a languorous quality to the image below. (Photos by David Watanabe, Debora Hunter)

Fine Arts. What makes this picture different from standard father and son studio portrait shots is the soft focus, the large grain and the use of shadow for modeling. A fluid image, this rendition of a father-son relationship relies on a combination of various aesthetic and technical effects. (Photo by David Watanabe)

Fine Arts. Properties of the camera can be used to transform ordinary objects or people into representations of fantasy. Above, the shutter speed was slowed down while the figure moved. Below, strong lines and harsh background lighting bring out the soft, delicate quality of the figure and the fabric. (Photos by the author)

Preparing a portfolio that he plans to submit to a gallery director, the photographer must take a critical stance towards his own photographs during the selection or editing process. In theory, he assumes the role of his audience and evaluates his own work from their standpoint. However, because the tastes of gallery directors are not explicit and, furthermore, are capricious and unpredictable when it concerns new work, there are no formal rules or informal guidelines the neophyte photographer can apply to guide his selection of photographs. The photographer does not know, in advance, how and to what each gallery director will respond, since gallery directors themselves do not know.

Thus, to the extent that the fine arts photographer's audience, at this point, is a heterogeneous agglomeration of disparate tastes, the audience *qua* reference group might be viewed as more imaginary than real. Lacking any sort of concrete information that might help him orient himself to a real audience, the photographer becomes confused in terms of what criteria to employ in the evaluative editing of his own work. In the absence of any information which might help him put a portfolio together, the photographer's choices are often confused and arbitrary.[1]

From the standpoint of the gallery director, the evaluation of new work is difficult, for it places the director in the role of critic. *Every* gallery director interviewed found this aspect of work the most difficult and personally problematic. Because the gallery's financial existence depends upon its continuing ability to attract buyers, collectors and a walk-in audience, gallery directors are constrained to select a photographer they regard as a "good bet" and not a flash in the pan.[2]

But, since this evaluation is fraught with indeterminate variables and since no one director can divine the future, the decision to show a new photographer's work is often a collective one, made by the director and the gallery owner who are, in most cases, different people.

Once the decision is made, a series of steps is initiated which concludes with the opening of the show. First, depending upon the gallery, a contract may be drawn up between the photographer and the gallery, which specifies the number of photographs to be shown. Included in the contract are terms which may be idiosyncratic to the photographer. For instance, an inventory count may be requested by the photographer when the prints arrive at the gallery. Payment due dates are sometimes specified in the contract as well.

The gallery receives mounted prints from the photographer, usually about six weeks in advance of the opening. During this time, the gallery director and his assistants, if there are any, prepare for the show. An announcement is prepared for the press and for the people on the gallery's mailing list. This announcement is sent to photography critics, art critics, and interested columnists at newspapers and local magazines. A biography of the photographer is prepared, usually on gallery letterhead, which is mailed to the press along with the opening announcement. The prints must be matted, framed and hung. Finally, the gallery director arranges for the delivery of flowers or some

other kind of gift to the photographer on opening night, in addition to making arrangements for refreshments at the gallery on that night.

The photographer is expected to provide his prints on time and to price each print. However, since many young photographers seem anxious about their forthcoming shows, new photographers are notoriously late with their prints. Gallery directors suggest that established photographers get their work in on time because they are less anxious than a first-show photographer. In addition, established photographers have an inventory of their work on hand.

Financial arrangements vary from gallery to gallery. Some photo galleries model their financial arrangements on the terms which painters and sculptors conventionally arrange: a 60/40 split, with 60 percent of the selling price going to the photographer. These terms are general guidelines and are almost never attained. Since galleries need flexibility in pricing in order to generate business, particularly when the gallery opens, discounts are sometimes provided to customers, often at the discretion of the director. There are standard discounts: 10 percent courtesy discount for institutional buyers, a 30 percent discount to other galleries. But the director sometimes need more price flexibility beyond these standard terms:

> Gallery Director: Once I had to give a discount on the purchase of three or more prints. You have to negotiate. You can lessen the house commission while you are trying to build up institutional business.

Although people who drop in off the street might constitute a "looking" audience, they do not, with an occasional exception, buy photographs. The real customers are collectors and institutional buyers:

> Gallery Director: When I have a Maholy-Nagy, I can call up people in Houston, in England, in Japan. I can call them up in the morning and have a sale by the afternoon. It's making it through the first year or two, building up those customers. In this business, the longer you stay alive, the better your chances for staying alive.

Thus, theoretically, having a show not only means social and artistic recognition for the photographer, it also means financial gain, for the photographer also enters an established economic network. However, in practice, this is not the case, because institutional buyers and collectors "do not buy an unknown. They want blue-chip photographers." This gallery director continues:

> Sure, people say that I don't love little great geniuses. And that they can't get recognition through my gallery. The point is that, if you are a collector or a beginning collector and you have $100, you want a name. I beg people to buy an unknown print, but people are not interested. They want a Weston. This gallery only shows famous people because that's what people want to buy. I have to stock them.

Since every gallery must survive financially in order to sustain itself, the aesthetic judgments and the personal convictions of the director, no matter how innovative the director might be, must always be subordinate to this financial imperative. Financial survival constrains the gallery director to feature blue-chip photographers but, at the same time, it conflicts with any other commitments which concern the advancement and promulgation of photography as an art. Furthermore, gallery directors report that they feel a social responsibility to feature the works of new photographers, since the gallery is the only way a new photographer can get public exposure. Gallery directors agree that the museum's commitment to its own collection precludes the possibility of its role as sponsor of new photographers.

Famous and non-famous photographers initiate shows differently. Non-famous photographers must contact the gallery director and leave their portfolios with him for evaluation. Famous photographers are *contacted* by the gallery director, who must often demonstrate to the photographer why his gallery is the photographer's best choice. Furthermore, photo galleries, like painters' galleries before them, offer the photographer exclusive contracts. The gallery then acts as the photographer's agent. Under an exclusive contract, any sales of his photographs must be handled by the gallery. This arrangement not only frees the photographer from any financial haggling with potential buyers, but it also provides him with an automatic outlet for his work. The famous photographer can translate his reputation into sales, promotion and distribution of his new work, if he accepts an exclusive contract. But, most important, the "famous" label means that photographer has an immediately receptive audience for his new work, through the institutional and economic network that the gallery provides.

The Impact of "Having a Show."

Museums never give a new, unknown photographer his own one-man show, but rather wait until the photographer acquires his reputation through gallery shows and other forms of exposure. Thus, the museum is dependent upon galleries literally to screen photographers for them. The vast number of photographers is reduced, through competition at the gallery level, to a number the museums can consider for purchase and for shows. Thus, "having a show" in a gallery is a public ritual which photographers, themselves, define as the only serious and legitimate means of acquiring social recognition as fine arts photographers: it opens up museum doors. But it is the museum that is regarded by photographers as the *only* legitimate institution within the art world that is mandated to confer the artistic stamp of approval. Thus, when a gallery director selects a new photographer for a show, he is fully aware that he is making opportunities possible for the photographer. He is initiating a labeling process, one outcome of which is the legitimate artistic recognition of his "good bet." When that recognition is conferred, the gallery director is rewarded financially, since he can now command higher prices for each

photograph. On an institutional level, galleries and museums are mutually interdependent, if not symbiotic, and each can benefit from the other's decisions.

By comparing the differences between famous and non-famous photographers, we inevitably uncover institutionally patterned forms of recognition. Moreover, the significance of relationships between the gallery, the museum and the photographer become evident. All seventeen fine arts photographers I interviewed had already had their first gallery shows. Eight went on to acquire extensive recognition. Museums purchased their photographs, and galleries around the country requested the opportunity to sell their work. Another three, at the time I interviewed them, were in the process of preparing photographs for tentative shows in the future. Yet the other six photographers, despite positive feedback on their first shows, have not acquired the fame that was promised by "having a show." Surely, as I suggested before, the careers of these six photographers can be considered in terms of the natural attrition that occurs from the gallery level to the museum level. Yet these six photographers all have something in common: despite going through the first show successfully, in terms of critical notices, these photographers did not stabilize their new self-conceptions into a lasting identity (Becker, 1956). The other eleven photographers, when socially recognized as "a fine arts photographer" after their first show, went on to invoke the rights and obligations of the new status. These photographers activated the networks made available to them when they were accepted into the fine arts community. Each one, in his or her own way, actively participated in translating this initial recognition into career currency. A show does *not* mean tremendous financial success from the sales of photographs. A show does mean acquiring a reputation and a transformation of identity.

> Fine Arts Photographer: Maybe I sold a few prints, but it doesn't make a difference. Nobody came and offered me a fantastic assignment after the show. I don't think it works that way. People know me now. I think it increases your reputation and name. And there's a certain kind of prestige in that you are written up. And even though you don't get financial support, what happens is that you can say, "Look, I'm here. I'm a photographer. This is my work."

It is the photographer who goes on to pursue occupational opportunities made available by having a show—the photographer who accepts a teaching job, runs a workshop, attempts to obtain grants—who actively transforms the recognition conferred upon him, who can stabilize his new identity. Photographers who define "having a show" as a terminus in the career cycle and perceive this recognition as an end in itself do not seem to go on to acquire fame. On the other hand, photographers who perceive recognition as instrumental do seem to go on to acquire the "famous" label. Thus, young

photographers must learn to transform initial recognition into marketable currency if they are to stabilize the recognition and self-conception this *rite de passage* provides.

Museums

When a new, unknown photographer submits his work to the photographic curator of a museum and his work is rejected, either for purchase and/or for show, his temptation to define the "museum as mausoleum" is great. Insofar as this characterizes the museum's (*qua* institution) tendency to acquire the work of established photographers, this definition is accurate. This also reflects the conflict between fine arts photographers who wish the museum's major function to be the sponsorship of contemporary artists, and the museum's self-definition as the official societal repository for works of art. Museums, however, do differ from one another and there are several variables which need to be made explicit here.

First, the general policymaking goals of the board of trustees of each museum and how they see the museum's role in the larger society determines whether the purchases, in general, will be of historical or contemporary works of art. Second, museums differ with respect to their status as public or private institutions. Public funding means public accountability and the curators of public museums with whom I spoke emphasized the museum's role in serving the community at large. Private funding, on the other hand, means the board of trustees can allocate funds differently from a public institution. Specifically, a public museum sponsors educational programs, lecture series, films for children and sometimes concerts or public happenings. As a result, public museums have less money in their purchase funds than do private museums, which do not sponsor public events, on a proportionate basis. Third, the amount of money available for each department is another variable. A fourth variable is the autonomy of the photography department. In some museums, photography comes under the province of the Department of Prints and Drawings; in others the Department of Photography is an autonomous section. The photography curator's autonomy is a fifth variable. In some museums, the board of trustees routinely approves any decisions the photographic curator makes, in terms of purchases or shows. In other museums, the board of trustees exercises its control over curators and, often, curators are required to demonstrate to the board why a show or a purchase will benefit the museum. Finally, a psychological variable—the goals, the philosophy and the aesthetic sensibility of the individual curator— is another determinant of how funds are allocated within each department.

Fine arts photographers who submit their work to the photographic curator never seem to realize the organizational boundaries and constraints within which curators must operate and which often tie the curator's hands. Instead, photographers give highly charged, emotional responses in which they blame the curator for their lack of museum recognition. They called curators

"assholes," "cheap," "misogynists," "homosexuals," and other pejorative terms. In addition to these personal allegations, they characterized museums as "stinking" and "uptight" places.

The curators vary with respect to how they manage the conflicts inherent in that role. One curator, for instance, reduced his conflict by selecting and adhering to a view of photography that is, compared with the other five curators, somewhat more narrow:

> Every curator has his own particular point of view and, of course, no one is right. I believe that the history of civilization in printed images is one of the most important aspects of photography and a museum is a place where these images can be preserved and stored. Many curators are concerned with collecting the photographs of identifiable artists, but I think they neglect a good deal of historical ephemera. Some curators tend to emphasize the artistic aspects of photographs. I tend to have more of a regard for historical images than most.

Another curator, on the other hand, rejects many donations she received because, in her view, "Photographs must have some artistic values as well as being 75 years old."

One difficulty facing curators and photographers alike is making distinctions between "historical" and "contemporary" photographers, since the field is about 130 years old. As one curator said, "Many of the masters of the field are still alive and still working. Are they historical or contemporary?"

In contrast to the two curators described above, whose philosophies towards photography helped them reduce role conflict, a third curator was especially concerned about these conflicts:

> Some curators feel better if the photographer has been dead for at least 20 years. It's easier to account to the board. Here, we make a big effort to look at work that's going on right now. But you don't have any idea of the problems that entails. There's no guarantee the work will go anywhere. Sure, we might buy a print from a promising young photographer but . . . do you know what percentage of photographers drop off, from the time we buy the first print of his work? It's incredible what a small percentage of work will develop after the initial purchase. On the whole, photographers might be the most prolific in comparison with all other media. And the pace of work is different, too. But, even though it is a prolific medium, a fantastic percentage of photographers drop off. OK . . . and there are other considerations as well which begin after the launch-date. What is his need? What is the museum's need? What is your commitment to him? After the launch-date, are you committed to buying prints from him every year? Even in his bad years? And, if it's good, how many do you buy? Can you afford to buy his work? Because his prices, remember, are going up. Can you store his work? Are you going to file them in boxes and select a print when a new acquisitions collection is shown? A new acquisitions show reflects the state of the medium, not one specific photographer's work. So, are you going to buy a few prints and leave them in boxes and keep reappraising them? Will you buy one print for the show and that's it? These are very complicated questions and decisions. And then there's the critical judgment and critical stands of the

individual curators. A museum curator sees an overview and it's both good and bad. I am sometimes numb to idiosyncracies of highly individual work. Not in terms of formalistic problems, but in terms of statement or in terms of content. Newhall, Steichen, all the curators . . . we all have biases and tendencies in one direction or another. We all know that. The major consideration is that the biases shouldn't be simplistic.

In summary, organizational imperatives constrain curators to the extent that their sponsorship of unknown photographers is virtually impossible. Museum recognition is the final step in the career pattern, not the beginning.

When a curator wants to purchase or show the work of a well-known photographer, he contacts the photographer directly or, now that galleries act as the photographer's agent under an exclusive contract, he contacts the gallery director. Like galleries, museums also draw up a contract between themselves and the photographer. Many of the details of the contract are worked out in preliminary discussions, as in the curator's account of a recent show:

> Curator: Well, we talked about how many prints would be in the show. And how we would go about picking them. In this case, he picked all the prints. And before the show, we had a long talk about the nature of the work. . . .
>
> Me: You mean whether it would be a retrospective show or his new work?
>
> Curator: Exactly. Or sometimes the photographer has been working . . . you can call it exploring new subject matter or new techniques. But we talked about everything before we signed the contract. Now in the current show, X and I went over the work together. Sometimes we disagree, but it's loose and we are both very un-uptight people. Or we're planning a show for the future on women photographers. I'll be working with Z (a well-known female photographer and critic). She's been researching this for a long time now, and I'll defer to her judgments. In general, I suppose the famous photographers are the ones who pick their own work to show. Yes, you could say that.

Like the gallery, the museum staff mats, frames, and hangs the photographs. Unlike the gallery, the museum can make arrangements with museums all around the country to exhibit the show. A famous photographer's reputation can increase regionally and internationally through the apparatus of the "traveling show."

The critical notices a show receives and the number of other museums that will accept it as a traveling show can be translated into kudos for the curator, prestige for the photographer and, in the long run, increased value for the original museum's own collection. The curator is congratulated for his success in bringing together a coherent and integrated presentation of the photographer's work; he has done his job well and he is given credit for it through critical acclaim. The photographer can increase the number of sales of his prints through exposure, especially if the show travels. Although it does not happen frequently, many museum-goers see a print they want to buy. Museum-goers who purchase prints are often not from the same population as those who

frequent the photo galleries, although the photographer can anticipate some additional income from such sales.

The appraisal value of the museum's own collection increases as the price of each print increases. As the photographer's reputation increases, so does his price and, therefore, the value of the museum-owned prints. The curator, therefore, has a stake in the increasing reputations of photographers whose prints the museum has already purchased. Prints the curator purchased five years ago at $35 or $50 each might now command between $125 and $250 (sometimes as high as $500) in the gallery marketplace. Thus, the museum's participation in the creation of the photographer's reputation, through local exposure and national exposure via the "traveling show," may be motivated by its own economic self-interest, in addition to other factors.

In order to achieve the recognition from the general public, a fine arts photographer must first receive the stamp of approval from the inner fraternity of the photographic art world. While I have focused here exclusively on museums and galleries, additional first-hand data on the roles of critics and collectors would be very useful, for it would enable us to understand more precisely the mechanisms by which reputation or "fame" is constructed. Further analysis of the relationships between critics, curators and galleries would deepen our understanding of the processes through which photographers attain social recognition (see Kramer, 1968).

The Job

Fine arts photographers make pictures for exhibition and for themselves, independent of their sources of income, and to push for structural parallelism with news and advertising photography would not be empirically faithful. Some fine arts photographers teach to make money. Others drive taxis, run elevators. By working at non-photographic jobs, they attempt to segregate the "sacred" from the "profane," for they regard the mixture of money and photography as a powerfully corrupting influence. Other photographers make money by doing commercial photographic work of all sorts; some do fashion, others take baby pictures and others shoot interiors for decorators' portfolios. No matter what their sources of income, fine arts photographers make photographs for their own personal expression and communication. This is their special insignia.

Controls and Constraints

In order to trace the social bases of styles in fine arts photography, it is necessary to identify the social factors that circumscribe what photographers can and cannot do. These controls and constraints yield a picture of a fine arts photographer who works in a craft mode and who must attempt to gain recognition by exhibiting in a tightly controlled and competitive market.

With respect to production, fine arts photographers determine for themselves practically all aspects of the labor process, including the rhythm and pace of their work and the quality and quantity of their output. They determine what techniques will be employed, what equipment will be used. The photographer controls each of the hundreds of little decisions that go into making the picture. Since there is generally no division of labor, he can make one decision with "reference to how he will do another" (Dewey, 1934: 45). The fine arts photographer can "think" in terms of an aesthetic totality and can apprehend various relations among all the steps. By not selling his services to a client and by not involving himself in a structure where he is required to make pictures for his livelihood, the fine arts photographer retains his autonomy and control over the picture-making process and the methods of production.

Unlike news and advertising, where many aspects of work are structurally and organizationally predetermined, fine arts photographers vary tremendously in their work methods. Fine arts photographers' work methods are as individual as each photographer I interviewed. To illustrate how much control over the work process fine arts photographers actually do have, let me furnish some examples of how they work.

One photographer I interviewed shoots every morning and develops his film in the afternoon. He hangs his wet negatives to dry during supper and, every evening after dinner, he contacts and prints the negatives. Another photographer shoots during the warm months, during which time he develops and contacts his negatives. He spends the long New England winters printing these negatives. A third photographer works sporadically, shooting on and off for months at a time and, at some point, he decides to develop all his film at once. At that time, he sometimes works in the darkroom for three days straight, day and night, developing and contacting the negatives.

Fine arts photographers generally agree that their creativity is cyclical. When a work cycle is over, the photographer needs to retreat from photography. During this, the photographer refreshes and refuels himself so that he can return to photography with renewed vigor. One photographer referred to this period as a time "when I take everything in, instead of giving everything out." Despite the high degree of variation in personal work styles in my sample, the thread that links these photographers is the virtual absence of the division of labor and absence of extensive technology. Every photographer did every step in the picture-making process by himself, ranging from the routine tasks of mixing chemicals and taking temperature readings of solutions, to the more demanding and complex work of printing the negatives. On occasion, I found a division of labor but, where it exists, its character is elementary. For instance, sometimes a famous photographer will hire his or her students to make multiple prints from one negative.

With respect to the technology of the photographic process, a remark made by one photographer applies to all the photographers I interviewed. He said, "Keep it simple" and, in fact, every photographer had a simple set up. Of course, darkrooms ranged in size and comfort, and some photographers had

more extensive equipment than others. But all in all, their darkrooms contained little gadgetry, no mechanized equipment and no "fancy" equipment that elaborated on the basic photographic process.

One reason for "keeping photography simple" is the small limited annual income of fine arts photographers. Keeping the darkroom supplied with printing paper is the fine arts photographer's biggest expense. Since he is concerned with matching an image with paper that is suitable for the particular image, the fine arts photographer needs a variety of papers on hand in the darkroom. Fine arts photographers are often concerned with making only enough money to enable them to purchase paper.

In the selection of subject matter and its rendition, advertising and news photographers receive their assignments from other people; they are told what to shoot. In contrast, fine arts photographers' assignments are self-generated and they select what they want to shoot. In my sample, they reported various ways in which they became interested in some specific subject matter or theme. For some, new subject matter organically grew out of the previous work. For others, preoccupation with an abstract idea, such as the relationship between lovers, propels the photographer to shoot specific subject matter. For another, it is a visual idea or a whim that engages the photographer and places him on a virtually uncharted course into a subject area.

Despite his autonomy, the fine arts photographers' freedom to produce any sort of imagery is limited by a few, but powerful, social factors. These are marketplace constraints, institutional pressure for originality, and the linkage between art schools, galleries and museums.

The Market

The market is a powerful source of control that influences, in part, what photographers shoot and determines what the public eventually sees and defines as fine arts photography. The market is highly competitive; there are many more photographers than there are outlets for exposure. Furthermore, the actual demand for purchase, while it has increased within recent years, does not approach the volume of supply. Institutional gatekeepers, such as museum curators, key gallery directors, critics and "important" collectors, define the current fashion through their own exhibitions and purchases. These definitions, of course, change from time to time. When I began this research, photographs of poor people in both rural and urban settings were in vogue. Another type of subject matter that was popular was the photographer's own family rendered in classically beautiful ways. When I finished, portraits of middle-income suburban families, often depicted as participating in family ritual, were popular.

Economic constraints imposed by the market structure exert pressure on gallery directors and museum curators to seek and find a "winner." They will mobilize their resources and stake their reputations on such a photographer. If

other people in the art world, especially critics, also agree that the photographer is a winner, the "backers" will eventually reap the financial and prestige rewards of their initial wisdom. But, in actuality, museums and galleries rarely back a new photographer or show his work, for there is little certainty of financial success in that. Rather, upcoming photographers appear in group shows and, more often than not, the gallery will show the new work in some of its exhibition space while elsewhere in the gallery the old "reliable" masters are on "permanent" exhibition. Buyers might enjoy new work, but they buy established photographers whose work has already been catalogued and classified within some "school" or "tradition." Thus, the economics of the art world has the latent consequence of maintaining the dominance of several photographic traditions, such as the West Coast landscape school. These categories are much more open in fine arts, and there is no enforcement structure or threat of loss that forces photographers to comply with any one tradition. But the market rewards photographers who do, in fact, work within one of several conventional traditions and select imagery that falls within approved and already "certified" directions. Here is an example of how these market factors are seen by one especially articulate photographer:

> I've won a Guggenheim, which is the highest award for a fine arts photographer. My work hangs in museums. But don't think that the museums are so noble and pure and sacred. X curator, he influences photographers' work, for good or for ill. The photographer develops a client relationship with the museums. X has an aesthetic that can be described: he likes photographs taken with large cameras, that are posed and that have a 19th century character to them. I personally feel that it's dangerous when an institution begins shaping the kind of pictures photographers make. And then Y is homosexual and he doesn't like pictures of women and the Z has academic and formalistic tastes. The museums have encouraged a preoccupation with neurotically personal and the aridly formal at a time when we are surrounded by an atmosphere of tremendous social agitation and polarization. My work is involved with social meanings and there is no museum or gallery that wants to show or buy my work now.

In short, powerful gatekeepers can make a trend. I do not mean to suggest that there is a conspiracy among curators or gallery directors in the sense that they decide what type of photography to encourage over the next few years. Rather, it seems that one consequence of the market structure is that it does, in fact, allocate enormous power among very few persons, with the unintended result that their decisions can create a wave whose wake seems to radiate to other strata and other regions in the photography world.

Photographers who do not produce imagery that conforms to prevailing definitions of photography are faced with the problem of how to get their work shown. For instance, a number of San Francisco and San Diego photographers see the art world as an institution of social and aesthetic control. They ideologically resist the hegemony of powerful gatekeepers and the prevailing definitions of photography as "art" by rejecting the definition of the single image as an

autonomous art object.[3] In their view, a photograph has no meaning in isolation, but rather its meaning is constructed through juxtaposition with other imagery. Since many of them have been influenced by semiology, they juxtapose the image with text but treat the text as part of the image, rather than treating it as ancillary to the image. Their definition of photography finds no sympathy or support among gatekeepers. These photographers do not get shows, not even at the local gallery level and, consequently, they have to create their own alternative systems for the distribution of their work. This case is a good example which shows the extent to which prevailing definitions filter down to regional and local galleries and, furthermore, the extent to which the economics of the art market upholds institutional definitions of purely pictorial photography, a tradition borrowed from painting, and which delegitimates the printed word as "art," and sees the printed word as "contamination."

Thus, the market may be seen as a source of control through its creation of boundaries, definitions and meanings. Constraints on photographers to produce work within a few established traditions arise from the market allocation of rewards. In other words, the market itself determines the definition of "fine arts photography" by virtue of what is selected for inclusion.

Institutional Pressure for Originality

Another pressure on photographers is to produce "original pictures." This presents a conflict between the marketplace's need for "traditional" pictures and the art world's emphasis on originality. "Originality" as a criterion for evaluation is emphasized by dealers and curators. Yet, when one actually looks at the economics of the art world and the way in which portfolios are selected, it is clear that gallery directors and curators sift out a great deal of "original" imagery, which results in the perpetuation of existing styles, *genres,* and traditions. Operating under the ideal of originality, photographers are pressured to photograph subject matter that has not been photographed before.

> Fine arts photographer: Well, Stieglitz was the first person to take pictures of hands. And then he took pictures of clouds. Now that, in itself, isn't very important but no one had ever thought of pointing the camera up and taking pictures of clouds.

Diane Arbus, too, was accorded recognition for her photographs of social misfits, a category not usually photographed. Similarly, in 1972, a photographer had a one-man show in a New York gallery which included many photographs of his wife, a subject not unusual for fine arts photographers. However, he photographed his wife standing with her legs apart, urinating, and since that had not been done before, the reviewers selected that photograph for extensive commentary.

Originality is also seen in terms of technique. We have already seen how technical innovation in advertising photography is defined as "creative." In

fine arts, technical innovation is also seen as part of "creativity," but furthermore it is seen as a search for something that enables the artist to express himself beyond the limitations of currently available materials.

Of the seventeen fine arts photographers I studied, five concocted their own noncommercial chemical mixtures to develop film, which enables them to obtain tonalities and other print qualities that commercially available products cannot yield. Some photographers who do not want to be limited do experimental work by coating glass, plastic, fabric, paper and other materials with light sensitive emulsions. For this kind of work, they must prepare their own emulsions. One photographer literally scraped the bottom of the barrel to get the emulsion he wanted:

> One day I was in the darkroom and I saw something I had always looked at but never seen. The wet papers you throw away in the garbage when you work in the darkroom. I saw things . . . colors . . . in these black and white papers. I got very excited and got down and collected all the emulsion that dripped to the bottom of the trash can. I know a lot about chemistry so I analyzed it and I prepared more of it. Then I used it to coat plexiglass.

Other photographers hunt for antique cameras or lenses in order to achieve certain effects that are impossible to achieve with contemporary equipment.

Art Schools and the Art World

Another source of control and constraint on the types of imagery photographers may choose is the effect of the educational-gallery-museum network system in the world of fine arts photography. There are linkages between gatekeepers and "important" university and college photography departments. Through the sponsorship system, students are structurally channeled into working within the tradition of their mentors and are often rewarded for that by the "connections" their mentor makes with his or her agent or gallery. This system of sponsorship can be seen as an extension of the marketplace in that it provides access and is a system of privileged recruitment. While this social arrangement furnishes a mobility path for upcoming young photographers, it also at the same time tends to perpetuate the dominance and continuation of several photographic traditions. For instance, one gallery director reported to me that she could identify a photographer's teacher simply by looking at his portfolio.

Three structural sources of constraints have been identified in this chapter and can be seen to exert social pressures on photographers to produce pictures that partake of some conventional traditions. Of course, there are occasional exceptions. Some careers, in fact, are begun by an outrageous violation of convention and tradition. But these cases are rare indeed. Typically, photographers get shows when their work has been defined as falling within some already existing tradition in fine arts photography. The influence of social structural features on the production of imagery operates in the world of fine

arts photography but, in contrast to news and advertising, the structural sources of convention are generated primarily through the distribution systems, rather than through the organization of production.

Conceptions of Creativity

Because they do not produce pictures to fit someone else's output needs, when fine arts photographers talk about "creativity," their conceptions are multiple and complex; for them, creativity encompasses a whole range of feeling, thinking and doing. Fine arts photographers enjoy the luxury of being able to self-consciously talk about "what is art?" The fact that fine arts photographers can and do talk about creativity in multidimensional terms can be reasonably interpreted as a reflection of the degrees of freedom they perceive in their roles as "fine arts photographers."

The Person and the Photograph

In chapter two, in the section on socialization in fine arts photography, I mentioned that students are taught the logic of making inferences about a person from his pictures. Another way to make characterological inferences is to evaluate photographs in terms of how difficult it is to obtain the pictures. Photographers have these photographs as testimony to their tourism in hard to reach places and treat them as medals of bravery and conquest. Street photography in seamy neighborhoods is regarded as one of these arenas of combat and conquest. When I have gone into such areas by myself or accompanying photographer friends, people hid their faces, turned their backs or shouted to us. On one occasion, a photographer-friend and I went to an area of Manhattan that is a meeting place for prostitutes and clients and also for male homosexual pickups. While photographing in that area, my friend was verbally assaulted and chased by a woman obviously felt invaded by our presence. Yet, my friend saw this encounter as an added "story," a badge of her courage and bravery.

Some photographers feel uneasy and uncomfortable when photographing strangers and so decide to shoot their friends. Yet, the same criterion seems to be applied here too: how much you can get your friends to do. How far they will go is seen as evidence that the photographer is a creative, innovative, and emotionally courageous person. One photographer encountered initial resistance from friends and family when he asked to photograph them in unconventional, often unflattering nude scenes. Here is another photographer's view of this issue:

> They got used to seeing me take pictures all the time. I always had my camera out. Whenever we went anywhere, I always took pictures. Or just sitting around the house. I'd be taking pictures. After awhile, I asked my wife to pose in the nude. She was a little uptight at first but she was pretty much used to being

photographed. And then I started taking pictures of her doing things that are kind of private or sensitive moments. I mean, there were situations that I never photographed because they were emotionally off-limits. Like you don't photograph your wife when she's crying or upset or in the middle of a fight that both of you are having. But photography is very personal to me and I want to document my life, my family . . . my emotional relationships . . . and I had to do it.

Whether photographing friends or strangers, the fine arts photographer can ask people to assume unconventional poses, to wear weird clothing or to wear nothing at all. He can "get away" with photographic requests that would ordinarily violate commonsense notions of propriety by assuring the participants that his interest is artistic and not voyeuristic. Thus, invoking the traditional rights of the "artist" role is a strategy that enables fine arts photographers to overcome the obstacles that arise from the normative constraints that govern everyday situations. News photographers must work within such constraints. But fine arts photographers can utilize the role of "artist" to go beyond the customary social boundaries of everyday situations. They can use the role to achieve access to more intense and, possibly, original portrayals of life.

The Creative Moment

When I asked photographers questions about creativity, the answers I got were in terms of two different time orientations. The first I will call "personal historical time," and the second I will call "photographic time." When a photographer considers creativity in terms of personal historical time, he examines his entire autobiography to look for psychological forces that have contributed to his creative development. The following quotation is an example of personal historical time. It shows that the photographer sees creativity as an ongoing and cumulative process of personal growth, adaptation and change:

I think the meaningful influences that get you started working are unconscious. Maybe you go to a museum one day and browse around and see something interesting in a painting. Maybe it's the way the light looks. And that starts you off for a year. You never know. It's not that you just see something out of the blue and you photograph it and get a great picture. You've been thinking for some time about something and you tend to trip over the same problems or different examples of the same problem again and again. Like I've been photographing houses for awhile now and just the other day I saw a house with some interesting hedges and trees around it. The hedges were cut into animal shapes. But here it is: you can say that a theme I've been working on in my pictures is shadows. But in this case, the subject matter is the building. What interests me is the relationship of the lights and shadows and the forms. But it could be this house or any other house. The problem is the same. And you keep on working on it and refining it.

In contrast, "photographic time" is a way of locating the creative moments and creative tasks in relation to the photographic process itself. Within the photographic timetable, some photographers locate creativity before the shutter is clicked; others think it happens afterwards. In order to understand this a little better, we should look at the ideas of Ansel Adams, Minor White and other photographers associated with what is known as previsualization.

Previsualization is a term associated with a method of making photographs that is called the "zone system" (White, 1963). The range of tonalities from black to white is divided up and scaled from one to ten; each numerical value represents a "zone." The *Zone System Manual: How to Previsual Your Pictures* (White, 1963) provides extensive technical data on the exposure and development of negatives so that the final print is the result of the most meticulous and maximum control over light and relationships between tones.

But previsualization is more than a technical guide that enables a photographer to look at a scene and then translate the distribution of light into corresponding zones. Previsualization is a philosophy of making pictures and the *Zone System Manual* (White, 1968: 13) can be construed as a didactic and pedagogical treatise.

> Previsualization refers to the learnable power to look at a scene, person, place or situation and "see" at the same time on the back of the eyelids, or "sense" deep in the mind or body, the various ways photography can render the subject. Then out of all the potential renderings, select one to photograph. Such selection makes up a large share of the photographer's creativity. Previsualization is always done according to the nature of the film in the camera and the photographic printing paper in the darkroom. Hence, the actual light sensitive material in the camera and how this will be processed and printed is always taken into account as the basis of photographic previsualization.

Photographers who employ the zone/previsualization system regard "creativity" in photography as making the picture in the mind's eye. The photographer selects the angle, focus and lighting *in his mind* before actually exposing the negative. As a result, the creative act, in their view, occurs before the shutter is clicked. The remainder of the photographic process, developing the negative and printing it, is simply the technical part of photography. Furthermore, in their view, manual manipulation during the printing process is not required, for if the photographer previsualized the zones correctly, the negative is "perfect" and can be printed "straight," without any manipulation. One photographer who subscribes to this way describes how he works:

> I set up something I want to photograph, look at it for awhile, make some changes if I have to. Then I make one exposure and take the negative directly to the darkroom. I develop it and then study it for awhile. I don't need to print it because I read the negative. . . . I mean I can visualize what a print will look like just by looking at the negative. If I have to, I make corrections and then do another negative. I'll do this until I get the perfect negative, which is about the second or third one, and then I'll shoot another just for a safety. Then I'll just print it another time.

In this quotation, we see how previsualization is utilized primarily as a guide, or as a method, for working. In the quotation below, previsualization *qua* philosophy is emphasized.

> Photographer: Look, if I'm going to take a picture of you, I've got to see what's in front me. I'm not going to manipulate it. . . .
> Me: What do you mean by manipulate?
> Photographer: The use of any device to alter the image now or later. Well, let's say I'm going to take your picture. Part of your face is very sharp, another part is not so sharp. Behind you, it's less sharp. I look around, there is no black. There is no white. There are ranges in between. I am looking at you at a certain angle. All these things can express the intensity with which I see you. The eye, taking the picture, that's the art. The print is really only an object, after the fact. Seeing, it's all in seeing. Like for example, I see horizontally. I see things in ovals in front of me. I hardly ever take vertical shots because I don't see that way. Also, the camera is not really made to take verticals. But a lot of commercial and magazine work are verticals. I just don't see the world like that.

In contrast to photographers who utilize previsualization in their thinking or in their work, other photographers react against the zone system and locate the creative part of photography *after* the camera has been clicked. For them, post-shooting discovery is creativity, as one photographer points out:

> Well, you've got a negative and you know there is something there. You go in and monkey around with printing. You still don't have it right. Maybe you didn't expose the negative just right. Maybe it's too contrasty in places. But by working with it, you begin to understand what you want out of it. Let's say you get an idea about how you want that print to look, but the negative you have won't give it. You may have to reshoot, but when you do, you're five steps ahead than when you first walked into the darkroom to print it for the first time.

For these photographers, each step in the sequence of picture making is an activity which is independent of, but informed by, the original conceptual act of shooting. In other words, by treating each step in the photographic process as separate—shooting, editing, printing, cropping, reshooting—the photographer builds into his method of working the possibility of creating new awareness and discovery with each step. Note the following photographer's attitudes towards printing, particularly the anti-technical tone of his comments:

> Photographer: I was working a print of weeds in the snow and I know that Adams would want the texture of the snow to be very clear. But I didn't care about the snow texture. I printed it white and I saw a new thing about weeds in the snow. And I worked on that idea for awhile. I kept on shooting snow in that new way. Then I

Me: printed it dark. You see things in a new way too when you print it dark. It is different. It's a different way of seeing. And then I worked on that for awhile.

Me: But how about previsualization?

Photographer: I think previsualization is overdone. Art is an act of God and they're trying to make a science out of it. You check out the tones and do this and that reading and move the dials on your light meter and decide where the tones are going to end up and how the image is going to be. I'm not concerned about that. I don't care if the zone of my sand matches some tone in reality and that the other tones are in proportion to that. I'm concerned about the quality I want in that sand. The way I work, many of my ideas about pictures come from printing.

Thus, for these photographers, printing is seen as an act which can enhance the original conception, not just a process that results in an enlarged, positive projection of a celluloid negative. For them, printing is an interpretive and creative step. Here is a quotation that shows how growth, development and creativity are seen by a photographer:

Photographer: All I can say is that God reveals new things to you. Photography is a revelatory process.

Me: Then, if I understand you, the whole idea of previsualization is the antithesis of revelation. . . .

Photographer: Exactly, and I've been fighting previsualization now for a very long time. I don't believe they are telling the truth. They are trying to dignify photography and make it art. Read Weston on this. He talks a lot about it. Weston said that he could see the photograph, not the image, in the ground glass. That he could translate the tones and the image and that he actually saw a photograph. I think it's a question of degree. How much do you translate? You are working with a square or rectangular shape. Inside the borders, there are shapes and tones. How do you translate? Weston makes the picture. But did he make a new picture? I don't think like that. I think you keep on making judgments and decisions. You change it when you print. You keep on thinking about it. You change you mind. It's as simple as that: you change your mind. Working in the darkroom is different from working outdoors. It's a different process. You look at the print and see how tight or spread the tones are. Sometimes it's too good like a painter who makes the perfect brush strokes whenever he wants to. But the thing is that you have to look at it. Look at it and print it. And keep working on it. You must keep working on it, always making it better. When you get a print you like, keep it. I don't believe you don't change from the moment of looking at it in the ground glass to the finished print. You are always changing and reinterpreting the image.

Technical, Aesthetic and Political Dimensions

The camera's ability to capture exactly whatever lies in front of the lens and to render it in sharp detail is a physical property around which controversies have developed. We have already seen in the previous discussion of previsualization that some photographers feel that the distribution of light in the print should try to approximate the actual distribution of light in "reality." Other photographers disagree. Another controversy which concerns "reality" is the matter of cropping. Some photographers view cropping as a creative darkroom technique. Others feel that it is a violation of the "reality" aesthetic and see it as a fundamentally dishonest act. If the image needs alteration, they would maintain, then the photographer should learn to see better and practice by accounting for every square centimeter within the frame while he is shooting. These photographers print full frame and, to make certain that their audience understands this, they print with a black border which can only be created in the darkroom if the image is not cropped. The convention of the black border, then, is a way photographers can communicate that their work is unadulterated.

Although photographers think about the relationship between "reality" and photographic technique, the most important issues and disagreements concern photographers' attitudes towards their subjects and not the technique. The photographer's conception of reality is inferred from his work. His work is then evaluated in terms of his visual representation of life, a dimension which is used to assess creativity. In the following quotation, one photographer comments on the underlying attitudes of a particular school of photography. I include it here as an example of the type of considerations that are taken into account when photographers evaluate one another's work:

> Take the nature photographers on the West Coast. It's the vogue. Weston approached his photographs from an interesting view, but he had a much greater, much deeper understanding and preoccupation than just nature. But the others, they are mirror images of other mirror images. It's intellectual poverty. They don't know a thing about Darwin. They record nature's beauty . . . well, they have a commitment to conservation and wilderness and preservation. But, in their depiction of nature, the great American art nature photograph, there is an indefensible view of the way they see the world. We see violence in urban poverty but calm serenity in nature. Not true, not true at all. Read Darwin.

These sorts of considerations form the basis of a type of photographic criticism that is commonly found in reviews of shows and publications. The photographer's personal statement is evaluated in terms of his political stance which, in turn, is taken to be a dimension of creativity.

During the research period, a book of photographs that created quite a stir in the art world was published. The photographer depicted life in an urban black ghetto. Not *one* photographer I interviewed, nor any of the critical reviewers, criticized the images from points of view which emphasized shape,

forms or spatial interaction. Instead, most of the people I spoke with criticized the photographer for his attitude towards his subject matter: poverty is beautiful and dignified. The photographer, who has written extensively about these photographs, wanted to show that poor people have an essential human dignity that transcends the shabby tenement apartments in which they were photographed. The photographer posed the people he photographed and employed what one curator referred to as "a 19th century aesthetic." The photographs were richly detailed, sharply focused and the range of tonalities demonstrated the photographer's understanding of light, particularly its mood-inducing ability. In short, the photographs were beautifully executed. But this is precisely the issue that became a point of contention. Other photographers and reviewers challenged his political attitude towards his subject matter; they felt poverty is far from beautiful. In other words, they accused him of misrepresenting his subject matter by his having photographed poor people from an aesthetic tradition that emphasizes beauty.

Similarly, during the research period, another collection of photographs, depicting prison life, was published and reviewed. The photographs were considered adequate or good pictures, depending upon the reviewer, but reviewers concurred that the photographer misrepresented prison life. His photographs showed prisoners waiting on the chow line, playing chess or just sitting around talking. Reviewers suggested that he neglected to show violence, homosexuality, and some of the more unattractive aspects of the guard-prisoner relationship. Where the photographer emphasized the death-like boredom of daily prison life, his critics reproached him for producing a narrow, if not misleading, caricature of prison life. The photographer's attitude towards subject matter, then, enters into the assessment of his creativity.

We would expect that a multiplicity of conceptions of "creative" would be found in the art world where, as was already pointed out, institutional pressure for originality is a major component of art world ideology. If this were indeed the case, we would then expect fine arts photography to consist of multitudes of individualistic images, distinguished by personal symbolic systems, introverted complexities and idiosyncratic renditions. If this were, indeed, the empirical situation, we would then define fine arts photography as a residual category that scoops up all the "personal" and unclassifiable pictures that do not fit under any other categories of photography.

But the fact is that fine arts photography is not a residual category, and it does not have an unlimited capacity to absorb all types of imagery. While its boundaries may be more elastic than those of news and advertising photography, the boundaries are there nonetheless. This suggests that the economic realities take precedence over cultural stereotypes: the economics of the art market temper, modify and contradict the idealized version of the "free," unrestrained and "original" artist. In fact, the strength of the market's influence is evident when we realize how *few* photographic traditions are defined as fine art, compared to the vast number of original portfolios that are

submitted to curators and gallery owners each month. The market's influence is also evident when we consider how market demands steer photographers to produce imagery in certain directions. Indeed, a dialectical tension can be discerned now that we have identified the constrictive role of the art market and the "expansionist" ideology that pervades the art world.

chapter 7
towards a sociology of style

The major claim of this study is that photographic styles are largely determined by work organization and the work role. The basis for this assertion consists of the findings which show that photographic styles are directly correlated with systems of production and distribution. News photography, a highly conventionalized and comparatively homogenous system of images, is generated by a bureaucratically coordinated social system that depends on predictable social action. Advertising is a client-controlled, fee-for-goods-and-service, competitive market structure which tends to generate a type of photography that is technically innovative, accented with novelty but which, on the whole, is also characterized by conventionalized mannerisms. Comparatively the most heterogenous and least conventionalized of all categories of photography, fine arts is associated with a particular kind of economic arrangement of production and distribution that is characteristically modern: the photographer makes pictures for an unknown audience and unknown buyers.

On this basis, we can infer that socioeconomic arrangements, particularly work organization and the work role, are partial determinants of style. These determinants can now be added to other theories of style which give primacy to such factors as time, place, capitalist economic organization, geographic location and the internal development of aesthetic style. This study has argued that style is not the outcome of the history of the rules of a form but rather the history of a work role. Work organization is a powerful determinant of style and is an independent variable that not only has its own effects but also interacts with other variables such as time or place.

Photography, then, is not an unlimited medium, as Sontag argues (1977). On the contrary, it is highly patterned. The photographer's selection and rendition of subject matter is largely determined by social considerations, many of which are actualized through the constraints of the role and the organization of labor. Photographic imagery is not as individual as each person who holds a camera. Socioeconomic factors play a significant role in shaping and perpetuating the aesthetic conventions associated with each type of photography. These social and economic factors have both conservatizing

and revitalizing effects on style. For instance, gallery and museum gate-keepers' vested interests in the continuity of stylistic traditions has a conservatizing effect. Market competition, on the other hand, seems to engender innovation. Not only do socioeconomic forces exert simultaneously contradictory influences in opposite directions of maintenance and invention but they also set the parameters for what may be defined as innovation. The conditions under which conservatizing or revitalizing forces dominate is an empirical question that invites further investigation.

While I have assumed the independence and distinctiveness of each of the three types of photography, there can be no doubt that there is borrowing and exchange between them. Clearly, fashion pictures sometimes have the look of a frozen action news shot. Fine arts pictures often borrow from the rhetoric of advertising. Cross-influences occur but they are not all equal. Advertising photography seems to be comparatively the most open and most receptive to the influences from news and fine arts. News seems to be less penetrable by either advertising and fine arts, while fine arts seems open to both but less open than advertising.

If the argument that work organization and the work role are responsible for a particular style is correct, then we would expect that the exchange and borrowing between styles could be explained by the mobility of photographers among the various worlds of photography. In other words, I am arguing that a photographer is a carrier of an acquired vision, which is partly determined by social structure. If he changes his type of work, he brings the vision with him to the new work. My data show, however, that cross-influences between styles is not due to occupational mobility. In addition to the data, published autobiographical and biographical accounts of photographers' careers show that, once they are initiated into a particular world, they do not switch. A news photographer does not seek employment in advertising when a newspaper folds. An advertising photographer does not look for a job at a magazine or a newspaper when he decides to go out of business. Fine arts photographers, while occasionally doing commercial work, will stay within the art-school world. Therefore, the question remains: if photographers do not move between the three worlds of photography, then what accounts for the exchange and borrowing of stylistic features? One plausible explanation is essentially a diffusion argument. The stylistic conventions become part of the larger culture, accessible to everyone. Sociologists sometimes refer to these widespread shared understandings as typifications (Schutz, 1964, 1971). Typifications are seen by all photographers because they are participants in the larger culture. Some photographers in one field might utilize the conventions usually associated with another type of photography and, if the conditions permit, the borrowed convention will enter another specialized photographic vocabulary. Related questions are: How firm and permeable are the boundaries? Under what conditions do the boundaries become emphasized and tightened? Under what conditions is there greater exchange?

If a photographic style is largely a function of the photographer's role and

its concommitant social limitations, then shouldn't we expect millions of ordinary people—people who are not a part of a defined photographic work organization—to produce images that do not fall under one or two or even several photographic styles? Shouldn't we expect enormous diversity among the imagery produced by amateur photographers? The answer is no because they are, in fact, in a photographer's role while taking the picture. Amateur photography is a product of an activity that is a highly conventionalized social ritual. We expect the products of such a ritual to be somewhat similar. When we look at home pictures, slides, family albums, vacation pictures, Christmas, birthday and baby pictures, the evidence is clear: these are highly stylized images which seem quite homogenous. In fact, that there could be such a category as the "snapshot aesthetic" is evidence of such homogeneity. Clearly, these pictures have emerged from a normative order that has grown up around what pictures of this sort ought to look like. The family picture is a situational product in which each of the participants plays his learned part in a photographing ceremony. Violations of the normative order, through violations of role conduct, generate sanctions of the "look pretty now" and "don't stick your tongue out" variety. Negative sanctions protect the seriousness of the ritual and insure that the appropriate presentation of self will be captured for progeny and posterity. Thus, by applying the explanation offered here to another branch of photography, we can see its general application. The stylistic features of amateur photography are further determined by the social organization of the activity and the weight of tradition that is incumbent in the photographer's role.

Thus work organization has direct effects on style, through structural characteristics such as technology or division of labor. It also exerts indirect effects on style which are mediated through the photographer's work role. The work role is patterned behavior: patterned by the organizational and institutional arrangements particular to its setting. Each role has a type of "vision" attached to it. That "vision" is acquired through socialization and through exposure to cultural imagery. It is maintained through the configuration of constraints and freedoms inherent in the work role. Thus, if style is the deposit of patterned behavior, then style must also be a deposit of the work role.

What features of social organizations seem particularly important in shaping the work role? Earlier, we set ourselves the taks of explaining the underlying social processes that contribute to the particular patterns of behavior we call the work role. To that end, structural features of socio-economic organization, both production and distribution, that seem to have important effects on style must be examined closely.

The Social Organization of Production

Three dimensions of production seem to have important consequences for stylistic outcomes. These are function, technology and the division of labor.

Function

A classic concern among aestheticians involves the nature of beauty and utility and their relationship to one another. In contemporary discourse, these categories or their variants are often used to distinguish between "art" and "non-art" or "art" and "craft" (Becker, 1978). There are some very sticky problems that arise from the application of the concept "function" to objects, much in the same way that the application of the "form" and "content" concepts are difficult to use. Clearly, many objects are multi-functional to begin with. But the more important problem is that the term "function" is more an attribution than an immanent property of the object. It is not good sociology to decide an object's function; it is good sociology to see the function of an object as a matter of social definition, rather than as an objective description, and to inquire about the bases of the definitional process.

Another way to think about function is to describe the object in terms of how it is used at its final destination. News and advertising pictures end up as part of something larger, such as a newspaper or a magazine. From the very beginning, then, news or advertising photographs serve at least two functions: first, they illustrate a story or display a product; secondly, they are a subset of a larger visual and informational unit. In contrast, a fine arts picture usually ends up by itself, until it is collected in a book with other photographs. Fine arts pictures are not designed to accompany anything or to illustrate any text. Making something to be part of something else is a characteristic of modern mass production for mass audiences and mass consumers; a good deal of manufacturing is devoted to making parts of things. When the product is a visual image that is part of a larger whole, we have to consider what the larger context is and how it may affect all the subparts. Earlier, we saw that advertising photographers differentiate between the various "looks" of magazines. Interview data indicate that the editorial staff of a magazine or a newspaper wants the advertising pages to blend with the editorial pages. Therefore, to understand why some photographs look the way they do, we should also examine the context in which they appear. News is mass-marketed information. Magazines carry mass-oriented specialized information about beauty, home care, food preparation and so on. Each newspaper or magazine has its own format, tone, ambience, layout and ideology. Pressures for unity and consistency may constrain photographers to take pictures in the particular style of the publication. Since the function of an object is associated with production, it is clear that anticipation of audience, which is a distribution factor, comes to influence production.

One hypothesis to consider is that the function of the larger product, the newspaper or the magazine, requires a form of social organization that has particular characteristics. For instance, in news, where timeliness is one major category used to evaluate a story's importance, deadlines become crucial. The fastest, most efficient way to get out the news is to employ all the technological advances currently available. The most efficient utilization of labor is organized around the principle of specialized tasks. Therefore, the purpose of the

enterprise or the product contains within it a dynamic which suggests that one form of social organization is best suited for its achievement. Clearly, function, purpose and goals are important dimensions of work organization.

Technology

Technology is one of those difficult concepts that has a dual status: it is seen simultaneously as an independent and dependent variable, depending on whom you read and what your politics are. Lasch puts the problem into an elegant nutshell (1978:8):

> Most students of modern technology write as if technology had a life of its own. Ignoring the social, cultural and political determinants of technological change, they see technology as a historical determinant in its own right that overrides politics and ideology, breaks down differences between capitalist and socialist economies and creates a new global culture based on the machine.

Technology has both direct and indirect effects on style. As Ivins (1953) has shown, the development of engraving technology, which permitted pictorial images to be repeated exactly, effected major changes in the conventions, symbolism and syntax of the graphic arts. Another example is the effect of electronic technology on jazz. Hennessey (1975) points out that jazz was nationalized, that is, local and idiosyncratic musical conventions were either dropped or incorporated when radio broadcasting and recordings became widely available. Another study of music (Kealy, 1974) found that technology was an important initiator of stylistic change. Where Hennessey found that technology had a flattening or homogenizing effect, Kealy found that technology generated diversity. It is very difficult to make definitive assertions about the consequences of a given technology. The impact of the same technology can vary with time and place and different technologies can have diverse social impacts as well as unintended similarities. We need to discover a great deal more about the role of technology, particularly the technology of multiple reproduction (Benjamin, 1969) for mass audiences and its consequences for musical and artistic forms. As we have seen here, the technology of photographic reproduction has a comparatively homogenizing effect on image making and imposes limitations on the vocabulary of visual items that can appear in newspapers and magazines. We might inquire if the technology of the wire service, which linked virtually all newspapers in the United States, also had a homogenizing—and possibly conservatizing—effect on photographic imagery.

It is empirically impossible to demonstrate whether technology alone or economic arrangements alone, or some combination of the two, "cause" limitations on aesthetic choices. Technology is always enmeshed in an economic, political and ideological system. We do know, however, that it is naive to consider technology as an exogenous variable that affects photography only at the production end. It is clear that technology has an important

role in shaping demand, distribution and audience expectations. Technology also shapes how photographer's associates, such as editors or clients, view and evaluate his pictures. The images that come across the wire services can create expectations on the part of the photo-editor so that he expects his own staff photographer's pictures to look like those taken by the photographers of news agencies. It is also important to consider the degree to which photographers use existing technologies to create visual effects in the pictures and to discover the conditions that generate reliance on technical "gimmicks" or "tricks." We might speculate that the fierce competition in advertising creates the need for unique and special effects. But, as in news, the role of technology in creating expectations has received little attention. This is true for the negative, as well as the positive, appeal of technology. Disdain of technological gimmicks and the social circumstances conducive to it must be considered. For instance, why do so many fine arts photographers have a purist ideology that denigrates the use of any visual effect created through the use of some technical device?

Technology, then, is an important structural characteristic that needs to be understood in terms of its complex impact on art forms. Even though certain technologies exist, they may not be used and, if they are used, we want to know the ways in which they are employed: in the service of efficiency and speed, in the service of profit, in the service of ideological purity.

The Division of Labor

The division of labor is a form of work organization in which a total process is segmented into smaller units, each of which is performed by a different person. In contrast, individual labor (Engels, 1962) is not segmented and all the tasks are performed by the same person. News and advertising are organized around the principle of the social division of labor, and fine arts can be seen as individual production.

The division of labor is one chief means by which production becomes increasingly efficient, systematized and rationalized (Weber, 1947). We know that the nature of the work role, the nature of the activities performed, job satisfaction and other factors depend on whether work is individually or socially organized. The division of labor—and rationalization of the work process in general—have important consequences not only for the nature of work and the work role but also for the character of the product. News is the most conventionalized and homogenous system of imagery. That it takes place in a work setting characterized by a comparatively high degree of rationalized social labor is not accidental. Nor is it accidental that fine arts, the least conventionalized system, is based on individual labor. Thus, rationalization of the work process, particularly the division of labor, leads to homogeneity of product. Through what precise mechanisms does the division of labor and rationalization of the work process result in homogeneity of

product? The simple fact that different people do different things does not explain why a product should be standardized or homogenized. In principle, the division of labor does not have to result in standardized products. If each person were allowed to impose his or her individual stamp on the product, there would be some variation among products. The fact is, however, that when different people do different things, rules and social agreements become necessary to coordinate their activities. The rules then become an independent system of social regulation that constrains all participants in one way or another. Therefore, the fact that a work process is fractionated does not necessarily lead to homogenous products. Rather, the rule system, itself, generates and is an indicator of the social propulsion towards predictability, consistency and calculability. It is true that the routinization of procedures, among other controls, maximizes the probability of predictable outcomes. Thus, it is in the character of social organization to constrain photographers to produce predictable and calculable pictures. Even if news and advertising photographers produced pictures that were highly variable, the decision-making system tends to exert a homogenizing effect on the images that the public finally sees. These features of bureaucracies help account for the fact that news and advertising pictures contain certain predictable combinations of conventions.

When work is segmented, when the procedures are routinized and pre-determined and when a system of social rules and agreements are a significant part of the work culture, we expect the stylistic outcome to be characterized by a formula aesthetic (Cawelti, 1970). Freidson (1975:95) explains it this way:

> In order for work to yield a predictable outcome, it must in some sense be standardized by criteria that can be laid out in advance by means of rules that minimize variability and discretion. Work thus gets transformed into something mechanical enough to produce a *standardized* result—either a standard product or a standard measure or a record of a product.

The nature of rules in organizations is an unsettled issue, one that is important for sociological theorizing about bureaucracies. For instance, are we talking about formalized and/or codified rules? Or shared understandings in the form of vague ideas that "everybody knows"? Research on the degree of formalization of rules and its relationship to stylistic outcomes has yet to be done. That notwithstanding, it is clear that the division of labor, among other forms of work organization, has important consequences for the "look" of the final product. One may argue that rationalization of the work process is associated with monopolistic concentration of capital production and that, together, both are responsible for the development of a narrow vocabulary of stylistic conventions. Looking at the styles of automobiles would be an interesting place to start. Thus, looking at the design of manufactured products in terms of a political economy perspective might be a promising direction for research.

The Social Organization of Distribution

Distribution may be conceptualized among other ways as the path along which the photograph travels until it reaches its final destination, the general public. At various points along the path, key people make crucial decisions which will affect the fate of the photograph. It can be stopped anytime. Most photographers are unconcerned about how the general public might respond to and evaluate their work. For them, the "general public" is too vague an audience. Rather, the photographer is concerned with the responses of people who make the stop-and-go decisions along the distribution channel, the people I have called gatekeepers. Gatekeepers constitute the photographers' "significant others" (Cooley, 1964; Mead, 1934), that is, their primary audience. This same pattern is seen in Etzkhorn's (1966) study of popular music songwriters, where he found that the significant other was not the general public and not even fellow musicians but rather music executives, the gatekeepers of the music business who make public exposure possible for the songwriters. Etzkhorn found that songwriters "evaluated their own creative efforts" from the music executives' perspectives (1966:44). Similarly, photographers who can know the taste and the preferences of the gatekeepers, such as in news or advertising, orient their work to the gatekeepers' expectations. To the extent that a photographer takes the significant audience's responses into account by orienting his work to them, we can say that the system for the distribution of photographs impacts the production of photographs.

This is certainly true for news and for advertising photographers who deal on a daily basis with the demands of their significant others, e.g. the art directors, the clients, the photo-editors, reporters and others. The case of the fine arts photographer is somewhat different. Ernst Fisher (1959:49) notes "previously the artisan had worked for a particular client." In contrast, the modern exchange system in the art world is characterized by impersonality; rarely does the photographer know who will exhibit or buy his work at the time he is making his pictures. Fine arts photographers are aware of the aesthetic preferences of some curators and gallery directors but, on the whole, they do not have a single significant audience in mind. From these data, we can infer that the degree to which the photographer specifies the audiences in his mind is an important dimension which we shall explore shortly in greater detail.

It is naive to think of audiences as passively receiving whatever artists produce. Rather, the influence of the audience and, especially patrons, on artist's styles has been documented and treated extensively in both historical and modern contexts (Henning, 1960; Pevsner, 1970; Fox, 1963; Schapiro, 1959; White and White, 1965; Rosenberg and Fliegel, 1965). These studies show that audiences and patrons vary with respect to the degree of the specificity of their demands. For instance, Antal (1970:291) found that artists during the Renaissance "had to satisfy every possible requirement of their clients." Since that time, there have been frequent rejections of traditional aesthetic conventions due to changes in the patronage system (Fox, 1963: 148). Fox notes, "When artists are not told what to paint . . . there are fewer

restraints on the free exercise of imagination" (1963:148). However, not all scholars are in agreement with Fox's interpretation. For instance, Pelles (1963:26) forcefully and convincingly argues that the patron's influence has been replaced by the modern institution of the museum and that the museums have, in effect, replaced the normative expectations previously imposed by the patron:

> More and more, museums and exhibitions became the destination for works of art, which acquired the new function of serving these institutions whose purpose in society was the perpetuation of art. Museums and galleries became the temples and chapels of the substitute religion of art, which virtually became an institution unto itself. They also came to have an effect on art styles.

We know that patronage, in one form or another, affects the final stylistic outcome. Our models of patronage systems, however, are largely based on a Renaissance mercantile economy in which a rising bourgeoisie and a powerful but already declining Catholic church employed artists to immortalize their greatness. We ought not think that the patronage system has disappeared simply because the forms of patronage have changed since the Renaissance. In fact, we need to explore contemporary social situations, especially those which are bureaucratically organized, and where the patron role is not as clearly defined as in past times but, nonetheless, exerts similar influences. Today, we might think in terms of bureaucratic patronage or corporate patronage and investigate its forms of organization. For instance, the client's influence on the final form of musical film scores has been described by Faulkner (1976). We might explore the influence of granting agencies on publicly supported educational television as a case of modern patronage and scrutinize how the contents and styles of imagery are shaped by that system. The point is that distribution and production are intermeshed with systems of patronage.

The Market

The political economy of distribution is an important ingredient for socio-logical analysis. This necessitates paying attention to the role of the market and to various forms of power relationships. Market conditions and their influence on the numbers and types of styles are important to examine. Despite its conceptual and methodological difficulties, the Peterson and Berger (1975) study of popular music styles as a function of market concentration represents one way to study cultural products. Eleanor Lyon (1975) has implied that high differentiation among the theatre market in Chicago means that a variety of theatrical companies, each with its own characteristic repertoire, can survive and sometimes flourish. Thus, we might hypothesize that the greater the differentiation among the market or the audience, the greater the number of styles possible. Another study which shows the connection between economics and the characteristics of cultural products

that become socially distributed was done by Martorella (1977), who showed how the selection of opera repertoire is a direct response to market demand.

One important market variation to study concerns the number of styles that can develop and flourish despite the hegemony of an official gatekeeping class. In some countries, such as in France, "official" art gatekeepers were appointed by the State. The degree of formalization of standards and criteria by which works of art are judged seems to be associated with whether or not there is an official gatekeeping class. Thus, understanding the structure of the systems which allocate and generate prestige in a society can sometimes help us understand the principles by which prestige is allocated and, furthermore, how the distribution of prestige affects the development of stylistic conventions. For instance, when an official gatekeeping class loses power, as in the decline of the official Salon in France, there seems to be a burst of innovation. The Whites (1965) indirectly made this point in their study of the careers of French Impressionist painters. Their study, then, is indirect support for the hypothesis that an official gatekeeping class tends to be associated with a small number of highly conventionalized art styles. A cross-national study which looks at homogeneity and diversity of art styles as a function of the degree of centralization of the gatekeeping class would be an important extension of the work already done by the Whites.

A plurality of aesthetic styles co-exist under the heading of fine arts photography. Fine arts photographers are not constrained by the rules of the job in the same sense that newspaper and advertising photographers are. There are several inferences to be drawn here, not only about the constraining effects of production but about distribution as well. One implication of this observation is that complex and diverse imagery develop and flourish under conditions in which unregulated market demands dominate rather than under conditions which guarantee publication and circulation. On the social-psychological level, it seems reasonable to suggest that photographers who know that there is a guaranteed outlet for their work do not have to take any additional visual risks. It appears that unregulated competition may stimulate the creation of innovative imagery and set the conditions for the pluralism of aesthetic styles.

It is clear that an analysis of market conditions must be augmented by an analysis of the organization of production in order to understand the development and maintenance of aesthetic styles. It is abundantly clear that the two must be analyzed together and that each alone would be an incomplete analysis of a very complex phenomenon. One possible study in which the combined effects might be seen would be to compare styles of art done under conditions of government support, distribution and sponsorship with the stylistic characteristics of work produced by artists during the same time period but without the benefit of government assistance. A comparison of the work done by artists in the WPA program in the 1930's with that of artists who were not in the program would be the type of study I have in mind. Clearly, individual differences must be taken into account in order to see the extent of social forces.

In conclusion, the analysis of production must be done in terms of the system of distribution. An analysis of production done in isolation cannot take into account the social limitations that are generated by the distribution system. Therefore, an analysis which seeks to understand why an object looks the way it does by looking at how it is made is, at best, a partial analysis. Similarly, an analysis which seeks to understand the look of an object by focusing exclusively on market or audience demands, is also an incomplete analysis. Both production and distribution must be analyzed together to understand their total impact on stylistic forms.

Work Roles

Although they are all called photographers, their tasks, duties, rights, obligations, habits, activities and role partners within the occupation vary enormously. In news, the photographer's work role is primarily one of *recording technician* who performs predetermined and circumscribed tasks in a form of work organization that, in some respects, resembles an assembly line. Advertising photographers are located within a market milieu and must depend on various photographic and extra-photographic skills for economic survival. The *merchant* role becomes salient in a market system; the fee-for-service system induces them to organize their daily activities and behavior around selling and delivering those skills. Fine arts photographers are socially channelled into the role of *artist*. Certainly, artists are concerned about their economic survival but, as we saw, the major market in which they operate is one in which prestige is allocated, distributed and exchanged. Symbolic rewards, such as prestige, are quite different from economic ones. For instance, prestige conferred by an authority legitimates the individual's claim to the specialized identity of artist. In contrast to the two other roles, both of which can be seen as service occupations, the fine arts photographer produces a product which, when entered in the marketplace, competes for approval in the forms of positive evaluation of the work and, by extension, positive labeling of the self from outside authorized sources.

These differences between photographers' work roles suggest that the occupation of photographer consists of a free-floating set of skills, talent and knowledge. Hughes' (1959) metaphor of an occupation as a "bundle of activities" is a beautiful and useful way of talking about occupations because it allows us to see the fixity and the fluidity simultaneously. It directs our attention to how institutional and organizational settings make some aspects of the bundle relevant, whereas other aspects will be defined as irrelevant and unimportant. Thus, each work role has different degrees of freedom, different types of external constraints, different areas in which the photographer is able to impose his or her personal vision upon the image. Each category of photographers has control over some areas of making pictures and little control over other area. Fine arts photographers, for example, have a great deal more control over the chemical processes than news photographers. Advertising photographers may have more control over lighting than the other two categories of photographers. In short,

photographers vary with respect to the degree of control they have over different dimensions of work. Systematic observation and analysis of such differences helps us understand more precisely the mechanisms by which the organization of work "shapes the nature of work itself" (Freidson, 1975:94). Ultimately, it illuminates the relationship between the worker's discretion (Thompson, 1967: 117–31) and stylistic outcomes.

Each system also has some degree of randomness and uncertainty. Fine arts seems to have the greatest uncertainty because the criteria for evaluation are not cooperatively defined nor consensually shared. In terms of the worker, however, the way work is organized and the ways in which work organization systematically makes some skills relevant is important. When some skills and not others are performed over time, there is a chance that the worker's general level of skill may decrease. This is sometimes called the degradation of labor, not in the sense that the job is a socially devalued one but rather in the sense that the skills which are not exercised fall below a previously held level. Thus, part of selling one's labor means that one hands over to the employer the right to define and utilize those aspects of one's skill, talent and knowledge that fits the employer's needs. Another meaning, then, of control over work concerns the right to select and to determine one's work activities, the prior determination of areas of discretion and autonomy. While the photographer's work identity is implied by the label, it is clear that the nature of the work is defined and structured by the setting.

Control Over Work

"Control over work," "discretion" and "autonomy" are terms used in the sociology of work and occupations. These terms are used somewhat interchangeably and for various purposes, such as determining whether a job should be classified as an occupation or a profession, depending on the autonomy of the practitioner. These terms are important because they refer to the most fundamental problem of sociological analysis: the relationship between the individual and society. Thus, when sociologists use these terms, it means the degree to which the individual's way of doing something can predominate, replace, modify or augment the socially established or socially regulated way of doing something. "Control over work" is one way of talking about the extent to which the social patterning of human behavior is flexible or rigid. These considerations do not imply an oppositional relationship between individuals and society. For instance, Freud believed that a person's individual needs and impulses had to be socially restrained in order to maintain social order (Freud, 1961). Sociologists do not usually think about the needs of the individual and social needs as contradictory or oppositional. Rather, they are seen as interactive since human individuality itself is defined in terms of the social order. "Control over work" is a significant concept because it concerns the degree to which human conduct is socially patterned and the means by which creative adaptations to social constraints are made by the individual.

These concepts help us understand more precisely the nature of artistic work and how it may be different from other types of labor. For this discussion, I will use all three terms interchangeably to signify the degree to which decision making is left to the individual rather than predetermined by the social organization of labor. We saw throughout this study that different photographers have different degrees of control over different aspects of the picture making process. Recognizing these differences is the first step. But there are theoretical and more general implications of these findings. They concern production and distribution.

Control over Production

Despite the similarities and differences between the three types of photographers in their "control over work," there is one underlying pattern that is more significant than the others. *The organization of work in news and advertising has the consequence of separating the execution of the photograph from its conception.* Newspaper and advertising photographs always get their assignments from another person and they always receive their assignments prior to the picture making process. In other words, the *idea* of a certain type of photograph always preceeds the actual execution of the picture (Read, 1965). Advertising and newspaper photographers, then, must always *illustrate* a pre-existing concept, in fact, a concept not of their own choosing.

The wedge between the conception and execution of a photograph is far greater and has more important consequences than the boundary that is created by having one person put a sheet of exposed photographic paper into a developing tray and another person washing prints. Not all boundary lines in the division of labor are equally significant; some are more meaningful and consequential than others. *However, the wedge between the execution and conception not only means that labor is fractionated: it also means that the total photographic process and experience is fragmented. The disunity between conception and execution precludes the possibility of their reciprocal and interactive effects.*

The unity and interaction between conception and execution is the cornerstone upon which the artistic experience is built (Read, 1965; Dewey, 1934; Langer, 1953, 1957). In fact, the *idea* of a work of art often emerges in the making of it. The idea becomes apparent to the artist only while working in the medium, while altering the light or changing the position of an object. John Dewey elucidates these issues (1934):

> The act of expression that constitutes a work of art is a construction in time, not an instantaneous emission. . . . It means that the expression of self in and through a medium, constituting a work of art, is *itself* a prolonged interaction of something issuing from the self with objective conditions, a process in which both of them acquire a form and order which they did not at first possess. . . . The quality of a work of *art* is *sui generis* because the manner in which general material is rendered transforms it into a substance that is fresh and vital.

Dewey is describing a certain kind of artistic experience which need not be confined to art or artists. In fact, cooking inventively completely satisfies Dewey's description of an artistic experience. Sociology can help us see that certain social processes and patterns may prevent or facilitate the possibility of having the kind of experience that integrates conception and execution. Deadlines, routinization, rationalization of labor and diffuse decision-making are all associated with modern work organization and all seem to prevent, either directly or indirectly, the possibility of unifying the conception and execution.

It should be clear now that the benefit of applying these concepts is that they help us understand the nature of artistic control. Artistic control does not simply mean dominating the techniques of production. It also means the ability to organize one's life around the possibility of unifying the acts of thinking and doing, of conceiving and executing. This implies that artistic control may mean having a life style that makes such an integration possible. Such a life style must be one that does not permit the intrusion of aspects of modern work organization such as deadlines or routinization. This suggests that individual labor, not social labor, is a necessity for artistic production because it insures the possibility of working in a craft mode, in which thinking and doing are united.

Organizing one's life in a manner that results in the unification of conception and execution may increase the probability of artistic experience. It also may provide a very satisfying life style. It has nothing to do, however, with the production of "art." The evaluation of the product as art is entirely different matter and depends on other socioeconomic and sociohistorical processes. In short, having an artist's life style is no guarantee that the products of labor will be defined as art. Indirect evidence for this point comes from an examination of the careers of several outstanding poets of the century. T. S. Eliot, Wallace Stevens and William Carlos Williams all had conventional occupations. The fact that they kept their incomes and their art separate supports the contention that their artistic labor was not fragmented. They did not sell their artistic labor; rather, they sold other skills and kept their full control over the total process of making a poem.

By investigating the artist's autonomy, we have discovered that artistic control (or aesthetic control) is not merely the ability to select which chemical or which paper one might use for a photograph. Rather, artistic control is a multi-dimensional concept grounded in and predicated on certain work organization and life-style considerations.

Control over Distribution

Photographers need distributive outlets so that audiences may see their work. In the case of news and advertising photographers, outlets and audiences are guaranteed to the photographer even before the picture is made. For fine arts photographers, distribution is not guaranteed. The economics of art are such that the exchange is uncertain and impersonal, so that most photographers

never know before making the picture who will buy it or show it. We saw that, in all three cases, a photographer had some audiences in mind. However, photographers varied with respect to the specificity of the audience or, to phrase it another way, how "real" the audience was for them. Newspaper photographers have two audiences in mind. One is a vague and amorphous collection of tastes known as "the general public" to whom they feel a vague responsibility. The more important audience, however, was the editor, who was perceived by photographers as having clearly identifiable tastes, preferences, biases and ideological proclivities. Advertising photographers have more significant others. They are concerned about the client, the art director, the magazine people, the account executives and a few others related primarily to the distribution of the ad. They had little sense or feeling for the public. Fine arts photographers have some notions about the aesthetic preferences of gallery directors and curators, but these conceptions are vague, in the same way that the "public" is for news and advertising photographers.

From these data, we can infer that the degree to which the photographer specifies the audience in his mind varies with the type of photography he does and what kind of social system he is attached to. I am suggesting here that "the specificity of audience" is a very important variable, one which is based on structural features of social systems, such as the number of significant others and their relative power in the distributive process. These structural features have important social-psychological consequences for work roles and for making photographs. Precedence for the importance of this variable comes from the work of Robert Merton (1957:215) who points out that an intellectual who works in a bureaucracy must deal with his client's demands. Usually a policy maker, the intellectual's client sometimes formulates his needs in very general ways and, at other times, formulates his needs in clear, precise and straightforward ways. Merton's theoretical speculations as to the importance of this variable are borne out by the data presented here.

To understand how audiences may affect artistic control over production, we turn to the work of Leonard Meyer, whose explanation of musical composition is derived from the social psychology of George Herbert Mead. Meyer states (1958:40-41):

> It is this internalization of gestures, what Mead calls "taking the role of the other" (the audience) which enables the creative artist, the composer, to communicate with listeners. It is because the composer is also a listener that he is able to control his inspiration with reference to the listener. For instance, the composer knows how the listener will respond to a deceptive cadence and controls the later stages of the composition with reference to that supposed response. The performer, too, is continually "taking the attitude of the other"— of the listener. As Leopold Mozart puts it, "the performer must play everything in such a way that he himself be moved by it." . . . It is precisely because he is continually taking the attitude of the listener that the composer becomes aware and conscious of his own self, his ego, in the process of creation. In this process of differentiation between himself as composer and himself as audience, the composer becomes self-conscious and objective.

Although Meyer's approach is appealing, it is more metaphoric than empirically useful. One problem is that Mead's original distinction between the "significant" and "generalized" other was not pursued. This has theoretical and practical significance. For now, however, we need to question seriously Meyer's approach. Who is the audience? Is the audience a music critic, a general public, friends, colleagues, music executives or studio recording engineers or even some imaginary combination of all of them? How can we be sure there is only one "listener"? Why aren't there multiple listeners? Shouldn't the number of listeners and the type of listeners make a difference?

Let me offer an alternative to Meyer's approach, one which also tries to make connections between social relations and subjective experience but one which tries to incorporate the practical realities of the marketplace. We begin with the assumption that, when there is a real person whose tastes an artist takes into consideration, this is a social relationship that has consequences for the kind of aesthetic vocabulary the artist incorporates into the work. From a symbolic interactionist point of view, the artist has an internal dialogue—the type Meyer suggests—with the "me" that is the internal representation of the real significant other. However, in order to understand the character of the internal dialogue and how it affects what aesthetic choices the artist makes, we need to know the aesthetic preferences of the significant other or, at the very least, the aesthetic preferences the artist imputes to the significant other. For instance, Degas once quipped that he painted for his dead artist friends, that they comprised his only significant audience. This suggests that Degas' dialogue with his dead friends must have been different from his dialogue with his living friends or the Parisian critics or the Salon administrators. In order to make Meyer's analysis empirically useful, we need to ground it in concrete social relations. We must know who the composer has in mind and what kinds of tastes the composer imputes to his listener before we can make any meaningful inferences about aesthetic outcomes.

We also need to know how many audiences there are because, as Linde-smith and Strauss note (1968:262–265), the number of significant others reaches a critical point at which they all blend together to become a "generalized other." Thus, when no one significant person functions as the major audience, it is likely that the organized set of attitudes known as the "generalized other" predominates. In other words, the artist's audience is an agglomerate of disparate, vague and unspecific tastes, an undifferentiated miasma of expectations. One might speculate that the character of the inner dialogue during creative work is totally different when one dialogues with a significant other or a generalized other. In fact, speculation is unnecessary, for we have a good deal of evidence from the writing of artists, composers, painters and writers regarding the character of their work under various audience conditions.

The unanswered question that Meyer's approach implies, then, is: under what circumstances does the artist relate to a generalized other or a significant other? The next question is: what difference does this make in terms of the styles of art objects?

I suggest that the answers lie somewhere in the practical realities of the marketplace, especially in the distribution systems. In news and advertising, which guarantee publication to photographers, the expectations are characterized by high specificity and can be socially grounded in the concrete needs and requirements of significant people who make stop-and-go decisions about the photograph. In fine arts, the distributive and exchange system is impersonal and anonymous, characterized by expectations which are diverse, elusive, and generalized, as if it were impossible to match the aesthetic preference with a real person. We are led to suggest, then, that the more routinized the distributive process, the more specific the audience's expectations. Put another way, the more rationalized a distributive system is, the more formalized the criteria for the evaluation of the products distributed. In contrast, we can suggest the reverse for fine arts: the more a distribution system resembles a free market, the less direct the controls, the less clear and specific the audience's expectations and the less formalized the criteria.

By considering audiences and distribution systems, we have discovered another dimension of the term, "control over work" or "artistic control." This aspect has to do with the ability to choose one's audience(s), that is, the freedom to select which internal voice will predominate, given the assumption that an audience comes to stand as an internal representation for a particular set of aesthetic choices, conventions, grammar and vocabulary. Having no audience in mind is freedom from social constraints but it is also an idealized and impossible version of reality. However, we might suggest that there is a greater possibility of imposing one's unique vision and one's own aesthetic preferences on a work of art when the audience has fewer specific expectations regarding the outcome of the work. In other words, the more diffuse the expectations, the greater the artist's freedom to inject the work with his or her own vision. I am not arguing in any way for the number of audiences nor am I claiming that there are more social constraints on advertising photographers because they have a greater number of audiences than news or fine arts photographers. Rather, the diffuse-specificity dimension is the key one, not the quantity of markets or audiences.

This argument is not exclusively social psychological, as is Meyer's. It is possible to argue that the social limitations on imagery can arise from the artist's imputation of expectations to his audience, expectations which may or may not exist. But social forces provide the background against which mental activity takes place. In Meyer's view, they appear to be played out in isolation; by placing them in a more social-structural context, audiences can be related to market forces, social hierarchies, power and prestige.

Control Over Work and Alienation

Alienation is a complex, multi-dimensional term (Seeman, 1959) whose roots are found in the work of Karl Marx. Marx defined alienation objectively, that is, as a product of a particular type of organization of labor, characterized by

the division of labor and the worker's need to sell his labor to get the use value from it. Naturally, this must be seen against a background of capitalist economic organization in which profit is derived from the surplus value of labor. Marx's conception of alienation was not concerned with subjective feelings of loneliness, isolation or existential pain. Although in the *Economic and Philosophical Manuscripts of 1844* Marx tended to see alienation in both objectivist and subjectivist terms, his later work clearly defined alienation objectively. The later definition is the one which has prevailed, and it is the one I shall be using here.

Using a Marxist framework, we would say that newspaper and advertising photographers are objectively alienated and that fine arts photographers are not. This assessment is biased on the nature of work organization and the fact that fine arts photographers are individual laborers, whereas the other two work under conditions of socially divided labor. Also, news and advertising photographers sell their labor to actualize it (or get the use value from it) and fine arts photographers do not. Yet, when photographers were asked to talk about job satisfaction, aesthetic satisfaction, artistic control and their happiness in general, their verbal accounts were inversely distributed against the Marxist predictions of objective alienation. By definition, we cannot use subjective reports as indicators of objective alienation, but it is interesting to see the differences. Newspaper photographers were the happiest of the lot. They loved their work; they felt appreciated and needed. Although advertising photographers complained about the stresses of the job, the pressures to please clients, the agony of too much or too little work, they seemed content and able to enjoy the intensity and liveliness of the advertising world. In contrast, fine arts photographers, who are not objectively alienated, were the most unhappy. They seemed to suffer in ways that the other two groups did not. They felt unappreciated in general and saw the world as depriving and demeaning. The tormented quality of their verbal responses—plus the fact that two were hospitalized for suicide attempts and one committed suicide a month before I was scheduled to interview her—suggests that they are subjectively the most unhappy and troubled group.

How do we reconcile the differences between the objective definition of alienation and the subjective assessments of contentment? A Marxist might say that the accounts which report high job satisfaction are examples of false consciousness and that they fail to understand the underlying class relations. Furthermore, one could say that newspaper and advertising photographers fail to understand how the organization of production separates the conception and the execution of the photography; otherwise why would they be so happy? A positivist might say that job satisfaction or happiness are not indicators of objective alienation or that the concept of alienation is tremendously complex, difficult to dimensionalize, operationalize and measure.

However, another explanation may be that alienation is not simply a result of the relations of production. *An analysis of the organization of production is insufficient to establish "alienation." One might not be alienated from the labor process but be alienated from the market and have no control over or*

power to determine the distribution process, including the selection of audiences who will evaluate the work. This suggests that, for artists, control over distribution is just as essential as control over production. The fruits and benefits of individual production are fragile and can easily be cancelled out if the organization of distribution contradicts the organization of production. I am suggesting that a complete analysis of alienation must take production and distribution into account. It is entirely conceivable that the proper focus of an analysis of the alienation of artists concerns distribution channels and not simply the organization of production.

A Sociological Approach to Creativity

Like the concept of intelligence, psychologists tend to treat "creativity" as a property of persons and therefore organize their research efforts around the operationalization and measurement of creativity (Guilford, 1968). Although they take social factors into account when trying to explain the variability of their results, they stop short of seeing the degree to which conceptions of creativity are socially based. I believe that a sociological perspective can rectify these shortcomings. The problem is that there are no sociological studies of creativity.

What have we learned about creativity from this study? In the first place, we saw that the feeling of "creativity" does not necessarily imply that one produces a "creative" or "good" photograph. The "creative experience" and the evaluation of products born of that experience are two entirely different processes. We have learned that "creative" is a social label, applied by one person to another person or to a thing produced by someone. This judgment may be based on qualities imminent in the photograph and/or qualities thought to be "in the person."

We saw that the definition of creativity varies. When we analyze the conceptions of creativity in different settings, we can see how well matched are the definitions with the organizational and institutional needs of each system. Definitions of creativity function in the service of organizational needs, not necessarily according to the needs of the individual photographers. To the degree that definitions of creativity serve to perpetuate the domination of gatekeepers who generate the definitions, we can call them "ideology." Thus, organizational and socioeconomic arrangements pattern, and partially construct, definitions of creativity. The application of a critical social science to the study of creativity is essential. We need to know more about how definitions of creativity are socially constructed. Most of all, we need to know what social conditions generate creative energies and facilitate their emergence, with all the joy and zest and *angst* that accompany human liberation.

notes

NOTES TO CHAPTER 1

1. The field of semiotics may be thought of as an attempt to solve the form and content distinctions by completely redefining the issues and changing the field of discourse.

NOTES TO CHAPTER 2

1. Most books on the history of photography tend to emphasize the technological and historical evolution of the medium, leaving aside aesthetic and stylistic questions. For a history of the invenetion of the daguerreotype, see Helmut and Alison Gernsheim, *L. J. M. Daguerre: The History of the Diorama and the Daguerreotype.* For general histories of photography, see Helmut and Alison Gernsheim, *A Concise History of Photography;* Beaumont Newhall, *The History of Photography;* Beaumont Newhall, *Photography: A Short Critical History;* Peter Pollack, *The Picture History of Photography.* For the reader who wishes to learn about photographic technique along with the history of photography, see the separate volumes in the Time-Life series on photography.

One recent book, *Masters of the Camera: Steiglitz, Steichen and Their Successors* (Gene Thornton for the American Federation of Arts), attempts to explain two types of photography by looking at the work of two photographers. While not a serious study, it is nonetheless an interesting collection of the work of two seminal photographers.

The assumption of linear development, which may hold for pre-nineteenth century painting and sculpture, is particularly problematic for historians of photography. Clearly, the empirical evidence shows that photography did not develop linearly, with one style replacing another, but rather, from its inception, it was used in a multiplicity of ways. Thus, the analyst or historian of photographic aesthetics must eventually come to terms with the question of which social forces produce different styles in the same time period. Although historians of photography have organized their books around the evolution of the medium, they have wisely avoided any analysis that assumes linearity. In any event, these tasks lie ahead of us.

NOTES TO CHAPTER 3

1. Where the apprenticeship period is circumscribed, the photographer's completion of it means he is "ready" to go on the streets. Where it is not, a photographer must wait until an opportunity arises, e.g., a photographer retires or he substitutes for a vacationing photographer.

2. On more than one occasion, I was asked by latecomers to fill them in on what was going on. Since I was jotting down field notes in a pad, it is possible that my presence was normalized by others who assumed I was also a reporter. Being defined as part of the working press allowed me to eavesdrop, smile when I wanted more information and, in general, manipulate the situation to my advantage perhaps more than if I made clear I was a sociologist. Dressing up for these occasions helped me "look the part," I suspect.

3. It is heartwarming to know that other occupational groups have their own versions of the sociologist's perennial dilemmas inherent in participation/observation.

4. Routine complaints also included number of hours, having to deal with highly eccentric employers and lack of appreciation.

5. Accidental discovery is discussed in the socialization of fine arts photographers, pp. 37.

6. Of the seventeen photographers I interviewed, four did not have reps. Of these four, two were going into business and were looking, but not ready, to hire a rep. The other two were already established in their own studios and had fired their previous reps. Both asked me if I knew or interviewed any reps they might contact. Although I was tempted to make matches, it was against my better judgment. I was not concerned about sustaining my role as observer/interviewer. Rather, I was very concerned about the *hubris* implicit in making these matches: if I had enough knowledge to make matches, why was I still in the field? Obviously, I was still doing field work because I didn't know enough and providing a referral required more knowledge and judgment than I had.

7. One amusing example is the case of a student at the San Francisco Art Institute who photographed himself in sexually suggestive positions with a vacuum cleaner hose. He reported that he was consciously working towards "phallic symbolism" in his photographs. During the class crit, however, he was told that his photographs were contrived, overstated and, consequently, were not erotic or sexually suggestive in any way. In fact, he reported that one student commented that the symbolism was so overdone that it wasn't symbolic.

NOTES TO CHAPTER 4

1. I tried to attend one of these meetings but they are closed to the public. I have heard, from several sources, that the "bullpen" meetings resemble a bargaining session. For instance, a city editor might say to a national editor, "Look, I need three extra columns today. I gave you five extra the other day when you needed it." It should be emphasized that page one and the feature pages are discussed at this meeting, not the smaller news items placed deeper into the paper.

2. This is the consensus of my respondents, not my own judgment.

3. Magazines, in contrast, use between 120–150 lines to the inch. *National Geographic,* for example, uses 133-line screen. Generally, the finer the screen, that is, the smaller the dots, the more detail in reproduction. Thus, a great density of dots will yield a greater spread of tones and, consequently, more detail in the reproduction. The size of the screen is coupled with appropriate paper. Newsprint is coupled with a 65-line screen. Glossy, magazine stock must be used to fully realize the reproduction quality of a 133-line screen.

4. One of the several drawbacks to this method is that the print is not permanently fixed until it is placed into a chemical hypo bath. Without the hypo bath, these prints will last for about six months, but after that, they will fade and discolor. With the hypo bath, they can be made permanent. A print can be reproduced on the paper and then returned to the darkroom for fixing, that is, a hypo bath. This is necessary because the print will be filed in the newspaper's own photographic library and will be sold to book and magazine publishers for reproduction.

5. These include papers which vary with respect to surface texture (smooth to rough), contrast range (low to high), surface sheen (glossy or matte) and tone (warm, cool or cold).

6. The technical steps in the photoengraving process and the resultant loss of detail were

first explained to me by a photoengraver, who provided a full tour of the photoengraving department. His estimates were corroborated in subsequent interviews with photographers, photo-editors, darkroom staff and other photoengravers.

7. At that time, the only comparison I could make was between these light prints and my photography instructor's expectations of students' prints. Had I shown my teacher such a light print, I would have been instructed to darken it two or three times, that is, let two or three times as much light pass through the enlarging lens.

8. These figures are based on each newspaper's own statistical surveys. Thus, these figures are averages.

9. Editors and staff photographers told me that readership surveys indicate that readers remember page one pictures more than they remember headlines and stories. Based upon these surveys, the picture editors felt that their selection of page one pictures helps sell newspapers at the stands.

10. At two newspapers, choice of shift was based on photographers' preferences. At a third, photographers rotated shifts in order to evenly distribute the night shift among the staff.

11. One characteristic of the telephoto lens is that its depth of field is extremely short. This means that, while a person's face may be in sharp focus, an object six inches in front or behind the person will be blurry.

NOTES TO CHAPTER 5

1. The surgical team metaphor, wherein a number of people collectively interact for the duration of a collective task, applies here.

2. This is a common term which refers to any ad that appears in a printed medium, e.g., newspapers, magazines, etc.

3. For an amusing picture of the "creative interaction" between the art director and the copywriter, see Jerry Della Femina's *From Those Wonderful Folks Who Gave You Pearl Harbor.*

NOTES TO CHAPTER 6

1. It seems to me that a folklore develops within the fine arts photography community. Often in the form of rumor, accusation and gossip, the folklore seems to provide photographers with information about the individual tastes of the "gate-keepers." Out of a total of seventeen, four fine arts photographers reported that they would not attempt to show female nudes to a certain person because he was incapable of separating his homosexuality from his photographic aesthetic. In my judgment, the veracity of the statements is not the issue, nor is the determination of veracity the sociologist's job. Rather, the sociologist begins with the fact that gossip exists. Smelser (1962) notes that rumors grow and spread in response to an information vacuum. This logic applies here as well. Photographers make up stories and information about people they must deal with, because the response of curators and gallery directors (critics, too) is unpredictable.

2. Editors in publishing are often required to make this evaluation of first-novel manuscripts they receive. Evaluating a "good bet" is an interesting question for future research.

3. A similar problem is faced by women who, as self-conscious feminist artists, wish to challenge current definitions of art on the basis that white males define it. Women's art centers seem to be a viable alternative but the point here is that these are still alternative and, therefore, seen as partially illegitimate or "renegade" outlets.

bibliography

Ackerman, James. "A Theory of Style." *Journal of Aesthetics and Art Criticism,* Spring 1962.

Adorno, Theodore W. "On Popular Music." In *Studies in Philosophy and Social Science.* New York: Institute for Social Research, 1941.

Albrecht, Milton C.; Barnett, James H.; and Griff, Mason. *The Sociology of Art and Literature.* New York: Praeger Publishers, 1970.

Allsopp, Bruce. *Style in the Visual Arts.* Newcastle Upon Tyne, England: Oriel Press, Ltd., 1956.

Antal, Frederick. *Classicism and Romanticism.* New York: Basic Books, 1966.

———. "Social Position of the Artist: Contemporary Views on Art." In Milton Albrecht, Mason Griff, and James Barnett (eds.). *Sociology of Art and Literature.* New York: Praeger Publishers, 1970.

Baxandall, Lee (ed.). *Radical Perspectives in the Arts.* Middlesex, England: Penguin Books, 1972.

Baynes, Ken; Hopkinson, Tom; Hutt, Allan; and Knight, Derrick. *Scoop, Scandal and Strife: A Study of Photography in Newspapers.* London: Lund Humphries Publishers, Ltd., 1971.

Becker, Howard S. (with James Carper). "The Development of Identification With an Occupation." *American Journal of Sociology,* vol. 61, pp. 289–98, January 1956.

———. "Art as Collective Action," *American Sociological Review,* vol. 39, pp. 767–76, 1974.

———. "Arts and Crafts." *American Journal of Sociology,* vol. 83, no. 4, pp. 862–889, 1978.

Benjamin, Walter. *Illuminations.* New York: Schocken Books, 1969.

Bennett, H. Stith. "Other People's Music." Unpublished Ph.D. dissertation, Sociology Department, Northwestern University, Evanston, Illinois, 1972.

Berenson, Bernard. *The Italian Painters of the Renaissance.* London: Oxford University Press, 1930.

Berger, Peter; and Luckman, Thomas. *The Social Construction of Reality.* New York: Doubleday, 1969.

Bernstein, Basil. *Class, Codes and Control, Vol. 1: Theoretical Studies Towards a Sociology of Language.* London: Routledge and Kegan Paul, 1970.

Bethers, Ray. *How to Find Your Own Style in Painting.* New York: Hastings House, 1957.

Birdwhistell, Ray. *Kinesics and Context: Essays on Body Motion Communication.* Philadelphia: University of Pennsylvania Press, 1970.

Blauner, Robert. *Alienation and Freedom.* Chicago: University of Chicago Press, 1964.

Braverman, Harry. *Labor and Monopoly Capital.* New York: Monthly Review Press, 1974.

Briggs, W. G. *The Camera in Advertising and Industry.* New York: Pitman Publishing Corporation, 1939.

Burns, Elizabeth. *Theatricality: A Study of Convention in the Theatre and in Social Life.* New York: Harper Torch Books, 1972.

———. and Burns, Tom. *Sociology of Literature and Drama.* Middlesex, England: Penguin Books, 1973.

Castaneda, Carlos. *The Teachings of Don Juan.* New York: Bantam Books, 1968.

Cawelti, John. *The Six-Gun Mystique.* Bowling Green, Ohio: Bowling Green University Popular Press, 1970.

Cooley, Charles Horton. *Human Nature and the Social Order.* New York: Schocken Books, 1964.

Croce, Bennedetto. *Aesthetic as a Science of Expressions and General Linguistic.* New York: Noonday, 1953.

Croy, O. R. *Camera Close Up.* London: Focal Press, Ltd., 1961.

Della Femina, Jerry. *From Those Wonderful Folks Who Gave You Pearl Harbor.* New York: Simon and Schuster, 1970.

Dewey, John. *Art as Experience.* New York: Capricorn Books, 1934.

Durkheim, Emile. *Rules of the Sociological Method.* New York: Free Press, 1938.

Duvignaud, Jean. *The Sociology of Art.* New York: Harper and Row, 1967.

Engels, Friedrich. "Socialization: Utopian and Scientific." In Lewis S. Feuer (ed.). *Marx and Engels.* Garden City, New York: Doubleday, 1959.

Etzkorn, Peter. "On Esthetic Standards and Reference Groups of Popular Songwriters." *Sociological Inquiry,* vol. 36, no. 1, pp. 39–47, Winter 1966.

Ezickson, A. J. *Get That Picture! The Story of the News Cameraman.* New York: National Library Press, 1938.

Faulkner, Robert R. *Hollywood Studio Musicians.* Chicago: Aldine Publishing Co., 1971.

———. "Dilemmas in Commercial Work: Hollywood Film Composers and Their Clients." *Urban Life,* vol. 5, pp. 3–32, 1976.

Finch, Margaret. *Style in Art History.* Metuchen, New Jersey: The Scarecrow Press, 1974.

Fisher, Ernst. *The Necessity of Art, A Marxist Approach.* Baltimore: Penguin Books, 1963.

Fowler, Roger. *Style and Structure in Literature: Essays in the New Stylistics.* Ithaca, New York: Cornell University Press, 1975.

Fox, Daniel M. "Artists in the Modern State: The Nineteenth Century Background." *Journal of Aesthetics and Art Criticism,* vol. 23, no. 2, pp. 135–48, Winter 1963.

Freud, Sigmund. *Leonardo DaVinci, A Study in Psychosexuality.* New York: Modern Library, 1947.

———. *Civilization and Its Discontents.* New York: W. W. Norton Company, 1961.

Freidson, Eliot. *Profession of Medicine.* New York: Dodd, Mead and Co., Inc., 1970.

———. *The Professions and Their Prospects.* Beverly Hills, California: Sage Publications, 1971.

――. *Doctoring Together.* New York: Elsevier Scientific Publishing Co., 1975.

Gernsheim, Helmut; and Gernsheim, Alison. *A Concise History of Photography.* New York: Grosset and Dunlop, 1965.

Glaser, Barney G. *Organizational Scientists: Their Professional Careers.* New York: Bobbs-Merrill Co., 1964.

Golding, John. *Cubism: A History and Analysis, 1907–1914.* Boston: Boston Book and Art Shop, 1959.

Goldmann, Lucien. *Pour une Sociologie du Roman.* Paris: Gallimard, 1964.

――. "Sociology of Literature-Status and Problems of Method." *International Social Science Journal,* vol. XIX, no. 4, 1967.

Goldwater, Robert; and Treves, Marlo (eds.). *Artists on Art: From the Fourteenth to the Twentieth Century.* New York: Pantheon Books, 1945.

Gombrich, E. H. *Art and Illusion.* New York: Pantheon Books, 1960.

――. *Meditations on a Hobby Horse.* London: Phaidon, 1963.

――. *Norm and Form, Studies in the Art of the Renaissance.* London: Phaidon. 1966.

Gotshalk, D. W. *Art and the Social Order.* New York: Dover Publications, 1947.

Griff, Mason. "The Commercial Artist: A Study of Changing and Consistent Identities." In Maurice Stein et al. (eds.) *Identity and Anxiety.* New York: Free Press, 1960.

Guilford, Joy Paul. *Intelligence, Creativity and Their Educational Implications.* San Diego, California: R. R. Knapp, 1968.

Hall, Edward T. *The Silent Language.* Garden City, New York: Doubleday, 1959.

Harris, Neil. *The Artist in American Society.* New York: Harper and Row, 1970.

Hauser, Arnold. *The Social History of Art.* 4 vols. New York: Vintage Books, 1958.

Hennessy, Thomas J. "The Nationalization of Jazz, 1929–1935." Unpublished paper, 1975.

Henning, Edward B. "Patronage and Style in the Arts: A Suggestion Concerning Their Relation." *Journal of Aesthetics and Art Criticism,* vol. 18, pp. 464–75, 1960.

Hicks, Wilson. *Words and Pictures.* New York: Harper and Row, 1952.

Hough, Graham. *Style and Stylistics.* London: Routledge and Kegan Paul, Ltd., 1969.

Hughes, Everet C. *Men and Their Work.* New York: Free Press, 1958.

――. "The Study of Occupations." In Robert Merton, Leonard Broom and Leonard Cottrell, Jr. (eds.), *Sociology Today,* vol. II, pp. 442–60. New York: Harper Torchbooks, 1959.

Ivins, William M., Jr. *Prints and Visual Communication.* Cambridge, Massachusetts: M.I.T. Press, 1963.

Kaplan, Abraham. *The Conduct of Inquiry.* San Francisco, California: Chandler Publishing Company, 1964.

Kealy, Edward. "The Real Rock Revolution: Sound Mixers, Social Inequality and the Aesthetics of Popular Music Production." Unpublished Ph.D. dissertation, Sociology Department, Northwestern University, Evanston, Illinois, 1974.

Kramer, Judith. "The Social Role of the Literary Critic." In Milton Albrecht, James Barnett and Mason Griff (eds.), *The Sociology of Art and Literature,* pp. 437–454. New York: Praeger Publishers, 1970.

Kroeber, Alfred L. *Style and Civilization.* Ithaca, New York: Cornell University Press, 1957.

Lang, Berel; and Williams, Forrest. *Marxism and Art.* New York: David McKay Co., 1972.

Langer, Susanne. *Philosophy in a New Key.* New York: Mentor Books, 1942.

——. *Feeling and Form.* New York: Scribner's Sons, 1953.

——. *Problems of Art.* New York: Scribner's Sons, 1957.

——. *Philosophical Sketches.* New York: Mentor Books, 1964.

Lanham, Richard. *Style: An Anti-Textbook.* New Haven: Yale University Press, 1974.

Lasch, Christopher. "A Dangerous Instrument." Book review of *The Social Impact of the Telephone*, edited by Ithiel de Sola Pool. Cambridge, Mass.: M.I.T. Press, 1977. Book Review Section, New York Times, Sunday, Jan. 1, 1978, pp. 8, 24.

Lindesmith, Alfred; and Strauss, Anselm. *Social Psychology.* New York: Holt, Rinehart and Winston, 1968.

Lukács, Georg. *The Historical Novel.* Middlesex, England: Penguin Books, 1969.

Lyon, Eleanor. "Behind the Scenes: The Organization of Theatrical Production." Unpublished Ph.D. dissertation, Sociology Department, Northwestern University, Evanston, Illinois, 1975.

Lyons, Nathan (ed.). *Photographers on Photography.* Englewood Cliffs, New Jersey: Prentice-Hall, 1966.

Martorella, Roseanne. "The Relationship Between Box Office and Repertoire: The Case of Opera." *Sociological Quarterly,* vol. 18, no. 3, pp. 354–66, Summer 1977.

Marx, Karl. *Early Writings* (Philosophical Manuscripts of 1844). New York: McGraw-Hill, 1964.

——. *Capital.* New York: International Publishers, 1967.

Marynowicz, W. *Photography as an Art Form.* London: Maclaren and Sons, Ltd., 1969.

Matejka, Ladislav; and Titunik, Irwin R. *Semiotics of Art: Prague School Contributions.* Cambridge, Massachusetts: M.I.T. Press, 1976.

Mead, George Herbert. *Mind, Self and Society.* Chicago: University of Chicago Press, 1934.

Merton, Robert. *Social Theory and Social Structure.* New York: Free Press, 1957.

Meyer, Leonard B. *Emotion and Meaning in Music.* Chicago: University of Chicago Press, 1956.

Miles, Josephine. *Style and Proportion: The Language of Prose and Poetry.* Boston: Little, Brown and Co., 1967.

Milic, Louis T. *Stylists on Style.* New York: Scribner's Sons, 1969.

Molotch, Harvey; and Lester, Marilyn. "News as Purposive Behavior: On the Strategic Use of Routine Events, Accidents and Scandals." *American Sociological Review,* vol. 39, pp. 101–12, 1974.

Mukerji, Chandra. "Film Games." *Symbolic Interaction,* vol. 1, no. 1, pp. 20–32, Fall, 1977.

Newhall, Beaumont. *Photography: A Short Critical History.* New York: Museum of Modern Art, 1938.

——. *The History of Photography.* New York: Museum of Modern Art, 1964.

Nurnberg, Walter. *The Science and Technique of Advertising Photography.* London: The Studio Publications, 1940.

Panofsky, Erwin. *Gothic Architecture and Scholasticism.* New York: Meridian Books, 1957.

——. *Meaning in the Visual Arts.* New York: Doubleday Anchor, 1955.

Peckham, Morse. *Man's Rage for Chaos: Biology, Behavior and the Arts.* New York: Schocken Books, 1967.

Pelles, Geraldine. *Art, Artists and Society.* Englewood Cliffs, New Jersey: Prentice-Hall, 1963.

Peterson, Richard A.; and Berger, David G. "Cycles in Symbol Production: The Case of Popular Music." *American Sociological Review,* vol. 40, pp. 158–73, 1975.

Pevsner, Nikolaus. "French and Dutch Artists in the Seventeenth Century." In Milton C. Albrecht, James H. Barnett and Mason Griff (eds.), *The Sociology of Art and Literature.* New York: Praeger Publishers, 1970.

Pollack, Peter. *The Picture History of Photography.* New York: Harry D. Abrams, 1969.

Read, Sir Herbert. *The Grass Roots of Art.* New York: Meridian Books, 1961.

———. *Icon and Idea.* New York: Schocken Books, 1965.

———. *Art and Society.* New York: Schocken Books, 1966.

———. *Art and Alienation.* New York: Viking Press, 1967.

Rosenberg, Bernard; and White, David Manning (eds.). *Mass Culture.* New York: Free Press, 1957.

———. and Fleigel, Norris. *The Vanguard Artist.* Chicago: Quadrangle Books, 1965.

Rosenberg, Harold. *The Tradition of the New.* New York: Grove Press, 1961.

Rothschild, Lincoln. *Style in Art: The Dynamics of Art as Cultural Expression.* New York: Thomas Yoseloff, Inc., 1960.

Rothstein, Arthur. *Photojournalism.* New York: American Photographic Book Publishing Company, 1956.

Sanchez Vazquez, Adolfo. *Art and Society: Essays in Marxist Aesthetics.* New York: Monthly Review Press, 1973.

Schapiro, Meyer. "Style." In Sol Tax (ed.), *Anthropology Today.* Chicago: University of Chicago Press, 1962.

Schutz, Alfred. *Collected Papers,* vols. I and II. The Hague: Martinus Nijhoff, 1964 and 1971.

Seeman, Melvin. "On the Meaning of Alienation." *American Sociological Review,* vol. 24, pp. 783–91, 1959.

Shapiro, David. *Neurotic Styles.* New York: Basic Books, 1965.

Shibutani, Tomatsu. "Reference Groups as Perspectives." *American Journal of Sociology,* vol. 60, pp. 562–69, 1955.

———. *Society and Personality.* Englewood Cliffs, New Jersey: Prentice-Hall, 1961.

Singleton, Ralph H. *Style.* San Francisco, California: Chandler Publishing Co., 1966.

Smelser, Neil. *Theory of Collective Behavior.* New York: Free Press, 1963.

Sontag, Susan. "On Style." In Susan Sontag, *Against Interpretation and Other Essays.* New York: Farrar, Straus and Giroux, 1961.

Taft, Robert. *Photography and the American Scene.* New York: Macmillan, 1938.

Thompson, James. *Organizations in Action.* New York: Macmillan, 1967.

Thornton, Gene. *Masters of the Camera: Steiglitz, Steichen and Their Successors.* New York: Holt, Rinehart and Winston, 1976.

Tuchman, Gaye. "Making News by Doing Work: Routinizing the Unexpected." *American Journal of Sociology,* vol. 79, pp. 110–31, 1973.

Turner, G. W. *Stylistics.* London: Penguin Books, Ltd., 1973.

Turner, Ralph H. "Role-Taking, Role-Standpoint and Reference Group Behavior." *American Journal of Sociology,* vol. 61, pp. 316–28, 1956.

Weber, Max. *The Theory of Social and Economic Organization.* New York: Free Press, 1947.

White, Cynthia; and White, Harrison C. *Canvasses and Careers.* New York: John Wiley and Sons, 1965.

White, Minor. *The Zone System Manual.* Hastings-on-the-Hudson, New York: Morgan and Morgan, 1968.

Wilson, Robert (ed.). *The Arts in Society.* Englewood Cliffs, New Jersey: Prentice-Hall, 1964.

Wolff, Janet. *Hermenentic Philosophy and the Sociology of Art.* London: Routledge and Kegan Paul, 1975.

Zucker, Paul. *Styles in Painting: A Comparative Study.* New York: Dover Publications, 1963.

index

Ackerman, James, 2
Adams, Ansel, 104, 105
Adorno, Theodore, 5
Advertising: clients' preconceptions of, 80–81; social background of, 63–67, 80
Advertising agencies, activities of, 63–67; medium, determination of, 64; photographers, selection of, 65–66; problem, determination of, 63–64; visuals, creation of, 64–65
Advertising photographers: acquiring clients, 30–31; and alienation, 128; audiences of, 125; constraints on, 75–82; creativity, opportunities for, 82–85, 123; human resources required by, 67–68; interaction with models by, 69–71; opening own shop, 29–31; preliminary planning, value of, to, 68; representatives for, 30–31; socialization of, 25–31; top vs. typical, 82–83; value of lighting to, 72; work role of, 121
Advertising photography: ad illustration, 72–73; categories of, 68, 74; characteristics of, 15–16, 114; credibility in, 73; editorial work, 74; shooting fashion, 68–71; still-life shooting, 71–72; visual unnaturalness of, 82
Alienation, 7–8, 127–129; Marx's definition of, 127–128
Allsop, Bruce, 2
American Newspaper Guild, 25
Angle, in photography, 71, 72, 79, 104
Antal, Frederick, 118
Arbus, Diane, 100
Aristotle, 34
Art school critiques, importance of, 34–36, 37
Artistic control. See Control over work
Audiences, importance of, to photographers, 124–127
Automation: of film printing, 44–45; of film processing, 43–44, 51–52
Autonomy. See Control over work

Becker, Howard S., 4, 92, 114
Benjamin, Walter, 5, 115
Bennett, H. Stith, 40
Berenson, Bernard, 6
Berger, David G., 5, 119
Berger, Peter, 26, 55
Bernstein, Basil, 55
Bethers, Ray, 2
Birdwhistell, Ray, 23
Black borders, 107
Blauner, Robert, 7
Bracketing, 83
Burns, Elizabeth, 4

Castaneda, Carlos, 19
Cawelti, John, 60, 117
Chiaroscuro, 16
Constraints on advertising photographers, 75–82; art directors, limitations placed by, 76–77, 80; client and agency budgets, 75–76; clients' intrusions and policing, 77–79; clients' preconceptions of advertising, 80–81; interference by models, 79–80
Constraints on fine arts photographers, 87; market, 98–100, 101, 108–109; or originality, 100
Constraints on newspaper photographers, 51–57; of assignment, 53–54; in decision making, 54; situational, 55–57; technological, 51–53
Contact sheets, 44, 52
Contacting, 44, 97
Control over work, 7, 8, 121–129; distribution and audiences, 124–127; by fine arts photographers, 87, 97–98, 102; production, artistry of, 123–124
Cooley, Charles Horton, 118
Cooperative ads, 66
Creativity, 8, 57–62, 100–101; cyclical nature of, for fine arts photographers, 97; political aspects of, 107–108; previsualization and, 104–106; sociological analysis of, 129; in subject choice, 102–103; time orientations of, 103–106
Crimmins, Alice, 21

141

Cropping, 107
Cubism, 2

Da Vinci, Leonardo, 6
Darwin, 107
Degas, Hilaire, 126
Dewey, John, 97, 123–124
Discretion. *See* Control over work
Distribution of photographs, and style, 118–121; control over, 8; market, diversity of, 119–120; patronage, 118–119
Dodging, 45, 51

Economic and Philosophical Manuscripts of 1844, 124
Eliot, T.S., 124
Engels, Friedrich, 116
Esquire (magazine), 75
Etzkorn, Peter, 118

Faulkner, Robert R., 119
Film processing, automated, 43–44, 51–52
Finch, Margaret, 2, 3
Fine arts photographers, 7; and alienation, 128; autonomy of, 87, 97–98, 102; constraints of originality on, 100; constraints on, 87; and creativity, 97, 102–106, 107–108; and the creative moment, 103–105; exclusive contracts for famous, 91, 95; famous, 91, 95; gallery shows by, 88–91, 92; market constraints on, 98–100, 101, 108–109; museum contracts for, 95; non-famous, 88–92, 93; and originality, 100–101, 108; and photographic time, 104–105; portfolio submissions by, 88–89, 91; products of art schools, 31–39; recognition, achieving, 38–39, 88, 92–93; redefinition of self required, 36–38; seeing photographically by, 32–36; socialization of, 31–39; two classes of, 88; work role of, 121; work styles of, 97–98
Fine arts photographs, limiting copies of, 87; as personal expression, 96; proper presentation of, 88
Fine arts photography, 87–109; categorizing, difficulty of, 17; characteristics of, 17–18; creativity, time orientation of, 103–106; creativity in choice of subjects, 102–103; and previsualization, 104–106; reality and, 107; self-conscious representation of, 17–18
Fisher, Ernst, 5, 118
Flexibility, in news stories, 58–59
Fliegel, Norris, 118
Focus, in photography, 71, 72, 104
Fowler, Roger, 2
Fox, Daniel M., 118–119
France, 120
Freidson, Eliot, 7, 76, 117, 122
Freud, Sigmund, 6, 122
Function, and style, 114–115

Galleries, photographic, 88–93; directors of, 88–89, 90, 91–92; financial arrangements with, 90; portfolio submissions to, 88–89, 91; shows at, 89–90
Gatekeepers, 99, 118, 120, 129
Gernsheim, Helmut, 32
Golding, John, 2
Goldmann, Lucien, 5
Gombrich, E. H., 2, 3, 13
Gourmet (magazine), 75
Griff, Mason, 39
Guilford, Joy Paul, 129

Hall, Edward T., 23
Hauser, Arnold, 5
Hennessy, Thomas J., 115
Henning, Edward B., 118
Hough, Graham, 2, 3
Hughes, Everet C., 26, 80, 121

Ivins, William M., Jr., 115

Kaplan, Abraham, 8
Kealy, Edward, 115
Kramer, Judith, 96
Kroeber, Alfred L., 2, 4

Labor, degradation of, 122
Labor, division of: constraints from, in news photography, 53–55; and style, 116–117, 123, 128
Langer, Susanne K., 32–33, 123
Lanham, Richard, 2
Lasch, Christopher, 115
Layouts, art directors', 64–65, 67, 71, 72, 73, 81, 82–83
Le Corbusier, 33
Lester, Marilyn, 41
Life (magazine), 22, 75
Lighting, 16, 20, 71–72, 84; importance of, to models, 79–80; Polaroid shots for checking, 72, 79–80
Lindesmith, Alfred, 126
Look (magazine), 22
Luckman, Thomas, 26, 55
Lukács, George, 5
Lyon, Eleanor, 119
Lyons, Nathan, 18

Madison Avenue Handbook, 65
Maholy-Nagy, 90
Martorella, Roseanne, 120
Marx, Karl, 8, 127–128
Marxism, 5, 7, 8, 128
Matejka, Ladislav, 2
Mead, George Herbert, 23, 118, 125–126
Merton, Robert, 28, 55, 125
Meyer, Leonard, 125–126, 127
Miles, Josephine, 2

Models, photographic, 68–71, 79–80
Molotch, Harvey, 41
Mozart, Leopold, 125
Mukerji, Chandra, 33, 35
Museum of Modern Art, 32
Museums, 93–96; handling of photographers by, 91; judgments of photo curators in, 93–95, 99; and patronage, 118–119; values of collections in, 96; variables among, 93

New York Times, 76
Newhall, Beaumont, 32, 95
Newspaper photographers, 7; and alienation, 128; anticipation, sense of, needed by, 24; assignments and specialization, 53–54, 61, 123; audiences of, 125; constraints in decision making on, 54–55; coverage by, 49–50; creativity of, 57–62; getting caption information, 50; hours and shifts of, 48–49; information not shared with reporters by, 20, 21–22; maintenance of reality by, 22–24; no choice in photo selection by, 44; self-image of, 61–62; situational constraints on, 55–57; socialization of, 19–25; technical constraints on, 51–53; unobtrusiveness of, 22–24; work role of, 121
Newspaper photographs: automated printing of, 44–45; automated processing of, 43–44, 51–52; defining a "good" one, 57; interpretive areas in printing of, 45–46; poor quality of, 45–46, 51–53; scaling of, 48; selection of, 44, 46–47, 57–60
Newspaper photography: characteristics of, 13–15; classification of news events and, 60; division of labor, constraints from, 53–55; situational constraints on, 55–57; technological constraints on, 51–53
Newspapers, general background of, 41–48; different definitions of news, 41–43

"Original standard pictures," 81
Originality, fine arts photographers and, 100–101, 108

Panofsky, Erwin, 2, 3, 13
Patronage, 118–119
Peckham, Morse, 2, 4, 18
Pelles, Geraldine, 119
Personal historical time, 103
Peterson, Richard A., 5, 119
Pevsner, Nikolaus, 118
Photo-editors: activities of, 41–43, 44, 46–48; creativity judgments by, 57–60
Photographic styles: advertising, 15–16; fine arts, 17–18; news, 13–15
Photographic styles, determinants of, 111–129; alienation, 127–129; control over work, 122–127; distribution system, 118–121; production, three dimensions of, 113–117;

socioeconomic, 111–112; work organization, 111, 112, 113–117; work roles, 121–122
Photographic styles, innovation and, 112
Photographic styles, sociology and, 1–11; borrowings between, 112; differences among, 111; social-behavioral aspects of style, 4–9; stylistic analysis, 2–9; typifications, 112
Photographic time, 104–106
Picasso, Pablo, 2
Place sensibility, 14
Pollack, Peter, 32
Prestige, 121
Previsualization, 104–106
Printing, and post-shooting creativity, 105–106
Production, dimensions of, and style, 113–117; function, 114–115; labor, division of, 116–117; technology, 115–116
Public service ads, 72

Read, Sir Herbert, 14, 123
Research methods, 9–11; participant observation, 9
Retouching, photograph: advertising, 66, 70–71, 78; news, 48
Rosenberg, Bernard, 118
Rothschild, Lincoln, 2, 4

San Francisco Art Institute, 34
Sanchez Vasquez, Adolpho, 5
Scaling, of news photos, 48
Schapiro, Meyer, 1, 2, 3, 118
Schutz, Alfred, 55, 70, 112
"Seeing," 19, 33–36
Seeman, Melvin, 127
Shibutani, Tomatsu, 19, 23, 28
Snapshot aesthetic, 113
Social History of Art, The, 5
Socialization, 19, 39–40; of advertising photographers, 25–31; of fine arts photographers, 31–39; of news photographers, 19–25
Sontag, Susan, 3, 18, 111
Space sensibility, 14
Steichen, Edward, 95
Stevens, Wallace, 124
Stieglitz, Alfred, 100
Strauss, Anselm, 126
Style, a sociological approach to, 1–11

Taft, Robert, 32
Technology in production, and style, 115–116
Thompson, James, 122
Time (magazine), 75
Titunik, Irwin R., 2
Tuchman, Gaye, 41
Turner, G. W., 2
Turner, Ralph, 28
TV filming, conflicts with, 20
Typifications, 112

Wall Street Journal, 76
Watanabe, David, 17
Weber, Max, 116
Weston, 90, 106, 107
White, Cynthia, and Harrison C. White, 118, 120
White, Minor, 104
Williams, William Carlos, 124

Work, organization of, 6–7, 111, 112, 113–117
Work roles, 113–117, 121–122
WPA, 120

Zone system, 104
Zone System Manual: How to Previsual Your Pictures, 104
Zucker, Paul, 2, 14